POINT
AND
SHOOT

D1119695

POINT
AND
SHOOT

HOW TO TAKE GREAT PICTURES
WITH AUTOMATIC CAMERAS
LOU JACOBS, JR.

AMPHOTO

an imprint of Watson-Guptill Publications/New York

Lou Jacobs, Jr., a well-known writer and photographer, is the author of more than 20 books on photography, including *Developing Your Own Style*, *Available Light Photography*, and *Selling Photographs*, all published by Amphoto. He is a past president of the American Society of Magazine Photographers (ASMP) and is currently a member of its board of directors. Jacobs has taught photography courses at UCLA, Cal State Northridge, and Brooks Institute of Photography, and has written extensively for photographic magazines. He lives with his wife, Kathy, in Cathedral City, California.

A number of people have generously lent me excellent photographs to help illustrate this book, and I want to thank them all, especially Austin MacRae. I would also like to thank Liz Harvey for her careful editing, and my wife, Kathy, for her help and encouragement.

Every photograph appearing in this book is copyrighted in the name of each individual photographer. Publication rights remain in their possession. All photographs not otherwise credited are copyrighted by the author.

Editorial concept by Robin Simmen
Edited by Liz Harvey
Designed by Bob Fillie, Graphiti Graphics
Graphic production by Ellen Greene

Copyright © 1993 by Lou Jacobs, Jr.
First published 1993 in New York by Amphoto,
an imprint of Watson-Guptill Publications,
a division of BPI Communications, Inc.,
1515 Broadway, New York, NY 10036

Library of Congress Cataloging-in-Publication Data
Jacobs, Lou.
 Point and shoot/Lou Jacobs, Jr.
 Includes index.
 ISBN 0-8174-5535-3
 1. Electric eye cameras—Handbooks, manuals, etc.
2. Photography—Handbooks, manuals, etc. I. Title.
TR260.5.J33 1993
771.3'2—dc20 93-17720
 CIP

All rights reserved. No part of this publication may be reproduced or used in any form or by any means—graphic, electronic, or mechanical, including photocopying, recording, taping, or information-storage-and-retrieval systems—without written permission of the publisher.

Manufactured in Hong Kong

1 2 3 4 5 6 7 8 9/00 99 98 97 96 95 94 93

CONTENTS

INTRODUCTION

This compelling ice cave in Grindelwald, Switzerland, challenged my P&S camera's autoexposure system when I used its widest 38mm setting and ISO 200 film. The bright center area called for an exposure that caused the interior cave walls to appear somewhat dark, but the highlights add to the image's stark pictorial drama.

Point-and-shoot (P&S) cameras, which are also called *compact cameras* or *lens/shutter cameras*, are easy-to-carry, easy-to-use, and often "automatic-everything" cameras. Millions of them are currently used by enthusiastic photographers, and millions more are purchased each year. Early P&S models weren't as versatile as today's electronic wonders, which are designed to automatically focus and expose in the blink of an eye. Many models do much more. In addition to putting dates on your prints, they enable you to shoot at night and to take self-timer shots. Although *single-lens-reflex (SLR) cameras* also offer automatic features, they are larger, heavier, more expensive, and usually more complex than P&S cameras. Both SLR and P&S cameras give you similar wizardry of sensors, computer chips, intricate circuits, miniature motors, and amazing zoom lenses. But P&S cameras combine those features in a compact body to encourage more frequent picture-taking; some P&S models are even pocket-size. Most P&S cameras can be used with ease after you read the accompanying instruction booklet, which tells you how to operate the camera—but not how to take good pictures with it.

You don't need much photographic experience to use a P&S camera, but you wouldn't be reading this if you didn't have higher-than-average expectations. You can merely load a camera with color film and start taking pictures, but you want to learn how to take more exciting pictures than you do now. The technical information and creative tips in this book can give you confidence as you get more photographic experience, which is necessary for successful P&S photography. Reading and shooting lead to new visual awareness, which in turn leads to producing better pictures of friends, family, scenics, pets, or dozens of other subjects.

Photography is like learning to play golf. You practice shooting, you get the feel of the equipment, you study your prints with care, and you learn from your mistakes. Your reward is to avoid making the same mistakes again. You can't expect to shoot a golf course in par perfectly the first time, and you can't get pictures that will be admired without trial and error either.

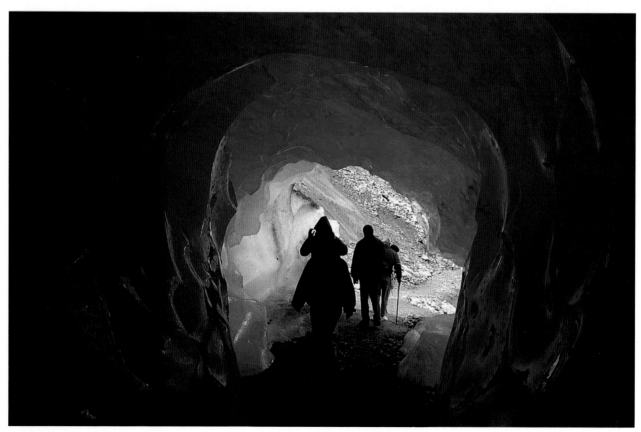

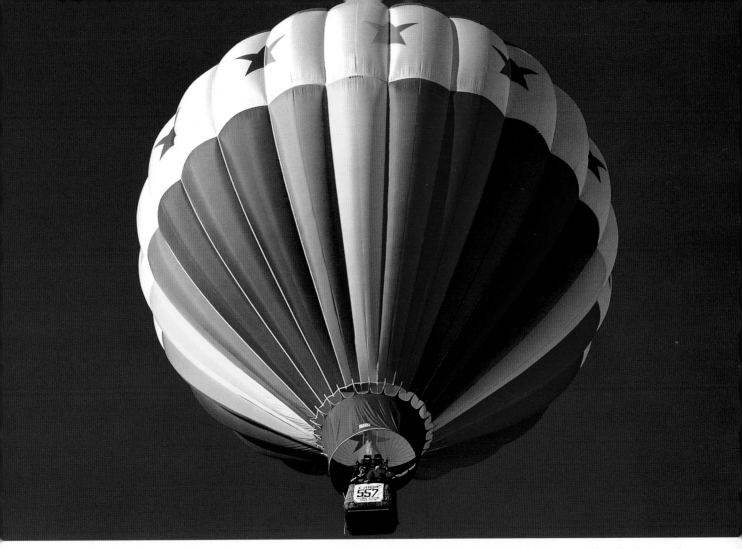

You'll learn how to visualize pictures in your mind as you see the subject through the camera's viewfinder. You'll use your imagination and enjoy feeling creative as you look at the world around you. You'll see colors in nature and in man-made objects in a refreshing way, and you may view works of art with more interest. It is very helpful to observe the way painters and printmakers compose scenes, and how they place colors together. You may feel like a casual photographer, but the stimulation you'll feel trying to make good pictures can turn into an avenue of adventurous and rewarding self-expression.

"DRIVING" YOUR CAMERA

The better you understand all the basic photographic theories, the better you'll understand your camera's instruction manual and the better you'll "drive" your camera. To elaborate, no matter how simple or sophisticated your modern P&S camera is, you are in charge of "driving" it. Just as you do when driving a car, you must watch the dials and know which buttons to push. You have to "steer" the camera through the

viewfinder in order to choose the subject and compose the picture. Your finger on the shutter-release button decides when to snap. Like driving, photography requires making decisions; here, however, your physical safety isn't in danger. I hope that this book can help make you comfortable and confident when you face image-making challenges and responsibilities. As a reward, you'll get more interesting pictures that gratify your eyes and ego, as well as praise from other people.

LETTING YOUR POINT-AND-SHOOT CAMERA DO THE WORK

George Eastman, who invented the Kodak camera, coined the phrase, "You push the button and we do the rest." This slogan referred to the 1888 Kodak camera that made 100 exposures on a roll of film. The whole camera was then sent back to the Kodak factory for film development and reloading. In dramatic contrast more than a century later, your compact P&S camera allows you to simply push a few buttons, including mode buttons and switches, and the camera does the rest, activating focus,

When the photographer saw this multicolored balloon ascending, he knew that he'd come upon a perfect picture situation: no distracting elements, the brilliant light of New Mexico, and a deep blue sky as a background. Shooting with a zoom lens set at about 90mm, he made 10 exposures in a minute or so, realizing that this opportunity would quickly float away. Courtesy of Austin MacRae.

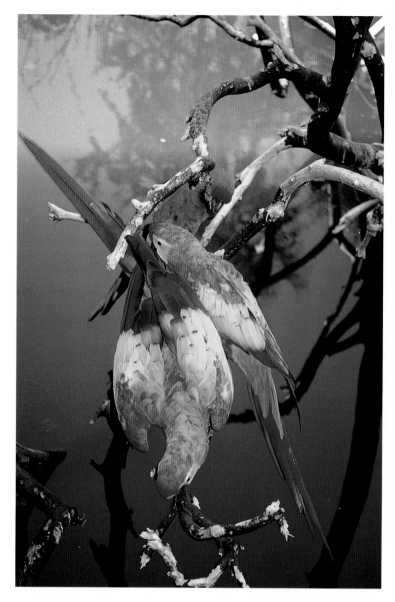

Here, existing daylight and flash blend beautifully (above). The right amount of flash adds sparkle to the color of these parrots at the San Diego Wild Animal Park.

For this shot of a Navajo weaver in Utah, the photographer knew that his P&S camera would make the necessary adjustments (opposite page). Shooting with ISO 100 film and a zoom lens, he decided not to use fill-flash; he felt the shadows would make the image stronger. Courtesy of Austin MacRae.

exposure, shutter, and flash. You zoom the lens, though some cameras even do that for you. Within hours, you can see color prints Eastman never imagined.

Shooting pictures worth saving and framing also depends on seeing and snapping interesting, attractive subjects in pictorial light. I chose the words and pictures in this book to help you become more aware of light, so that you'll be more sensitive to lighting effects. You'll also learn how to make more pleasing, exciting compositions and to shoot more effective action photography.

Although I've done most of my photography for publications with SLR cameras, in 1987 I began using a P&S camera for pictures of friends, family, and social events. I wanted a more convenient way to shoot color prints for myself and to give away, and a P&S camera with

automation and built-in flash was the answer. Today, I'm hooked on the pleasures of P&S photography, and I enjoy using color-negative films because they are much less temperamental than slide films. Conveniently, you can also make slides or black-and-white prints from color negatives. Over the years, I've compared numerous films shot with six different P&S cameras (several borrowed from Olympus) as I upgraded from a dual-lens P&S camera to various zoom-lens models, each offering more than the preceding one. The P&S model I now use is more automated than some of the SLRs I once used.

I'm absolutely sold on P&S autofocus and autoexposure capabilities, as well as built-in flash and all the other welcome electronic features that make photography easier and more reliable. The versatility of color-print films also makes shooting with compact cameras more enjoyable. I hope that my enthusiasm about what you can expect from a compact automated P&S model and color films will be contagious. These pages offer guidance to anyone who wants to make pictures with greater pictorial impact, which means sharp, well-composed prints that show spontaneous action, lively expressions, or beautiful scenes. Such photographs can be taken almost anywhere in various lighting conditions of your choice. The many photographic techniques covered in this book are intended for photographers with creative ambition as well as for casual snapshooters. The book can also benefit owners of so-called "bridge" cameras, which are very similar to SLR cameras but lack removable lenses.

Included in each chapter are clear, detailed explanations and pictures with instructive captions to inspire you and show you how to get the most from any brand or model of P&S compact camera. Enjoy the photographs, and read the captions, which condense very useful information. Shoot plenty of pictures as you go along. There is no substitute for the learning experiences you have when you use your own P&S equipment.

After you read through this book, you'll understand P&S camera functions better than instruction brochures can explain. You'll also improve your visual sensitivity and be assured of shooting more satisfying photographs of whatever subject matter appeals to you.

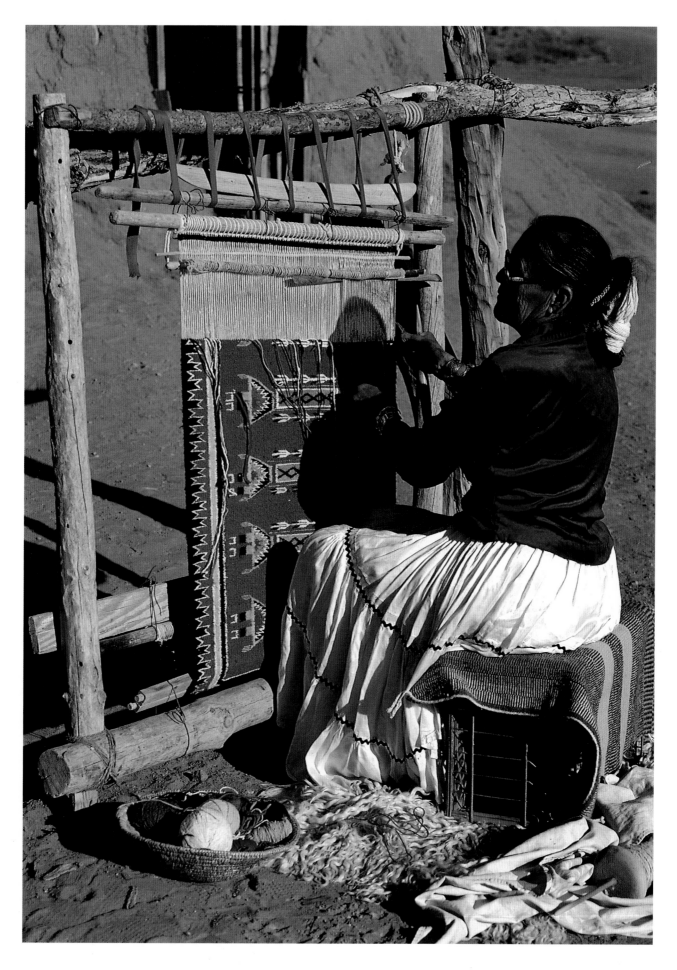

THE JOYS OF POINT-AND-SHOOT CAMERAS

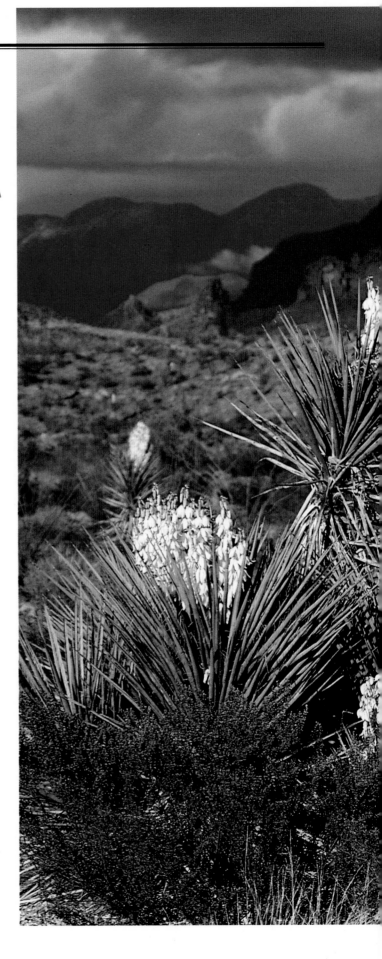

In Big Bend National Park, Texas, lupin lines the highway and yucca flowers bloom in spring. I chose a viewpoint that combines a floral foreground with strong contrasting mountains and clouds in the background. Since only part of the curving road is visible, it doesn't cut the composition in half.

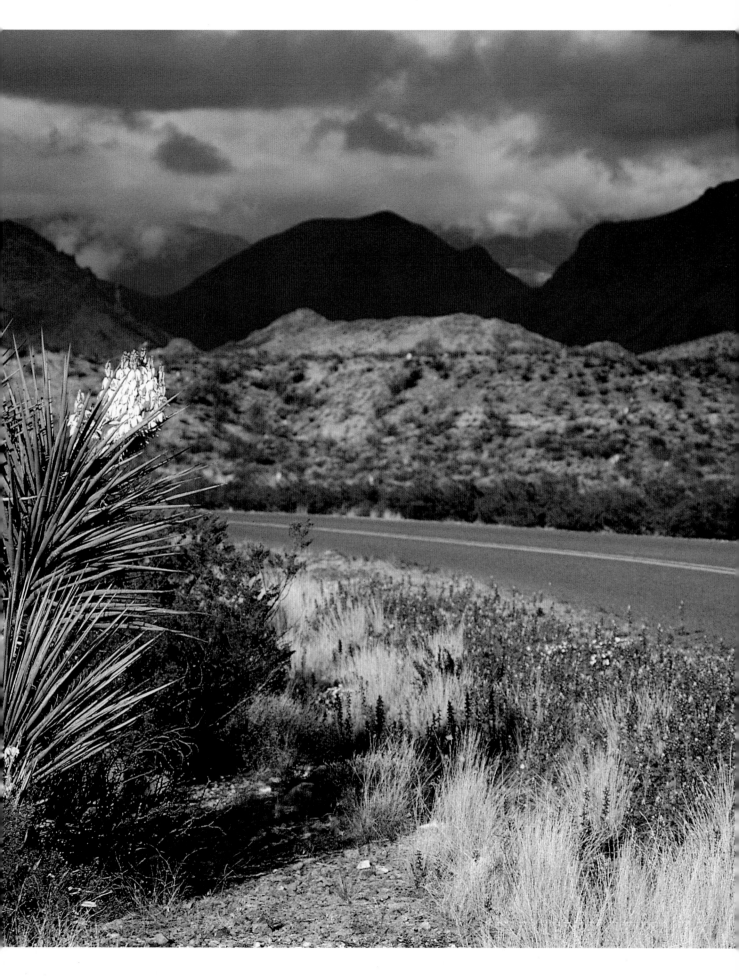

Shooting with a point-and-shoot (P&S) camera can be very simple: turn it on, look through the viewfinder, decide what you want to include in your picture, and press the shutter-release button. If there is enough light, the camera will make the proper exposure, the film will advance, and the camera will be ready to shoot again. But if the light is dim, most cameras will trigger the built-in flash automatically and the exposure will be fine. When you need more light to brighten shadows in sun or shade,

The sensible way to start is to *read the instruction manual that came with your camera.* Complex cameras with special picture-taking features usually come with the longest and most detailed instructions. My latest, sophisticated P&S camera has a 40-page booklet that explains its operations. My wife and I have both read this compact booklet several times in order to memorize the functions we use most. We still carry the booklet with us to refresh our memories about how to program such options as multiple self-timer shots or time exposures at night.

In the front of your camera, there may be several small windows besides the viewfinder. These windows are sensors for the automatic focus and automatic flash. Try to keep your fingers away from these windows as you shoot, and wipe them clean occasionally.

Some P&S brands and models use a *liquid crystal display (LCD)* on top of or at the back of the camera body. The LCD indicates the operations of the camera's automatic options in numbers or symbols. If your P&S camera uses an LCD display, study the illustrations in the instruction book so that you can interpret the data. Understanding the display panel is the key to photographic control. I can explain P&S operations, but you must be familiar with the specific instructions for your own camera.

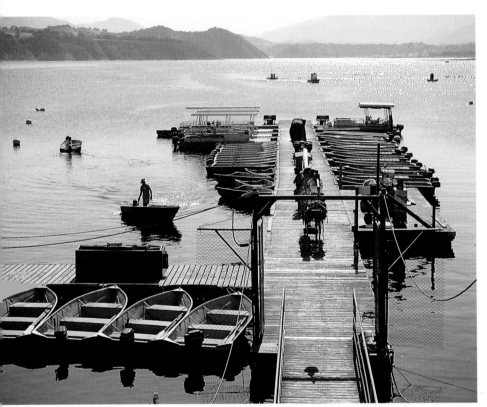

For this early-morning shot of California's Lake Cachuma, I mounted my P&S camera on a tripod and used ISO 100 film. Using the wide-angle view of the camera's 35mm lens enabled me to show the backlighted dock, as you can see from both the direction of the shadows and the highlight pattern on the background water.

many cameras provide the right amount of flash to help prevent dark shadows that might spoil pictures. After the last exposure on the roll, most cameras rewind the film automatically.

These basic P&S operations make good pictures possible with minimum effort. However, with more effort, you can achieve far better photographs. Whether you use an inexpensive P&S model or you use a more advanced zoom-lens P&S camera, you certainly owe it to yourself to think about more serious picture-taking. That means making prints that are more than just "clear" or prompt you to say, "They came out."

There is no substitute for becoming familiar with your own camera manual. I emphasize this point because you need its invaluable help not only for basic functions, but also when creative ideas come to you. Because all cameras operate somewhat differently, I can't tell you which buttons to push in order to set a particular camera function; however, I can describe the photographic techniques those buttons make possible. Experimenting with the basic and advanced options your camera offers is the best way to become comfortable with it and what it can do.

Despite the many convenient features of P&S cameras, they aren't foolproof. The simplest models make picture-taking seem easy, and you are likely to get casual, often pleasing snapshots. Eventually, you may be challenged to own a more complex camera that will enable you to take faster action shots, compose pictures more precisely with a zoom lens, or make moody images without flash. Better P&S cameras add flash automatically, and the most desirable models now have built-in zoom lenses. If you're thinking about getting a new P&S camera, you need to consider—and to understand—all the options available (see chapter 13).

P&S cameras are intriguing pieces of photography equipment. A dozen years ago, I never imagined that today's models could be designed and produced. For example, automatic focus seemed to be an impossible dream: how could a camera know what part of the subject you wanted to be sharp? However, camera automation has advanced remarkably, to the point where cameras make technical decisions; eliminating the need to make these often distracting choices has greatly simplified photographers' lives. Today, the autofocus feature is included on all but the most basic P&S cameras, as well as on many SLR cameras, which are heavier and more expensive. In fact, both camera types offer a long list of automatic controls.

Space-age technology, complete with computer chips and circuitry, does automatically what photographers used to do manually, or not at all. The more expensive and more contemporary a P&S camera is, the higher the number of automatic features you can expect it to have. These include:

Automatic Focus. With automatic focus, the camera lens focuses on a subject that appears within a rectangle or circle in the viewfinder as you press the shutter-release button. As the feature's name implies, autofocus is instantaneous. In addition, it requires virtually no effort on your part. When the main subject is off-center, you simply hold the shutter-release button halfway down with the autofocus mark over what you want sharp, and recompose. The main subject will then be in focus.

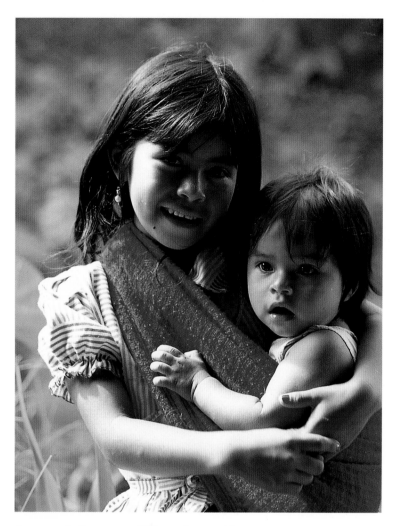

Automatic Exposure. This option enables your P&S camera to determine the right exposure for a scene with amazing accuracy milliseconds before you take a picture. Both autofocus and autoexposure free you from technical worries that used to vex many photographers, thereby letting you concentrate on composing pictures and recording action, facial expressions, or beautiful scenes.

Automatic Film-Speed Setting. The black and silver DX code on each 35mm film cartridge signals to the camera the speed of the film. This means that you don't have to be concerned about forgetting to set a film-speed dial when you switch from one film to another.

Automatic Film Advance and Rewind. This combination feature is a real boon to many photographers. Once you load the film as indicated by the diagram or arrows inside the camera and close the camera

Traveling in Ecuador's Amazon Basin, the photographer came upon a village of Quechua Indians, where she decided to photograph a number of the children. For this portrait of two sisters, the photographer relied on her compact, zoom-lens P&S camera's automation. She tried fill-flash here but decided that she preferred the effect of the available light; at times, bright shadows seem artificial to her. Courtesy of Terri Wright.

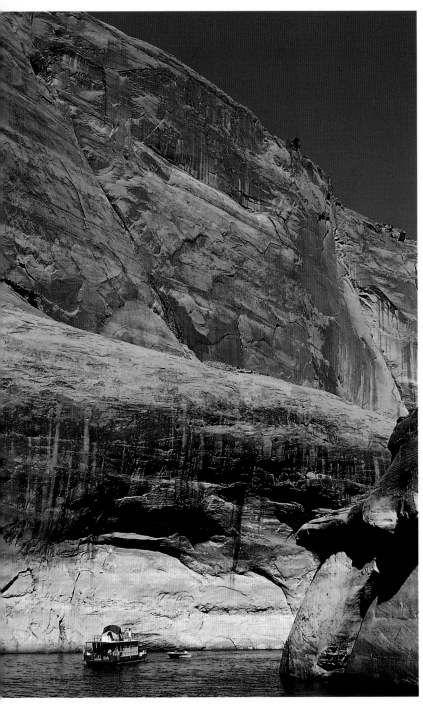

As you ride a tour boat on Utah's Lake Powell, spectacular views inspire you to take plenty of pictures. Using a dual-lens or zoom-lens camera allows you extra flexibility, and color-print films provide a way to get accurate color in almost all exposure situations. When traveling, shoot away: film and processing cost much less than food and lodging, and you can never put a price on a missed shot.

back, a miniature motor winds the film to the first frame. Each time you shoot, the film advances automatically. Most P&S cameras indicate when the film doesn't begin winding, and won't operate until the film winds and the lens is uncovered. When the last frame is exposed, the camera senses this and automatically rewinds the film into the cartridge. More sophisticated P&S models offer a mid-roll rewind feature; this is convenient when you decide not to finish shooting a roll and want to see prints sooner. The film is completely rewound into the cartridge, so you can't make a mistake and load it again.

Automatic Flash. Several flash modes are built into many P&S camera models (see chapter 4). In most cameras, the flash operates automatically when there isn't enough light to permit you to hold the camera steady. Modulated autoflash also brightens shadows in sunlight, which is especially flattering for shots of people. This is called *fill-flash* or *fill-in flash*, and the camera computes the proper exposure for more attractive pictures.

Automatic Composition. In a few camera models with zoom lenses, the camera zooms to an "ideal" composition focal length when you hold the viewfinder to your eye or select the *portrait mode*. Of course, you can change the lens length if you wish. This feature is very handy for some people, particularly beginners. Some P&S models offer an *automatic-zoom mode* just for portraits. It gives you varied views of the same subject from the same spot by presetting the autozoom function.

Battery Condition Indicator. Many P&S models include a small symbol that shows when the battery (or batteries) is weak and needs to be changed.

SPECIAL ADVANTAGES
OF P&S PHOTOGRAPHY

An old friend of mine traveled around the world about 25 years ago taking pictures with a small *rangefinder camera* with no automatic features. The camera had no exposure meter, but fortunately my friend was able to guess exposure times based on printed data that came with the film. She carried packages of little flash bulbs for night shots and spent a great deal of time making camera adjustments. She had no urge to experiment. With one of today's P&S camera, my friend could be carefree as she shot pictures of people, places, and

things, while concentrating on lighting, facial expressions, or people at play. Her flash pictures would be much simpler to make than they were 25 years ago because of exposure automation.

P&S photography is a pleasure in other ways as well. Because your P&S camera fits in a small shoulder bag, jacket pocket, or purse, you are more likely to carry it with you than you would an SLR camera, which doesn't tuck away or operate as easily. As a result, you are also more likely to take pictures more often. Another important advantage of P&S cameras is that they are primarily designed to use color-print films, which can be manipulated more readily than color-slide films. The brilliance and color fidelity of modern color-print films and the quality of the average automated processing are impressive.

Photography today can be more fun and rewarding because there is an enormous number of P&S picture possibilities, and dozens of different P&S cameras are handy to use. Prepare to shoot an endless variety of subjects, from a field of wildflowers to a bunch of wild children at play. And as your P&S skills improve, you'll find yourself becoming more satisfied with and excited by your photography. You face fewer pictorial limits when your enthusiasm and your ability work together.

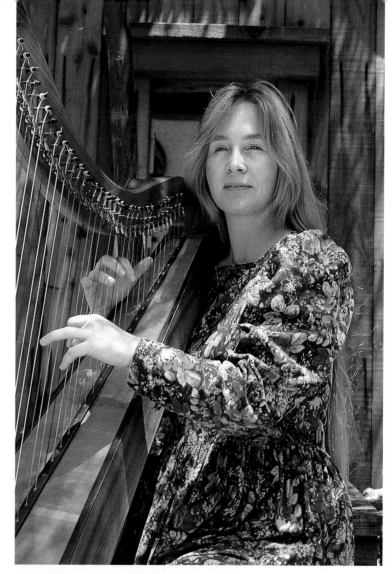

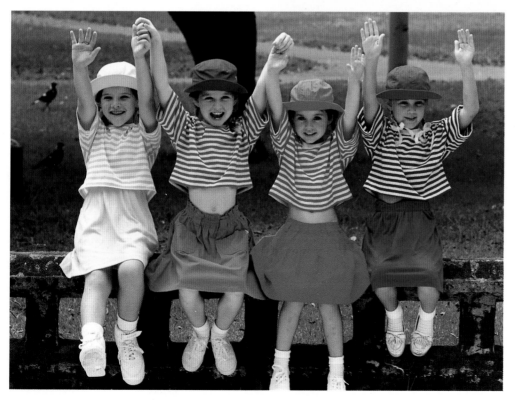

P&S cameras take the guesswork out of photography. Even the least expensive P&S cameras can provide excellent exposures and sharp-focus images with little effort on your part. After listening to this harpist at an art fair, I asked to take some pictures of her and received permission (above). Shooting with a 38mm lens from a low angle, I used fill-flash to soften the shadows.

For this photograph, the decorative colors and stripes were chosen for visual appeal, and soft fill-flash or a reflector brightened the little girls' faces (left). This picture shows how careful preparation and a harmonious setting combine to warm viewers' hearts. Courtesy of Fuji Photo Film U.S.A.

LENSES, SHUTTERS, AND AUTOEXPOSURE SYSTEMS

Scenic pictures can be enlarged and framed, given as gifts, used as personal greeting cards, or submitted to contests. Scenics are always popular subjects because people are inevitably drawn to the pageant of beauty that nature puts on worldwide. I made this photograph one afternoon in Canyonlands National Park, Utah, when a cloud temporarily cast a shadow on the foreground, creating a frame for the landscape. Here, I used ISO 200 color-print film and set my P&S camera's zoom lens at 35mm.

Familiarity with how your point-and-shoot (P&S) camera works improves your confidence and helps you take better pictures. For example, being aware of how different lens openings affect your pictures increases your control. The least expensive P&S models offer fewer lens options, but the more advanced models that have several lenses or a zoom lens enable you to take more interesting and exciting pictures. It is good to feel creative with your P&S camera, even if you often shoot casually. The camera does a great deal for you automatically, but a little photographic theory goes a long way toward putting you in charge.

Camera lenses are identified by their focal length and maximum *f*-stops or apertures. By knowing the significance of these terms, you'll have a better basis for buying and using a P&S camera with added skill. *Focal length* describes the angle of view of a lens. Millimeter numbers on the lens or camera body indicate the varying sizes of images you get on the film. Smaller focal length numbers, such as 35mm and 38mm, indicate short focal lengths; these *wide-angle lenses* record a broader view of the scene. A medium focal length is about 50mm. In 35mm photography, 50mm lenses are referred to as *standard*, or *normal*, *lenses*. Larger numbers, such as 80mm, 90mm, and 105mm, indicate a narrower viewing angle and longer focal lengths. These *telephoto lenses* "reach out" to make larger or closer images from a given viewpoint than wide-angle and standard lenses do.

Inside a camera lens is a diaphragm made of overlapping metal blades that open and close to form a circular opening, which is determined by the camera's exposure system. This *lens opening*, or *aperture*, regulates the amount of light that strikes the film and together with the shutter, determines photographic exposure. The widest opening of a lens is its largest aperture, also known as its *maximum f-stop*. Standard *f*-stops on P&S camera lenses are *f*/2.8, *f*/3.5, *f*/4.5, *f*/5.6, *f*/8, *f*/11, *f*/16, and *f*/22. Zoom lenses are marked with two *f*-stops; the first, such as *f*/3.5, pertains to

its wide-angle setting, and the other, such as *f*/8, to the maximum aperture at its telephoto setting.

The smaller the *f*-stop, the larger the lens opening and the faster the lens. "Faster" means that the lens admits more light at a large *f*-stop, such as *f*/3.5, than it does at a smaller *f*-stop, such as *f*/11. As *f*-stop numbers become higher, a lens admits less light. In other words, for example, at *f*/4.5 a lens admits half as much light as it does at *f*/3.5. Conversely, at *f*/5.6 a lens admits twice as much light as it does at *f*/8. An autoexposure system measures the intensity of the light in the scene, and sets smaller lens openings in bright light and

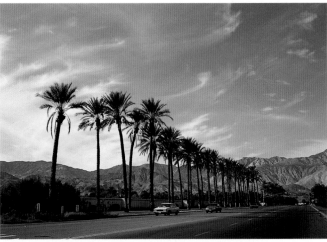

larger apertures in dim light. The auto-exposure system also sets faster or slower shutter speeds in conjunction with lens apertures, as required by the film speed. Smaller lens openings, which the camera is likely to set when you shoot outdoors, result in greater *depth of field* in pictures. Depth of field refers to how much of the scene is in sharp focus from foreground to background. You can increase depth of field in your images by using relatively fast films with ISO 200 or 400 ratings; this is especially helpful with fixed-focus P&S cameras.

Though you aren't aware of the *f*-stop or shutter speed your P&S camera auto-matically sets when you take a picture, it is useful to understand how lens openings and shutter speeds affect such pictorial qualities as sharpness and color in different lighting conditions. Knowing what is happening technically inside your camera can improve your photography.

SINGLE-LENS VERSUS DUAL-LENS CAMERAS

Many P&S cameras have only one lens, which may have a maximum opening of either $f/3.5$ or $f/4.5$. The simplest and least expensive versions of these single-lens cameras have a single wide-angle lens, usually 35mm or 38mm. However, the lenses of two 1992 P&S camera models have focal lengths of 24mm and 28mm, both ultrawide-angle.

Dual-lens cameras provide an intermediate lens option. The two focal lengths offered may be 38mm and 50mm, 60mm, 70mm, or 80mm. The wide-angle lens may have a maximum aperture of $f/3.5$ and the longer lens an aperture of $f/5.6$ or $f/6.3$. You can switch from one focal length to another simply by pressing a button or lever. An 80mm setting gets you more than

get closer to a distant mountain peak, isolate one sailboat among many, or photograph an entire person at a wide-angle setting and then zoom to just his or her face. To photograph a group when you can't move back very far, you simply have to zoom to the shortest focal length, such as 35mm or 38mm.

A zoom lens can also be set at many focal lengths between wide-angle and telephoto, which is a real photographic convenience. The viewfinder image changes to match what the lens sees. In addition, zoom lenses telescope neatly into the camera body when the power is turned off. Compact zoom lenses and zoom viewfinders are valuable camera features.

At 38mm, the maximum aperture of a zoom lens may be $f/3.5$, although at 80mm, 90mm, or 105mm, the maximum f-stop is

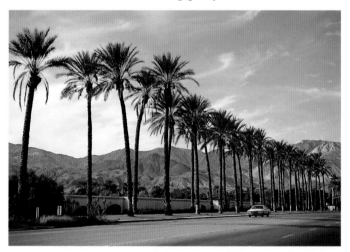
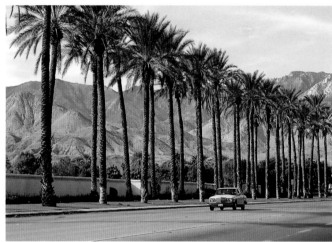

twice as close to a subject as a 35mm or 38mm setting does. This enables you to get two separate views of a subject from one vantage point with dual lenses. Both lenses may be useful when you want to shoot scenic pictures or group portraits.

ZOOM-LENS CAMERAS

These are the most versatile P&S cameras, and their focal lengths range anywhere between 35mm or 38mm and 70mm, 80mm, 90mm, 105mm, or 110mm. The greater the zoom range of the lens, the more versatile the camera is and the more it is likely to cost. Using two buttons or a switch, you can zoom the lens to its longest focal length, such as 105mm, for a telephoto view and then back to a 38mm wide-angle image. The advantage of using a zoom lens is that you can adjust it to shoot varying image sizes from one viewpoint. You can

reduced to about $f/5.6$ or $f/8$, so the cameras can be designed compactly and cost less. Clearly, a P&S camera is usually chosen because of its lens type—single, dual, or zoom—not for its maximum lens aperture. Even with a fast film, an $f/3.5$ aperture isn't very effective in dim light without flash because the system chooses a slow shutter speed, too, and camera movement, or *camera shake*, is almost inevitable. When you use the longer of two dual lenses or a zoom lens in its telephoto mode, the maximum f-stop in use is reduced; this is another indication that P&S cameras aren't specifically designed for some types of available-light photography. Without the use of a tripod, shutter speeds may be too slow. However, flash is always available, and automated P&S cameras and lenses are wonderful for a broad range of shooting situations.

I took these three pictures from the same position to demonstrate how a view changes as the lens focal length changes. Adjusting my 35-105mm zoom lens, I used the 35mm setting for the first shot (left), the 60mm setting for the next shot (center), and the 105mm setting for the last shot (right).

BRIDGE CAMERAS

More expensive and complex cameras in the luxury P&S category are called *bridge cameras* because they include features that bridge the gap between compact P&S models and larger SLR types. Much of the basic theory and information about shooting with P&S cameras, as well as all photographic theory, is applicable to bridge cameras. But bridge cameras are bulkier, more complex, and more expensive than other P&S models. They offer *through-the-lens (TTL) viewing*, just as SLR cameras do, and a nonremovable lens, just as P&S cameras do. However, bridge cameras provide a wider range of shutter speeds and adjustable aperture settings, stronger flash, and, in some models, add-on telephoto-lens attachments.

The advantage of a bridge camera, according to an Olympus booklet, is that you can enjoy certain SLR photographic controls without having to buy and carry an assortment of lenses. But if you want the versatility that comes with numerous camera options, I recommend considering automated SLR cameras with interchangeable lenses. These cameras may be only slightly more expensive than bridge models. P&S equipment has the advantage of being lightweight and compact; bridge cameras are somewhat less convenient to carry or handle. When you become more serious about photography, an SLR may beckon, but until then a versatile P&S camera can simplify your life and provide terrific pictures at the same time.

This photograph of Australia's famous Sydney Opera House at sunset under a series of dramatic clouds was shot with a bridge camera and a 105mm lens. Courtesy of Kristal Kimp.

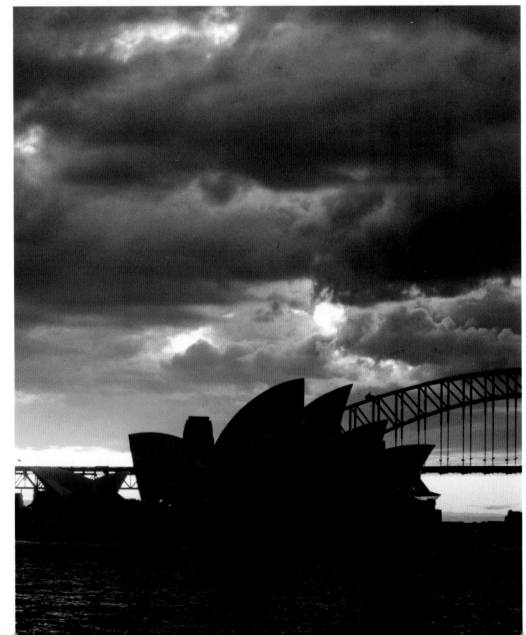

A 1992 chart of P&S cameras shows a large assortment of fast and slow shutter speeds among many brands and models. Maximum speeds range from 1/125 sec. to 1/1000 sec., with the average speed around 1/300 sec. Slow shutter speeds range from 1 or 2 seconds, to 1/2 sec., 1/4 sec., 1/3 sec., and 1/8 sec. More expensive cameras often have slower and faster speeds than lower-priced models, but some medium-priced cameras have a wider range, too. Fast shutter speeds are necessary for recording sharp action, while slow shutter speeds are valuable for shooting in dim light levels without flash and for time exposures. Ask about the high and low shutter speeds when you buy your next camera, and check the speeds for your present camera in the instruction booklet. Being familiar with how the camera may be operating with fast and slow shutter speeds is pictorially useful, though you can't be sure what speed the camera system chooses. You do learn to anticipate shutter speeds in relation to the light level as you study enough good and bad prints.

Shutter speeds of 1/125 sec. and 1/250 sec. are usually suitable for photographing children at play and other medium-fast action. But these speeds might not be fast enough to stop movement in sports, such as tennis, football, soccer, volleyball, or basketball, so some pictures will be blurred. Shutter speeds of 1/400 sec. and 1/500 sec. are more useful for sports action (see chapter 9).

When you use flash in dark places or dim light in order to shoot action, the speed of the flash itself both freezes motion and determines the exposure. The camera might choose a shutter speed of 1/125 sec., for example, for flash shots, but the flash pops at 1/500 sec. or faster. However, sometimes the ambient light is bright enough to register a moving subject slightly blurred in relation to its sharper appearance in a shot

made with flash. This blurred effect is called a *ghost image* and can be either decorative or annoying, depending on the subject. Unfortunately, camera instruction booklets don't indicate how the camera chooses a shutter speed in the fill-flash mode.

Some slow shutter speeds offer several photographic advantages and are really for more adventuresome photographers when they prefer not to use flash. At speeds slower than 1/30 sec., you should brace the camera on a stable surface or mount it on a tripod to avoid camera shake. Slow speeds

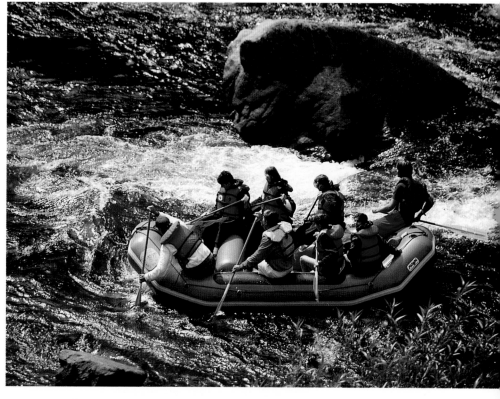

are very handy when you shoot at dusk or at the end of a sunset, as well as for low light levels indoors. Furthermore, slow shutter speeds are especially helpful when flash is useless for distant subjects, such as a brightly illuminated skyline. Since you aren't aware of the shutter speed a P&S camera chooses, you learn through experience when the speed is too slow for you to handhold the camera. If you get blurred pictures, try a tripod the next time you find yourself in a similar shooting situation. When moving subjects aren't sharp, use flash or enjoy the patterns of creative blur.

For this shot of people riding a raft on the Salmon River in Idaho, a shutter speed of 1/250 sec. was fast enough to produce a sharp image. This is because the subject was at least 40 feet away and was moving only a few miles per hour. If I'd been only 10 feet from the raft, some of the action might have blurred at 1/250 sec., which is the fastest speed on some P&S cameras.

Most camera instruction booklets advise something like, "Hold the camera steady, especially when shooting at a longer focal length, and when the light level is lower than normal." To get sharp pictures in good light, grip your camera firmly but not tensely, and hold your breath briefly as you depress the shutter-release button. You can depend on your P&S camera to choose a fast enough shutter speed to prevent camera shake, even in bright shade. Shooting a film rated ISO 200 or faster is also an advantage because it requires the exposure system to choose faster shutter speeds than a slower film does. You don't need the extra speed of an ISO 400 or 1000 film in bright light, so save these faster films for overcast and indoor situations.

Practice holding your camera steady, especially in the vertical position when your upper hand might tend to shake slightly. It is helpful to think vertically because of the tendency to shoot horizontally so often. Observe yourself in a mirror to see if you notice any camera shake. At the same time, be sure that your fingers don't cover the autofocus or autoexposure sensors or the flash. When a camera-holding position feels awkward to you, make adjustments until you are comfortable. You take better photographs when you have only to think about how to compose the subject and when to shoot.

During the time I worked on this book, I shot numerous photographs inside dimly illuminated cathedrals in Europe. Most of the time, I braced myself against stone pillars, knowing the camera would select its slowest shutter speeds, and I usually felt that I'd held my camera steady enough during 1/2 sec. or even 1 second exposures. But many of my pictures proved me wrong: they weren't sharp.

Check your own slow-speed steadiness with the following test. Load your camera with ISO 100 or 200 film. Choose a stationary subject, such as a dimly illuminated room interior or someone seated on a park bench at dusk. "Dimly illuminated" means you can see the subject well enough, but ordinarily you or the camera would switch the flash on. Set the flash on your P&S camera to the "off" position if possible. Start by taking a few handheld pictures, holding the camera without tension. You must, of course, be sure to hold your breath as you make each exposure. If there is a pole handy or something else you can brace yourself against, use it as an aid while you shoot a few pictures. It is likely that you'll feel you're holding the camera completely still; unfortunately, this is a common illusion.

Next, shoot the same pictures again without flash, with the camera on a tripod or on a flat, stable surface. In order to be thorough, buy a lightweight, inexpensive tripod, or borrow one if necessary, for this test. Finally, photograph the same subject once more with flash, holding the camera steady. Shoot this last image to take advantage of daylight, which might be diminishing.

After you have the film developed, compare the prints of the same nonmoving subject taken in three different ways. In the average dim-light situation, the handheld shots won't be sharp, although your camera technique might have seemed flawless. Pictures taken with the tripod should be sharp, and if the camera's shutter speed was slow enough, the existing-light scene may be moody and attractive. Even if it isn't, you'll see a distinct difference in sharpness between the shots made with the handheld and the tripod-mounted camera. You'll better understand how camera shake is possible in low light levels when you can't be sure which slow speed the camera is choosing. You'll also have a good idea of how available light adds a sense of reality to a situation. The pictures taken with flash should also be sharp, but that kind of flat light often isn't appealing, and there might be an artificial look to the scene. Flash is an invaluable option, but using a slow shutter speed may be more gratifying—if you can successfully brace the camera.

While some churches and cathedrals are so dark inside that they make P&S photography impossible, others are bright enough for fast films, even when the shutter speed is 1/2 sec. or faster. I braced my camera against a stone column for insurance while shooting this pretty passageway in St. Maurice Cathedral in Vienne, France. Getting a sharp wide-angle picture of this daylight scene while handholding the camera wasn't a problem with the ISO 200 film I used.

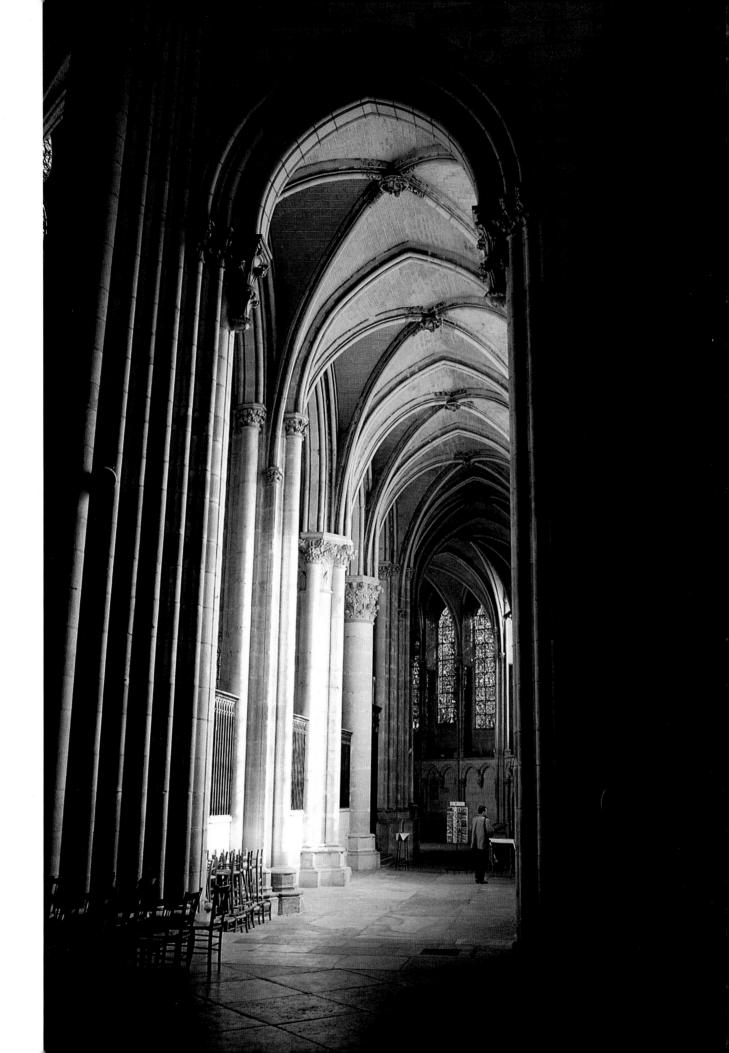

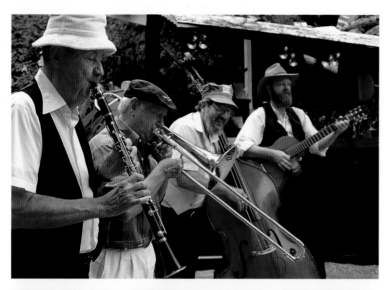

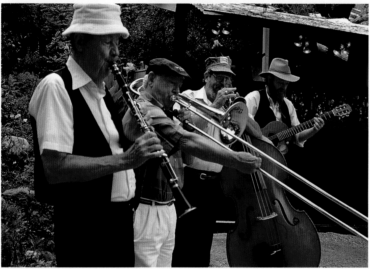

Lens focal length, aperture, and camera-to-subject distance all influence depth of field. Here, when I focused on the trombonist, the two men on the right, farthest from the camera, weren't in sharp focus (top). When I stepped back a few feet and zoomed from about 60mm to 40mm, still focusing on the trombonist, the two men in the back were sharp and the trombonist was almost sharp (bottom). Remember, depth of field increases more behind the point of focus than in front of it.

As mentioned earlier, depth of field is the area of acceptably sharp focus between the nearest and farthest objects in a picture. Four factors create and affect depth of field: how close you are to the subject the lens is focused on; the lens opening at the time of exposure; the focal length of the lens; and the film speed, which is indicated by the ISO rating of the film.

Distance from the Lens to the Subject. The closer you are to the point of focus, the less depth of field you can expect. For example, if you use the 50mm focal length on a zoom lens and focus on something 5 feet away from you, focus may carry to 10 or 15 feet, even in bright light, depending on the lens aperture. The farther away you focus, the greater the potential depth of field. If you focus on a house 30 feet away, in most circumstances everything behind it will be in focus. The area of sharp focus in front of the house will vary according to the light level, the lens opening, and the lens' focal length, but depth of field is always greater behind the place you focus than in front of it. When you shoot closeup pictures, you'll find that depth of field is sometimes reduced to inches, depending on the following three conditions:

Lens Opening at Time of Exposure. The smaller the *f*-stop, the greater the area of sharp focus in a picture will be. Therefore, in bright daylight, a camera loaded with an ISO 200 film sets a small *f*-stop, such as *f*/16 or *f*/22, so unless you focus only 3 or 4 feet from the lens, depth of field should be quite extensive. On a cloudy day or indoors, depth of field decreases because the *f*-stop gets larger. You have to guess about this now, but in time you'll be able to evaluate the light level in terms of depth of field by basing your determinations on pictures you've already taken and studied.

Lens Focal Length. A wide-angle lens offers greater depth of field than a telephoto lens does when they're focused at the same place from the same distance. For example, with a 35mm or 38mm wide-angle lens focused at 8 feet in sunlight, depth of field is greater than it is with an 80mm or 90mm telephoto lens focused at 8 feet from the same spot. (This isn't really a valid comparison because to shoot the same composition with a telephoto lens and a wide-angle lens, you would move farther away from the subject. In this case, depth of field would be the same. However, there are times when you might want to choose a wide-angle focal length, knowing that the lens' depth of field will be good.)

Film Speed. Film speeds are identified by ISO number ratings, such as 100, 200, and 400. ("ISO" stands for International Standards Organization, which establishes consistent criteria for rating film speeds, as well as other standards.) The difference in film speeds is due to the chemical and physical content of the *emulsion*, which is the light-sensitive component of film. The emulsion is made up of microscopic grains of silver, and the larger the grains, the faster the film. Films with low ISO numbers, such as 25 and 50, are fine-grained, *slow films*

that require relatively bright available light. Films with ISO ratings of 100 and 200 are all-purpose, *medium-speed films*; these are useful outdoors, as well as in many indoor shooting situations with and without flash. Films with ISO ratings of 400, 1000, 1600, and 3200 are *fast films*, suitable for taking pictures in relatively dim existing light.

In bright daylight, the difference between using an ISO 100 film and an ISO 200 film is negligible in terms of depth of field, unless you're shooting closeups; these pictures benefit from the use of faster films. Color fidelity in modern ISO 100, 200, and 400 films is very similar, and grain isn't noticeable in the faster films until you make an enlargement bigger than 8x10. When you shoot indoors or on a cloudy day when the light level is much lower than bright

daylight, using an ISO 200 or 400 film has advantages: the camera's exposure system sets smaller *f*-stops, which increases depth of field. At the same time, the camera sets faster shutter speeds, which help to freeze action and/or prevent camera shake.

There is no absolute photographic rule that states that pictures must be sharp from foreground to background, although many scenics and other subjects are more impressive with extensive depth of field. Portraits are often better with an out-of-focus background, which is what you are likely to get when you focus close to someone. In a really close portrait, it is possible that the subject's eye nearest the camera will be sharp and the other eye will be slightly out of focus. This results from minimal depth of field.

This shot was made with one of the few P&S cameras that has a 28mm wide-angle lens. The photographer was able to compose with her friend's head dominating the picture and still include the pattern of people in the background. Because she was so close to him, depth of field, even at an estimated aperture of *f*/11 or *f*/16, isn't extensive enough to show the background in sharp focus. If the photographer had moved back a few feet, both the man and the people behind him might have been sharp. Courtesy of Nicole A. Galli.

ESTIMATING DEPTH OF FIELD

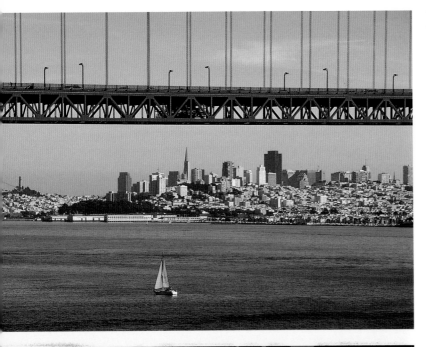

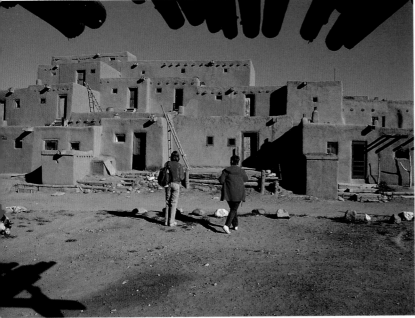

Trying to estimate depth of field is tricky because you can't set a P&S camera's *f*-stop, and there is no footage scale on the lens to show how far away you're focused. However, there is a technique for influencing depth of field and overall picture sharpness. In the viewfinder of your camera is a small rectangle, circle, lines, or brackets; all of these marks indicate the point of focus for the autofocus system. Position that autofocus mark over the subject you feel will help increase depth of field because of its distance from the lens, and press the shutter-release button halfway to lock focus. Some P&S cameras have a small light beside the viewfinder that turns on when focus is set. If yours does, use that light as your focusing aid; if it blinks, this might mean that you are too close or that you haven't focused properly for some reason. Try again until the indicator light stays on. Estimate possible depth of field according to the distance and the focal length of the lens, using mental images of good and bad pictures you've already taken as a guide. In this way, you can exert some control over which parts of your picture will be sharp.

Since you can't be really sure how much of a scene may be in focus, you may wonder how much concern you should give to depth of field as you shoot. The answer is that being aware of focusing distance, focal length, aperture, and film speed helps you understand how a P&S camera is programmed to provide practical sharpness in many circumstances. You can usually trust your camera to choose a small *f*-stop together with a fast shutter speed in relatively bright light. Remembering to lock focus when having both near and far subjects in focus will give you a better picture, and using an ISO 200 film is also helpful. Shoot plenty of test pictures, and save some of your mistakes for future reference. Experience is a great teacher.

For this spectacular view of San Francisco and part of the Golden Gate Bridge, the photographer used the 135mm zoom-lens setting on his bridge camera (top). With his camera on a tripod, he used ISO 200 film and an ultraviolet filter, which helps provide greater clarity for some distance shots. Courtesy of Austin MacRae.

Framing devices, both horizontal and vertical, are often used to add pictorial impact, especially to scenic images. For this shot of the Taos Pueblo in New Mexico, the photographer framed one set of buildings under the beams of another and planned the two spots of red as a welcome contrast to the location's earth colors (bottom). He set his zoom lens at 35mm and focused on the figures, knowing that in bright sun, depth of field would achieve foreground-to-background sharpness. Courtesy of Austin MacRae.

Images pass through your camera lens on rays of light and are captured on film. The camera's metering system determines the combination of f-stop and shutter speed appropriate to suit the brightness of the light, the reflective qualities of the subject, and the speed of the film. Automatic exposure in P&S cameras works well and makes photography more enjoyable. This feature enables you to concentrate on getting good pictures of people, places, and other subjects without worrying about technical matters. If you've ever had to manually adjust aperture and shutter speed by hand on a camera, you know what a relief automation can be.

The autoexposure system is activated by the *DX code* on the film cartridge. This is a grid of black and silver squares representing the film's ISO number. When you load the film, the camera programs the ISO speed into its circuitry so proper exposures can be set. Through a slim window in the back of the camera, you can see the type and speed of the film you're using on the cartridge.

P&S cameras are designed to choose lens openings and shutter speeds according to the speed of the film in use. A built-in light meter is activated by a small sensor above the lens that passes information about the brightness of a scene to the metering system, which chooses a combination of f-stop and shutter speed accordingly. In bright light, the system selects small f-stops and fast shutter speeds; in dim light, it chooses larger f-stops and slower shutter speeds. These combinations are made to achieve good depth of field as well as to stop action. This process is automatic, and in most lighting conditions I've found that camera exposure decisions are quite dependable.

ANTICIPATING EXPOSURE SETTINGS

Getting the most from your P&S camera means anticipating which f-stops and shutter speeds the autoexposure system might select in various lighting conditions. In typical bright outdoor light, the camera chooses as fast a shutter speed and as small a lens opening as possible to avoid blurred motion and to produce overall sharpness. In dim light, the autoexposure system may

activate the flash unless you turn it off. The camera gives you a signal via the flash-indicator light that you need flash to prevent camera shake. Understanding how the autoexposure system operates enables you to plan your pictures more effectively and to avoid underexposure, particularly in poor light.

As mentioned earlier, some top shutter speeds in P&S cameras aren't fast enough to freeze the action of tennis players, for example. Once you've taken some blurred pictures that you didn't expect to, you can better anticipate the limits of your camera's shutter.

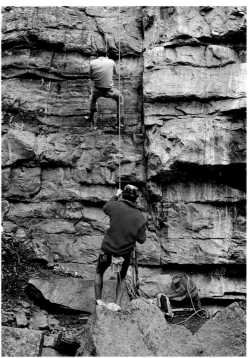

This photograph of rock climbers in the Lake Louise, Alberta, region was made on a bright day in a shady spot. Nevertheless, the tonality of the scene was easy for my P&S camera's autoexposure system to handle. The light was strong enough to generate good contrast between the figures and the rock wall, and the shadows add welcome texture. I've used five different P&S cameras over the years, and all provided reliable automatic exposures. Clearly, P&S cameras permit photographers to concentrate on good composition and lighting, not technical concerns.

The benefits of experience also apply to using slow shutter speeds when you must guard against the camera choosing a slow shutter speed at which you can't handhold it safely. When you shoot in low light levels with a handheld camera, try to remember how bright the light seemed when you study your prints. If details would have been sharper if the camera hadn't jiggled slightly, consider using a tripod in dim light outdoors and indoors. Your images will be sharper and clearer because you made the extra effort. (See chapter 11 for more about how a P&S exposure system works for night photography and how to calculate time exposures.)

METER AVERAGING

Some people wonder how an exposure meter can set the right *f*-stop and shutter speed for a scene that is bright in one place and dark with shadows in another. Basically, a metering system *averages* bright light, shadows, and all the medium tones and colors in between in any scene. These areas are estimated together into an *18-percent-gray tone* from which the autoexposure system makes its computations.

Some light conditions can trick the meter. When a scene is predominantly dark-toned, such as several dark books and a dark vase against a dark background, the meter "sees" this scene as a medium 18-percent gray and tends to overexpose it. In reverse, when a scene is predominantly light-toned, such as yellow dishes and cups against a white tablecloth, an 18-percent average results in some underexposure. Fortunately, such exposure situations are handled well by color-negative films that tolerate over- and underexposure deftly.

When color negatives are printed by automated processing machines, many compensations are possible. Contrast between light and dark subjects can be manipulated and corrected. Colors can be lightened, darkened, or tinted. Less-than-perfect negatives from P&S cameras often yield excellent prints. Occasionally, you'll get prints with a muddy, grayish color, indicating gross underexposure. Check the negatives; they'll appear almost transparent.

Meter averaging is usually efficient when you happen to shoot in dim light using a shutter speed and/or aperture that cause overexposure. You'll rarely get prints with washed-out colors, which are the result of overexposure, because today's color-print films are made to print well in such circumstances. One reason this latitude is necessary in color-negative films is that some inexpensive P&S cameras have exposure systems that aren't as fine-tuned as those of more sophisticated models.

Some more expensive P&S cameras include an *exposure-compensation mode* that enables you to manually alter the automatically set exposure. Experiment with this option when faced with predominantly bright or dark scenes. Overexpose at least half a stop for bright beach or snow scenes, and underexpose half a stop or more for shadowy situations with minimal contrast. Exposure compensation is particularly valuable if you shoot slide films, which require more precise exposure than color-negative films with their built-in flexibility do. If your camera doesn't include exposure compensation and you want to shoot slides, shoot a test roll or two and evaluate the exposures. If you aren't satisfied with the results, stick with color-negative films or consider buying a more sophisticated P&S camera or an SLR that offers exposure compensation.

Predominantly light-toned situations like this one can "trick" an autoexposure system toward underexposure, but the dark shadow tones evidently influenced my P&S camera to meter this scene normally. The couple is working on a sand sculpture at the San Diego Wild Animal Park, and the final photograph reproduced all detail accurately. Color-negative films do a fine job of tolerating exposure extremes.

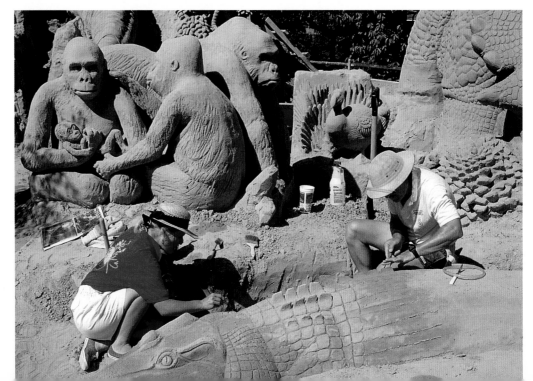

Basic P&S cameras, from the simplest inexpensive models packaged in plastic to slightly more complex single-lens models, usually offer only automatic daylight and flash exposures in addition to fixed-focus or autofocus capability. Additional features in more complex cameras are worth the investment because they add considerably to photographic versatility. Some of the special exposure techniques made possible by these extra controls built into a variety of P&S models include the following:

Self-Portraits. Most photography enthusiasts enjoy including themselves in occasional pictures, so using the self-timer is both functional and fun. One excellent opportunity is when you're shooting scenics alone and no one is around to add a human touch to the pictures. Place the camera on a tripod or balance it on a flat, stable surface, and then compose the picture. Anticipate how far you can get easily in 10 seconds to sit, stand, or walk in the picture, and try to guess how you'll relate to the background. Be sure to avoid having poles or trees growing from the top of your head.

If your camera lets you set the self-timer for two or more pictures, shoot several variations without going back to the camera. If you can use a remote-control device with your camera, stay within its operational limit, usually 15 to 20 feet, and make as many exposures as you wish without rushing. When I include myself in scenic pictures, I don't look at the lens, and I try to make whatever I'm doing seem like natural behavior for the average tourist. Finally, using the self-timer to make exposures without touching or shaking the camera is helpful in dim light when you anticipate the exposure system will choose a slow shutter speed. (See chapter 7 for more about self-timer portraits.)

Multiple Exposures. This feature of some P&S cameras permits you to program two and sometimes more images on the same frame of film, which I call *intentional double exposure*. In this mode, when you press the shutter-release button, autoexposure and autofocus are activated, but the film doesn't advance. In this way, you can shoot two exposures of a man seemingly talking to himself against a black background. You

can also create a random overlapping pattern of flowers or other subjects by combining two images. Keep in mind, however, that you have to underexpose each picture via an exposure-compensation system (see chapter 12).

Night Exposures. It is feasible to photograph well-lighted night scenes with a P&S camera that offers slow shutter speeds, such as 1 or 2 sec. Shooting with ISO 1000 and 1600 films may even make this possible with such shutter speeds as 1/2 sec. Make sure that you mount the camera on a tripod. You can also add flash during the exposure so that a subject in the foreground is illuminated by flash while a subject in the background is seen by existing light. (Night exposures timed manually are detailed in chapter 11.)

Interval Timing. Another sophisticated feature available in some P&S cameras enables you to shoot pictures automatically at timed intervals. A few cameras may be set to shoot pictures every 10 seconds and longer for many hours, until the roll of film is finished. One manufacturer calls this *time-lapse photography* and suggests various applications. These include regular exposures of a sunset or slow changes in the color of a skyline as the light fades. With patience in good conditions, a flower blooming can be photographed in sequential pictures over a 24-hour period.

In Auxerre, France, I was attracted to the colorful signs that illuminated parts of buildings, but I wasn't sure that I could successfully handhold my camera for the 1/2 sec. shutter speed I assumed was automatically set. The zoom lens was set at mid-range, about 80mm, and I used ISO 200 film. I placed the camera on top of a car across the street and made several exposures. The best one, shown here, came out sharper than I anticipated. When in doubt, take some pictures and hope to be pleasantly surprised by the results.

AUTOMATIC-FOCUS SYSTEMS

When you're flying, it is simply a matter of luck whether or not you'll be able to get good pictures of mountains, lakes, and other earthbound features. The air has to be clear, the sun has to be shining, and you can only hope the airplane window is clean and relatively distortion-free. I was fortunate to capture a bright view of Washington's Mt. Rainier during a flight to Seattle. I positioned my camera against the window, pressed the infinity setting, and took the picture, knowing the subject would be in focus. The plane was at an altitude of 35,000 feet, and the atmosphere gave the scene a bluish tint.

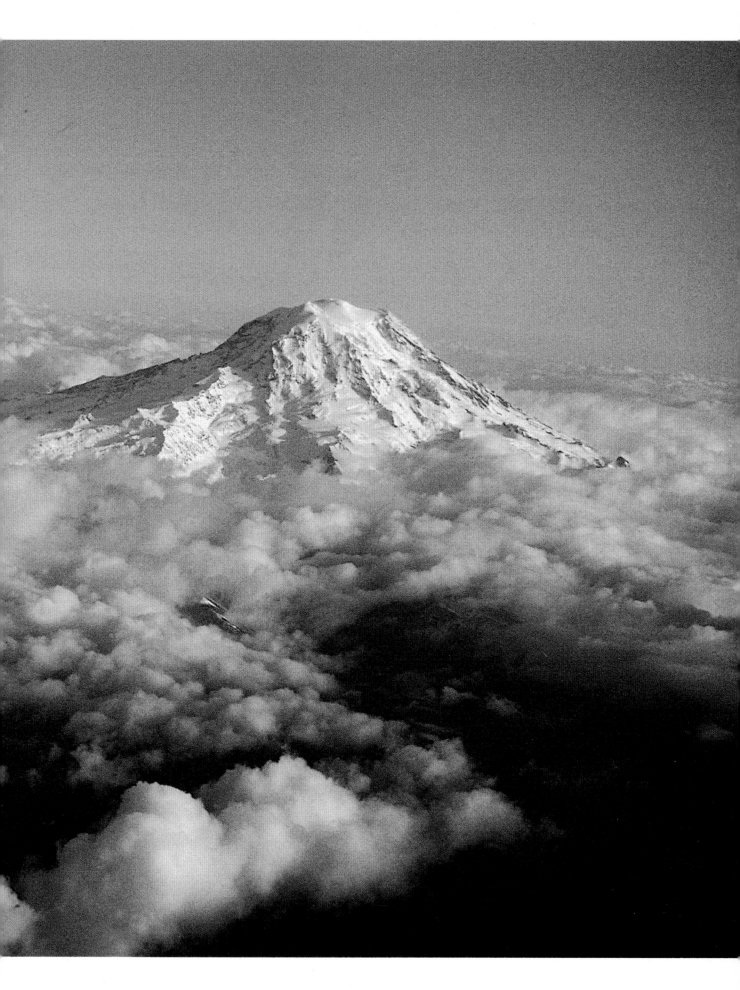

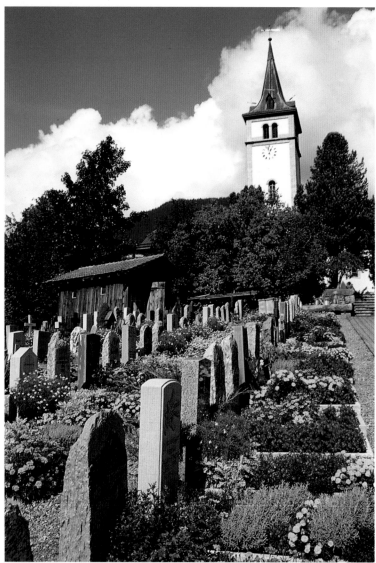

A P&S camera's autofocus system can readily handle a scene like this. By focusing on the third tombstone in the front center of the picture and locking focus before making the final composition, I was assured of overall sharp focus. This is because in bright sun with ISO 200 film, the camera selects a small f-stop, which guarantees extensive depth of field. If I'd locked focus on the front tombstone, the background might have been slightly out of focus.

The simplest point-and-shoot (P&S) cameras have *fixed-focus lenses* and are sometimes called *focus-free cameras*. These models are inexpensive, basic cameras for beginners. Fixed-focus lenses are prefocused to make acceptably sharp pictures from about 4 feet to infinity. These cameras usually have a 35mm or 38mm wide-angle lens and produce the most satisfactory results in bright daylight when depth of field is greatest. Because the required distance range is maintained, flash pictures are also sharp.

A majority of P&S cameras includes some kind of variable focus, and most use what is known as an *active-infrared autofocus system*. This is how it operates. As you depress the shutter-release button, part of the way or all the way, the camera projects an invisible infrared beam from one of its autofocus windows onto an object usually in the center of the viewfinder, which is indicated by a focus mark. When the beam reaches the subject, it is reflected back to the camera's other autofocus window. Instantaneously, the camera is informed of the distance to the subject, and a tiny motor adjusts a *fixed-focal-length lens*, or the elements of a *zoom lens*, in order to create a sharp image. This action takes place continuously as you photograph people or other subjects at varying distances from the camera. The sounds you hear when you take a picture are made by the *lens-focusing adjustment* (although this is often silent), the shutter operation, and the small motor that advances the film.

In the center of a P&S viewfinder is either a small circle or rectangle, or thin lines extending in four directions. When you place this *autofocus-indicator mark* over a person or object, the subject behind the mark will be in predictably sharp focus. With some cameras, when you press the shutter-release button part way, the autofocus system locks onto the indicated subject and holds focus until you lift your finger or shoot the picture.

In bright or dim light, you can estimate depth of field from the position of a subject in a scene that is covered by the focus indicator. You can't be absolutely certain of depth-of-field range, but always remember that sharp focus extends to a greater distance behind the subject the autofocus indicator covers than it does in front of it. Keep in mind, too, that depth of field is shallower when focus is fairly close, such as 4 or 5 feet. In a typical shooting situation, when a zoom lens is adjusted to 50mm, set at $f/11$, and focused at 9 feet, everything in the scene from about 6 feet to 20 feet is in focus. When you shoot in bright light with an ISO 200 or faster film, your camera will set the lens at $f/11$ or $f/16$ in order to achieve correct exposure. You can't be certain of lens settings and shutter speeds, and autofocus systems aren't foolproof, but with experience and careful study of your prints, you can sense where to set the autofocus mark for a practical depth-of-field estimate when you shoot.

In the real world, the most important people and objects you photograph often aren't centered in the frame. If you try to compose every picture with the important subject in the middle simply to ensure sharp focus, you'll have a lot of boring prints. To deal with this situation, camera manufacturers invented *focus-lock* for creative flexibility. The process is straightforward.

First, compose the picture you want to shoot. If the dominant subject is centered in the frame, hold your breath briefly and take the shot. When the main subject you want to feature is off-center, pivot the camera until the focus mark is on it, and press the shutter-release button *halfway*. Do this step gently so that you don't expose prematurely. Many cameras indicate that sharp focus is set via a green *light-emitting diode (LED)* next to the viewfinder; this LED turns on or blinks when the lens is focused. Then, while continuing to press the shutter-release button to hold the focus-lock, reposition the camera viewfinder until it shows the composition you want. Then shoot the picture. If you change your mind, release the focus-lock by lifting your finger off the shutter-release button. To shoot a different picture with the important subject off-center, repeat the focus-lock steps.

This is how to lock focus on a non-centered subject before making a final composition, but two things can upset your intentions. First, you might forget to lock focus because you're concentrating on an interesting subject or you're distracted by action, satisfying scenes, or facial expressions. Under these circumstances, you might blissfully ignore a gap between two people in the middle of your shot. As a result, they may be out of focus, and an irrelevant object behind and between them is sharp. When I get enthusiastic about what I'm photographing, I tend to become careless. Sometimes I get lucky when the desired subjects as well as the background are sharp because the depth-of-field range covers both. This is more apt to happen at a wide-angle focal length.

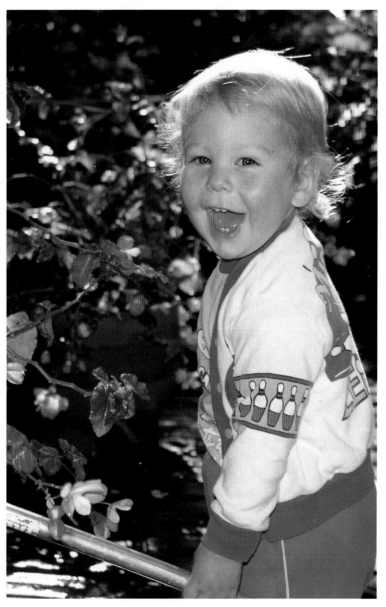

The second obstacle to effective use of the focus-lock feature is applying too much pressure on the shutter-release button. When you do this, you end up taking what my camera's instruction booklet calls "an unwanted picture." Fortunately, solving this problem is simple. If this seems to happen too easily with your camera, practice pressing the shutter-release button without film in the camera. You'll learn just the right touch in a few minutes.

Autofocus P&S cameras make capturing children's many expressions a pleasure. The photographer locked focus on this child, who stayed sharp even when he moved off-center. Fill-flash illuminated the boy's delightful smile. Overhead sunlight made the child's hair contrast dramatically with the garden background. Courtesy of Austin MacRae.

Several other autofocus features are included in some of the more expensive P&S cameras. However, variations of one feature, *zone-focusing*, are included in all autofocus models. Other special focusing methods, listed below, are options that can be helpful, but not all are worth spending extra money for. Be selective when you buy your new or your next P&S camera.

Multibeam Autofocus Systems. Some P&S cameras have autofocus systems in which the infrared beams are spread out over a wider portion of the image area. As a result, the autofocus system is able to gauge the distances of several subjects in mid-viewfinder and to select the closest one to focus on. If your camera offers this particular autofocus system, the instruction booklet will explain it.

Zone Focusing. Most autofocus camera lenses incorporate this feature. Here, lens elements shift in small steps to varying zones of sharp focus as you photograph subjects at different distances. The least complex cameras might focus through three zones, while others focus through 25, 50, or more zones. The P&S camera I used until recently focused through 48 zones. The camera's instruction booklet didn't mention anything about zone focusing, the zoom operated quite smoothly, and I considered the operation stepless. My newest P&S camera focuses through 188 zones and feels just about the same as its predecessor during operation. Although your camera may zone-focus in a few or in many steps, you can be confident that it will give you sharp pictures when the focus mark is on the subject you choose.

Fuzzy Mode. Electronic equipment with *fuzzy-logic programs* combine certain operations to make multiple decisions based on variables that the user doesn't have to predict. Your P&S camera has a built-in, intelligent microcomputer that enables you to get clear and properly exposed pictures via camera control of the zoom lens' focal length, flash, and shutter speed to match both the light level and the distance between the camera and the subject. Few P&S cameras offer a fuzzy mode. The instruction booklet of one model recommends using the fuzzy mode to avoid camera shake and underexposed subjects in your pictures. With your camera set to the fuzzy mode, the size of the subject in your picture might change because the lens automatically adjusts to provide optimal photographic conditions. I've tried the fuzzy mode in a sophisticated P&S camera and although I know fuzzy logic is state-of-the-art automation, I find it hard to be comfortable with zoom-lens movements that I didn't originate.

Automatic Composition. This feature is called "Eye Start" by Minolta and "Image Size Selector" by Nikon. With automatic composition, when you turn on the camera and raise the viewfinder to your eye, the lens zooms to a preliminary composition. For example, the lens might set itself for a small group or for an individual, depending on which subject you want to photograph. Once I aimed a Minolta at a family of four, and the camera zoomed in to tighten the composition, thereby improving it. Even so, I'm not sure that I would become accustomed to a camera program that predicts composition for me, but it is a great feature for the 12-year-old whose camera I'd borrowed.

Portrait-Zoom Mode. A variation of automatic composition, this feature is set to maintain a constant subject size in the viewfinder, even though the camera-to-subject distance varies. In this mode, which I admit makes me nervous, if you place your subject in the center of the viewfinder and depress the shutter-release button halfway, the zoom lens will function automatically to produce the same-size portrait even though you move closer or farther away. This mode is helpful to younger camera users and to anyone who appreciates some assistance with photographic decision-making. I prefer to be in control and to zoom the lens when shooting portraits myself.

For these photographs of a group of young dancers in costume in Kenya, East Africa, the photographer chose as neutral a background as possible. Using ISO 200 film to ensure a fast shutter speed and sharp focus, he shot a series of pictures as the men danced by. He was able to concentrate on various compositions and get a number of good shots because he knew that the camera's autofocus system would guarantee sharp images. Courtesy of Austin MacRae.

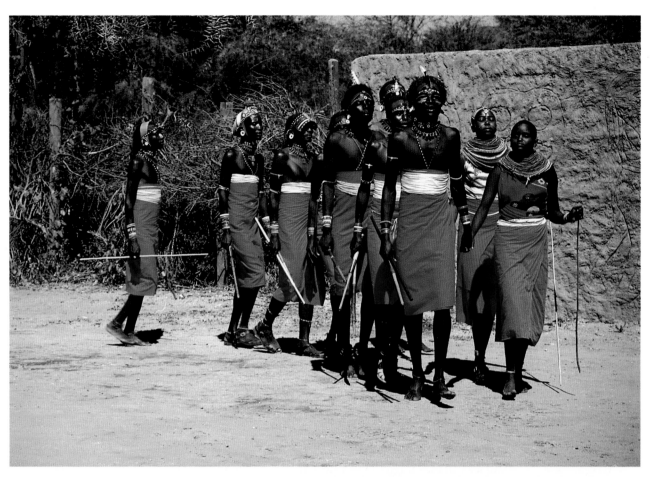

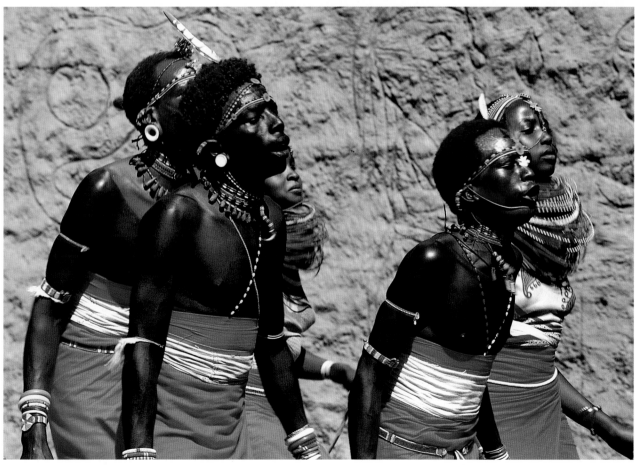

Since the infrared autofocus beam of a P&S camera causes the lens to focus on whatever is in the center of the viewfinder, trying to focus through interfering objects can be a problem. Here are some solutions to common autofocus dilemmas:

Shooting through Windows. The infrared focusing beam in a P&S camera is blocked when you try to shoot a scene through a window. You see through the glass, but in most cases the focusing system can't. The easiest way to deal with this is to use the "landscape" or "infinity" setting on your camera, if it has one. Just depress the proper button, and then press the shutter-release button. In this mode, the focusing

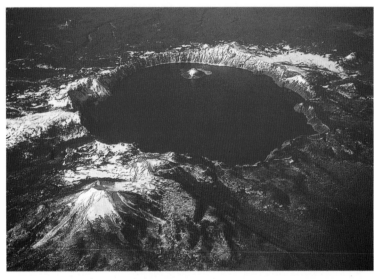

I made this shot of Oregon's Crater Lake from an airplane window. To prevent reflections from the glass interfering with this stunning view, I held my camera flush up against the window, pressed the infinity, or landscape, setting, pushed the shutter-release button, and hoped for the best.

beam ignores the window, sets focus at infinity, and in many cameras the flash is automatically turned off because it isn't needed. If your camera doesn't have a landscape setting, an Olympus booklet suggests that you position the camera flush against the window, which will "manually cause the camera to revert to infinity focus." Try this method to be sure that it works. Another way to approach shooting through a window is to aim through a door or go outdoors, lock focus on the scene you want or an alternate subject at the same distance as the window scene, and then simply recompose the image through the glass and shoot.

If a fence is interfering with the autofocus system, aim the camera at another subject that is at about the same distance as the one you want to shoot, lock focus, and shoot

through the fence. Be sure that the autofocus windows adjacent to your lens aren't blocked by a section of the fence. If the front of the lens fits through the grid in the fence, you might be able to avoid having a faint fence pattern in your picture.

Your camera may have an automatic-exposure lock that works in conjunction with the focus-lock. If you shoot slide film and want to lock focus, do so on another subject that is about as bright as the subject you want to shoot. The latitude of print film is so extensive that you'll get a good print in any case.

Reflections. According to an Olympus booklet on compact-camera photography: "Reflected scenes are not at the same distance from the camera as the surface doing the reflecting—they're actually further—but the AF system isn't programmed to know that." To deal with this problem, including photographing yourself in a mirror, keep in mind that the reflection is twice the distance from the camera lens than the reflecting surface is. Suppose that you are in bright light photographing the reflection of clouds in a large puddle. Set the lens to 35mm, 38mm, or 40mm (depending on your camera) when you're shooting ISO 200 or 400 film and the reflection is at least 6 or 7 feet away. Focus a few feet beyond the reflection, recompose, and then shoot. The wide-angle setting, the bright light, and the medium-speed film combine to make a camera choose a small aperture, so you can depend on the resulting depth of field to render an overall sharp image of the reflection and its surrounding area.

Shooting into Mirrors. Olympus says: "To take a sharply focused picture of your own mirror image, step back until you're twice as far from the mirror as you want to be when you take the picture. Lock focus, then return to your original position and shoot." This is good advice, but when you can't step back that far or there doesn't seem to be time, guess the distance to the mirror, aim the camera at something else that is twice as far away if possible, lock focus, and shoot your mirror picture. This advice applies to other reflections when you are closer than 6 or 7 feet. To shoot a reflection in a large hubcap from 3 feet away, for

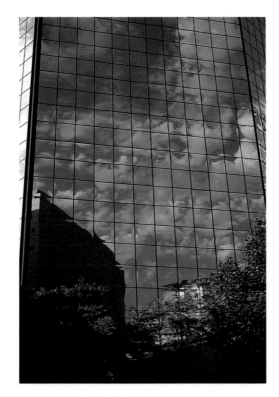

I shot this building reflecting clouds in the sky on a sunny day in Portland, Oregon (far left). A wide-angle 35mm lens setting was necessary, and the autofocus system worked well because the reflection was more than 50 feet away. The grid on the building converts spacial perspective into a flat, decorative pattern.

Although you may have to make focus adjustments for some reflections, I was able to focus normally on the window of this Paris beauty shop (left). I liked the combination of the poster and the people behind the glass. The reflected building is sharp because the ISO 200 film I used made the camera set a small enough lens opening to produce extensive depth of field.

example, focus the lens at something 6 feet away, lock focus, then shoot the hubcap.

My experience with shooting mirror images with ISO 200 film in bright light suggests that if you are between 7 and 10 feet away from the mirror, even without focusing at twice that distance, depth of field is likely to produce a sharp image. Experiment a bit for the educational fun of it. Remember to turn off the flash when shooting into any reflective surface unless you want an unpredictable splash of light as a special effect.

Glossy and Reflective Surfaces. The infrared focusing beam in a P&S camera can't bounce back easily in the following situations, which are difficult for its autofocus system to handle: large black walls with few details, brilliant reflections on water, smoke, and vast expanses of bare sky. To overcome some of these problems, shoot subjects that are 25 feet or farther away while using the camera's landscape or infinity mode. Otherwise, you can lock focus on another subject that is 100 feet away or at infinity, and then aim at the lights, smoke, or black objects. For closer subjects, prefocus about the same distance elsewhere, and then recompose and shoot.

Subjects Without Vertical Lines. A few P&S cameras use a passive autofocus system that operates on a different principle than the one described above.

This system's sensors are effective only on horizontal lines. Check your camera's instruction booklet for specific directions. The camera instructions will probably suggest that with a passive autofocus system, you turn your camera to the vertical position when focusing. This will cause the focusing system to see the lines as horizontal. Lock focus, and then shoot the horizontal image you prefer.

Close-Focusing. Check your camera specifications to know how close its autofocus system operates. The lens limit might be 2, 3, or 4 feet. When you shoot closer than the lens limit by accident, focus is usually soft. With a P&S camera that has a macro mode, you may be able to shoot at about 2 feet by pressing the macro button. Closeup photography is tricky because the viewfinder doesn't see the same scene the lens does. This is the result of a phenomenon called *parallax*. To correct for parallax, most P&S models have a close-focusing frame lines or corners lightly inscribed inside the viewfinder (see chapter 10 for more about closeup photography).

Modern autofocus systems are remarkable. They make photography more fun and eliminate a technical chore for you—almost. You can depend on your P&S focusing system just about everywhere, and when you face the exceptions mentioned, you can take control yourself.

CHAPTER 4

FLASH OPTIONS

Fill-flash is one of the true joys of P&S photography because the cameras automatically determine flash brightness. This picture illustrates the most graceful kind of fill-flash; as the women stand with their backs to the bright, high sun, their faces and shirts are softly illuminated. Courtesy of Fuji Film, Inc.

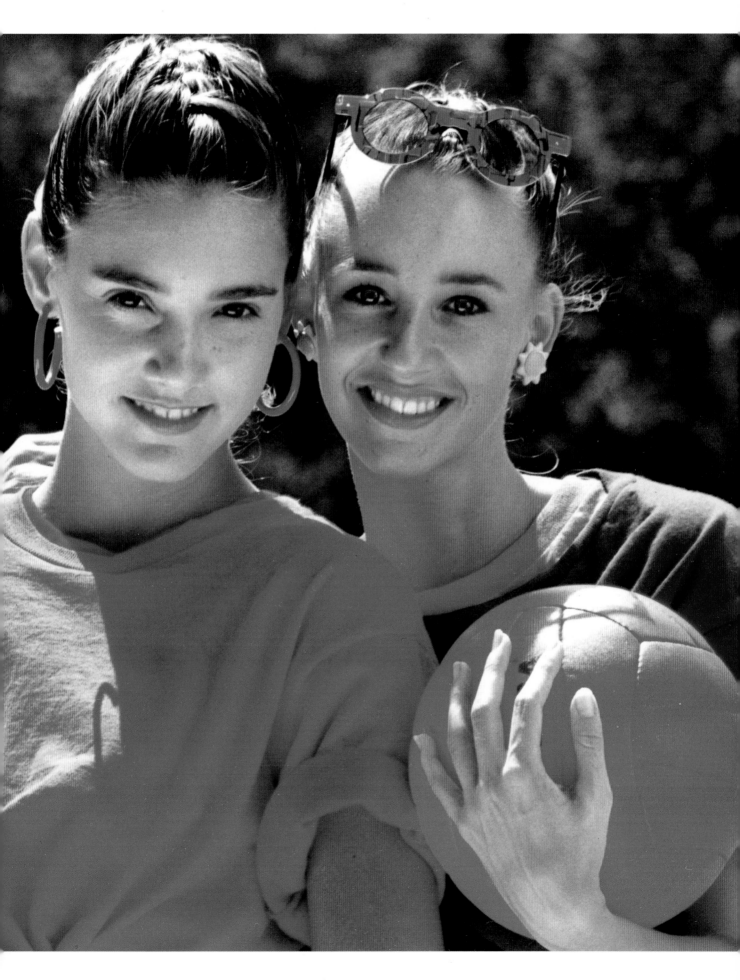

ELECTRONIC FLASH

You can see the highlights of subtle fill-flash in the eyes of this Masai woman, photographed in Kenya, East Africa. Shooting on a bright, overcast day, the photographer wasn't sure whether he wanted to use flash or not, so he photographed the woman both ways. He liked the added sparkle of the flash shots better. Having flash built into your P&S camera makes deciding when to use it painless. Courtesy of Austin MacRae.

Built-in electronic flash is a very welcome feature of almost every point-and-shoot (P&S) camera available today. A handy, small, quite versatile flash illuminates subjects in situations that are usually too dark for you to photograph otherwise. You may also use the fill-flash mode, which offers an almost foolproof way to illuminate shadows made by sunlight or to give a brighter accent to subjects in the shade. All of this calls for little effort on your part: just switch on the flash when necessary. Many camera systems automatically turn on the flash when a sensor indicates that there isn't enough existing light in a scene, although with most models you can turn off the flash if you prefer. The camera's autoexposure system sets the correct shutter speed and f-stop for flash alone or for a combination of flash and daylight. Built-in flash has been so successful in P&S cameras that it has been incorporated into many SLR cameras to function approximately the same way.

The first electronic flash units required connection to A/C electricity or to a large wet-cell battery. Early models included a flash tube larger than your P&S camera and a sizable reflector. Over the years, electronic flash units have been continually reduced in size, although larger units still generate the most light. Separate, portable electronic flash units made for other types of cameras offer more light output than the built-in flash of P&S cameras, but these units are heavier and, more important, they are unnecessary for the kinds of pictures P&S users usually take. And while large studio flash units produce many times more light than the tiny flash in your P&S camera or a portable unit does, these are costly and are designed for complex jobs.

All electronic flash units work in the same way: an electrical impulse ignites Xenon gas in a sealed flash tube, thereby causing a brief, bright burst of light that lasts between 1/500 sec. and 1/10,000 sec. It is hard to imagine that several decades ago photographers used flash bulbs that they tossed out after taking just one shot. Today, electronic flash units last for many years and put out thousands of flashes, making them an easy, efficient, and economical way to take pictures.

FREEZING ACTION
Because the duration of an electronic flash pop is so short, the light is able to *freeze* action much easier than the average P&S camera shutter can by itself. As you take pictures of people dancing or running, from a distance of 10 or 15 feet depending on the camera, flash stops the subject motion on film. In some shots, you might see the effect of flash freezing foreground action while more distant moving subjects are blurred because the image is made using two light sources. Fast electronic flash illuminates subjects up to 12 or fewer feet away; beyond that, weak existing light and a slow shutter speed result in blurred background subjects. This happens most often at dusk (see page 106).

P&S cameras use an automated method of exposure control that is keyed to the autofocus system. The system sets the correct aperture for the focused camera-to-subject distance, and the exposure is appropriate within the flash-operation range. You might notice a slight pause after you press the shutter-release button before the flash goes off and the picture is taken. Automatic computations are being made during this short interval.

FLASH RECYCLING TIME
Immediately after you shoot a flash picture, a component of the flash unit is resupplied with electricity from the camera battery, and the flash is ready to use again in three to six seconds depending on the battery source and camera model. The readying process is called *recycling*, and the faster it happens, the sooner you can take another picture with flash. Built-in P&S flash units always work at full power, and in many P&S cameras the flash won't fire until it is fully recharged. Some cameras have a small LED light near the viewfinder to show that the flash has recycled and is ready to be used again. In other cameras, a symbol that indicates this appears in the viewfinder.

Recycling times get longer and longer as the camera battery is drained, and flash drains the battery more than the autoexposure and autofocus systems do. Keep a spare battery handy to avoid a "blackout"; this is particularly critical when you are away from home.

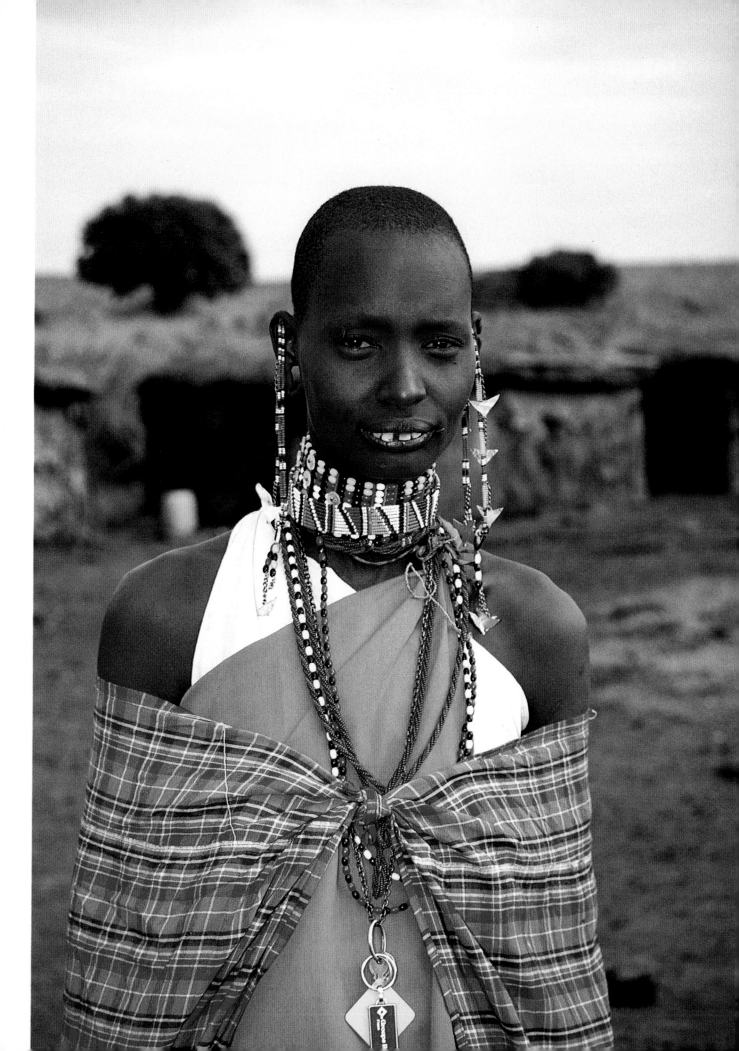

To illuminate a picture properly, you should be aware of the minimum and maximum *flash range* of your camera. Memorize the closest and farthest distances the light is effective, at least for the wide-angle setting of a zoom lens. You should find a small chart in the camera's instruction booklet that shows how far the flash carries when you shoot with ISO 100, 200, and 400 films based on the focal length of the lenses used. For a zoom lens, the chart usually lists the flash range at only the wide-angle and telephoto settings because these are all you need to know. When you shoot a 90mm zoom lens at its

FLASH EFFECTIVENESS

ISO Rating	Wide-Angle Lens	Telephoto Lens
100	2½ feet	15 feet
200	2½ feet	20 feet
400	2½ feet	33 feet

60mm setting, the flash will be effective if you are no farther away from the subject than the limit shown for the 90mm setting. Perhaps you've been to a night baseball or football game where people in the audience tried to shoot flash pictures of the action taking place 100 or 150 feet away! Trying to illuminate anything at that distance with a small flash can be a frustrating waste of film and energy.

The chart above shows typical figures averaged from data for several P&S cameras with similar zoom lenses. The numbers for the 38mm and 90mm settings are typical because the maximum light output of built-in electronic flash units in cameras that cost between $100 and $300 is very close.

If you use one film speed most of the time, you'll become aware of the flash footage range as you shoot. The closest distance remains the same for each film speed because the camera sets a smaller *f*-stop to compensate for faster films. If you want to shoot a large group of people with flash and need to stand beyond the distance range for an ISO 100 film, switch to an ISO 200 or 400 film. To shoot from an even greater distance, you'll need an even faster film. For example, if the flash range of an ISO 400 film is 33 feet, you'll need an ISO 1000 film, which is 2½ times faster, to achieve a flash range of about 45 feet. Test the flash with an unfamiliar fast film before using it for one-of-a-kind pictures.

The flash range of cameras with a single-focal-length lens and ISO 100 film averages about 2½ feet to 12 or 15 feet depending on the model. These cameras use lenses in the 35mm to 50mm range, and the flash unit is less powerful. The flash range of dual-lens cameras is similar to that of zoom-lens cameras with the same focal-length range.

Photographing a subject closer than the limit shown in the flash-range chart causes overexposure. Although some detail in the excessively bright close areas of a print can be accomplished via automated processing, color is usually correct in the properly exposed parts of the negative only. If the printer tries to darken the overexposed areas, the rest of the scene might be too dark in the final image as a result. At the other extreme, trying to photograph a subject beyond the flash range results in underexposure and degraded print color. You've undoubtedly seen group pictures taken with flash where the people in the back are too dark because they didn't receive enough illumination. Sometimes P&S flash is more effective indoors where walls and ceilings reflect and spread the light. Nevertheless, I'm always impressed by how well tiny P&S flash units do work.

For this picture of a woman in a large library, I used flash to counteract the relatively dim available light. Although flash usually ensures sharp images, it also can produce flat, artificial-looking illumination and slim black shadows.

FILL-IN FLASH

This very useful feature of most P&S cameras enables you to brighten dark shadow areas in faces, figures, or subjects that are within flash range. When you use the fill-flash setting, the brightness of the flash is automatically balanced to the level of existing light. The autoexposure system provides an ideal exposure for the combination of flash and sunlight, shade, or shadows that need brightening. With the fill-flash mode, you can also effectively photograph people posing in front of a brightly illuminated background, as well as backlit subjects. In both shooting situations, faces will appear dark and unappealing without additional light. When people pose with their backs to the sun, they don't have to squint so they'll look better in the final images. The capability to make outdoor portraits with fill-flash is one of the outstanding features of P&S photography. This advantage applies to groups, too. If you pose the group members with their backs to the sun, their pleasant expressions will prove that they are more comfortable. Adding fill-flash artfully improves your prints, which will both be softer and look more professional.

Don't go overboard with fill-flash. For example, on winter days in the northern hemisphere, the sun is at a high, slanted angle to the earth. So if you decide not to brighten the resulting shadows, the quality of your pictures may be excellent because high-angled sidelight shows form well. In any season, however, shadows made by bright sunlight usually aren't flattering to people. Also, camera-modulated fill-flash supplies the added illumination needed to soften the contrast between light and dark areas in an image without overpowering the existing light or eliminating the light-and-shadow effect.

FILL-FLASH FOR ACTION SHOTS

Frequent photographic subjects are active children, playground games, and other outdoor action in sunlight. Because P&S camera systems are designed to fire fill-flash at any shutter speed, fast or slow, you can use it for either static or moving subjects. When you shoot an ISO 200 film, which is matched well to P&S cameras, a fast shutter speed and correspondingly small aperture are usually the camera's choice. With a shutter speed of 1/250 sec. or faster, you can stop most of the action of playground games and other similar activities. Any action that the shutter doesn't stop may be frozen by the flash, thereby capturing spontaneous moments and improving your picture-taking.

After the sun had set toward the end of a family reunion, I asked these lively children to pose for me. The available light was too weak to shoot ISO 200 film handheld, so I used my P&S camera's convenient fill-flash feature. I also used the wide-angle setting on the 35-105mm lens.

Many subjects in sun and shade can benefit from the effortless use of flash, which most P&S cameras permit you to turn on and off at will. These two pictures of Halloween pumpkins, backlit by low sun, illustrate the value of fill-flash. Without flash, the pumpkins create a pleasant pattern, but there is too little detail in the shadows (left). By adding fill-flash, I was able to brighten the shadows without disturbing the basic appearance of the pumpkins (below).

ADDITIONAL FLASH OPTIONS

In general, the more you pay for a P&S camera, the higher the number of options it offers. These convenient features, such as a self-portrait mode and an infinity mode, also enable you to use flash in various ways. With the least expensive P&S cameras, you can't turn off the flash when you want to, nor do you get red-eye reduction. You'll find that medium-priced and more complex P&S models are more versatile, offering the following flash options:

Flash-Off Mode. Most of the time, you'll be thankful that the flash in your P&S camera fires automatically when the light level is low enough to cause camera shake. This happens near the end of the day, at night, in dimly illuminated rooms, and in shady spots where you might not realize there isn't enough existing light. However, you might want to retain the dramatic or realistic look of sunsets and subjects in moody lighting. In such instances, simply

I photographed this sea anemone behind the glass of a huge tank using ISO 200 film. I realized that my P&S camera's flash would pop automatically because much of the subject is dark, so I turned it off. Knowing that the exposure would be longer than 1/30 sec., I braced the camera to prevent camera shake. You must be able to anticipate slow exposures in poor light to avoid blurred pictures. Watch for a signal some cameras give to indicate the need for the use of flash and decide whether you can get sharp shots without it.

turn off the flash in your camera. You also need to switch off the flash when you shoot through a window or at a mirror, when the subject is too far away for the flash to reach it, and when you shoot where flash photography is prohibited. When the subject is too far away for the flash to be effective, such as at a football game or a city skyline at dusk, you should cancel the flash so that you don't look foolish when it pops unnecessarily. Without flash in some dim-lighting situations, you should brace the camera or use a lightweight, portable tripod for sharp pictures.

Night-Scene Flash. You can use flash for subjects that are close enough to the lens at night when the scene behind them is bright enough to register on film at a slow shutter speed but too far away for flash to be effective. For instance, suppose you want to photograph someone sitting on a low wall behind which are the lights of a city at dusk, or standing on a corner with a brightly illuminated street in the background. In both situations, the camera will choose the slowest shutter speed, such as 1 second. If your camera has a *bulb ("B")* or *night mode*, you can try it. In this mode, the shutter stays open until you lift your finger off the shutter-release button; the camera usually limits the interval to somewhere between 30 and 60 seconds. At the moment of exposure, flash illuminates the foreground subject while the slow shutter speed makes the city lights at night appear more luminous via a long exposure. Simply follow the night-scene-flash instructions in your camera manual. At night, when you can't handhold a camera steady enough to shoot sharp pictures, you'll find that using a tripod is a pleasure.

With the camera set to "B," the shutter remains open for the length of time you set, such as 3 sec., as you depress the shutter-release button. When you use flash to illuminate foreground subjects during long exposures, you might also get ghostly edges on people who move after the flash fires. In fact, you might even see lights right through them in the finished print. Try this for a special effect. (See chapter 11 for more about night photography.)

While looking for a new way to shoot a typical sunset, the photographer thought of including a friend's son on his tricycle in the foreground of the image. She mounted her camera on a tripod and posed the boy about 10 feet away from her, against the pleasantly incongruous background. She was confident that her P&S camera would expose correctly for the sky as well as for the flash. Courtesy of Kathleen Jaeger.

RED-EYE REDUCTION

When you use flash to photograph someone in relatively dark surroundings, the pupils of the subject's eyes are pretty wide open. Because the flash is adjacent to the camera lens, especially when you are fairly close to the person, the retina in the back of the subject's eyes registers the light as a red dot on color film. This effect is called *red-eye*, and many modern P&S cameras include a pre-flash feature to reduce or eliminate it. The camera emits one or more low-power pre-flashes before the regular flash that takes the picture. Pre-flashes cause the subject's pupils to contract, which significantly reduces red-eye.

The pre-flash system often works, but in my estimation it has one annoying drawback. During the one- or two-second delay between the pre-flash and the actual flash exposure, the facial expression you saw when you pressed the shutter-release button might have changed considerably, and what you record on film might be unpredictable and sometimes unflattering. I use red-eye reduction only when I am fairly close to the subject and the person (or group) will hold a pose or expression. One way to avoid the delay of red-eye pre-flash is to shoot in a fairly bright location where the subject's pupils are smaller and red reflections from the retinas are eliminated or minimized. Make a test in a fairly dark room. Shoot a few portraits at several focal-length settings, with and without red-eye reduction, and judge the results for yourself. If you eliminate red-eye without sacrificing spontaneous expressions, you've done well.

Red-eye reduction is included in many P&S cameras. With this feature, there is a delay between the pre-flash and the actual picture-taking flash, so the eye has time to adjust to the light. Although my camera flash was only 3 feet away from this beautifully decorated child, photographed at an art festival in Laguna Beach, California, no red dots are visible in her eyes.

Frontlighting from built-in flash is very functional and great for brightening shadows, but it usually isn't very aesthetically appealing. For welcome pictorial relief, you can supplement the built-in flash with a separate flash unit. Such an auxiliary-lighting unit can be small; however, if it isn't, you must be able to control its light output so that it doesn't strongly overpower the illumination from the built-in flash. By using a small flash unit that includes a built-in *slave trigger* or by attaching a slave trigger to a separate electronic flash unit, you can have the auxiliary light fire along with the camera flash. A slave trigger is an electronic sensor that activates the off-camera flash to fire at the same instant the camera flash does.

An off-camera flash is usually attached to a lightstand, bookshelf, or some other object via a small photographic clamp, which is available in photography-supply stores. You can also ask a friend to hold the auxiliary light. If you don't have a lightstand, a clamp, or an available friend, mount your camera on a tripod, set the self-timer, and hold the off-camera flash where you want it yourself.

Position the auxiliary flash at one side of the subject, and then point it at an angle to add highlights to faces, hair, figures, or objects. The extra light provides accents and helps give subjects a more three-dimensional look. If the camera is about 8 to 10 feet away from a group of people, place the auxiliary flash a few feet farther away from the nearest person. If you are familiar with *guide numbers (GNs)*, use the number for the auxiliary unit as a reference for estimating the proper distance from the subject. You have to guess because you don't know what *f*-stop the camera has chosen. Study your prints, and the next time you're faced with a similar shooting situation, move the off-camera flash farther away or closer as needed.

One additional way to position an off-camera flash is to bounce it off the ceiling or off a light-colored wall. These surfaces act as large reflectors that add soft fill light to pictures. Bounced flash is usually weaker than the built-in camera flash, but it still brightens shadow areas in and behind the main subject.

Lighting is more interesting when the camera and the auxiliary light aren't the same distance from the subject. One should be brighter, depending on the lighting effect you prefer. Remember that subjects on the same side as the auxiliary light might be brighter than those farther away. Experiment with the second light in different positions, and keep notes about distances; these will be useful the next time you use a second electronic flash unit.

Flash integrated into a P&S camera is a great tool. While people pictures with flash might not always seem artistic, they are easy, you see the people clearly, and you often catch interesting facial expressions or action. If you are adventuresome, try an auxiliary flash unit to see the effects for yourself. You might also want to borrow one with a slave trigger before you decide which type to buy.

For this charming family portrait, I mounted my P&S camera on a tripod. Off to the right was a tiny Morris Midi slave flash attached to a lightstand with a clamp. The camera's flash caused the slave flash to pop simultaneously; this helped eliminate shadows behind the subjects.

CHAPTER 5
CHOOSING FILMS

The late-afternoon sun makes this photograph of sand dunes in California's Death Valley dramatic. The photographer mounted his P&S camera on a tripod to ensure sharpness, used ISO 200 film, and set the lens to include the close dune and reach to those in the distance. Courtesy of Greg Lewis.

TYPES OF FILM

Just as modern camera equipment has become highly automated and is far more versatile today than it was 20 years ago, both films and printing papers for 35mm photography have been vastly improved during the past two decades. Manufacturers now offer color films with better color fidelity, finer grain, and more tolerance for exposure mistakes. And color-printing papers provide truer color, greater brilliance, and increased resistance to fading. Many people enjoy printing color film at home, although a majority prefers fast and accurate commercial processing, which is available virtually everywhere. If, however, there is no color-processing service or pickup spot where you live, you'll be glad to know that mail-order labs are also worthwhile. Today's black-and-white films and paper are superior, too, and are especially popular with photographers who enjoy doing their own darkroom work. Custom black-and-white processing and printing cost considerably more than comparable color services.

There are two types of color film: *color-print* or *color-negative films*, with names ending in "color," such as Agfacolor, Fujicolor, and Kodacolor; and *color-slide* or *color-transparency films*, with names ending in "chrome," such as Agfachrome, Ektachrome, and Fujichrome. Eastman Kodak, Fuji, and Ilford also offer various black-and-white films, in both print and negative forms.

COLOR-PRINT FILMS

As you shoot, always keep in mind that autofocus point-and-shoot (P&S) cameras are designed to use color-print films because they have a wider range of exposure latitude than color-slide films. This important feature means that you can under- or overexpose print films in bright sun, in shade, or indoors and still get rich, colorful prints. In a technical report in the August 1992 issue of *Petersen's Photographic* magazine, Jack and Sue Drafahl state that Kodak Gold Plus (my favorite print film) 100 and 200 films produce excellent results in an exposure range from two stops underexposed to four stops overexposed. According to these photographic experts, "The contrast and color saturation were

excellent in prints made from both ends of the latitude range."

This is a remarkable range of extreme exposures. Two stops overexposure (+2) or two stops underexposure (-2) are all you need for the majority of the pictures you shoot. Because P&S autoexposure systems are uniformly accurate and the use of fill-flash is so prevalent, I find that hard-to-print negatives are becoming rare. When color prints are made from negatives, the built-in latitude of the paper and printing system takes care of normal deviations. All of the different P&S cameras and brands I've used produced color negatives within the acceptable limits of color-print film. Chances are very good that your P&S camera can match these results, and a new

camera you buy in the future might even give you better prints.

Color-negative films are also very stable. Whether you store a color-negative film at room temperature before you use it or keep it in your camera, the film's color fidelity won't deteriorate for several months or even a year. Of course, you should always check the expiration date printed on the film carton. Film is considered "fresh" during the interval before the expiration date, which is usually a year or more from the time you buy it, so you shouldn't have a problem if you shoot the film before it expires. After that, the film may be good for six more months if it hasn't been stored in excessive heat or humidity. Fresh or not, once film is exposed, it is a good idea to have it processed within a few weeks (unless you're traveling and want to wait, even a few months, until you return home). Storing unprocessed film for weeks or months might reflect your detachment about taking pictures, which could, in turn, signify that you are in a rut.

Although color-negative films are made primarily for use in daylight or with flash, you can shoot them with indoor lighting in various ways. The film records indoor lighting as warmer than daylight, but prints are color-corrected during processing (see page 62).

COLOR-SLIDE FILMS

These films have much less exposure latitude than print films, which means that having even a single stop of over- or underexposure might make a slide unacceptable. Positive images are exposed in the camera, processed, and then mounted as slides. As such, the color and exposure manipulations that are usually done on prints during processing aren't feasible with slide films. Exposure has to be

In this moody sunset photograph of Kenya, East Africa, the color gradation of the sky behind the line of black trees creates pictorial impact. With ISO 200 color-slide film in a sophisticated P&S camera, which includes exposure compensation to lighten or darken slides, no exposure manipulation was needed here. The photographer knew from experience that the trees would appear silhouetted against the sky. The camera was on a tripod in order to achieve overall sharpness. Courtesy of Austin MacRae.

While on vacation in Kauai, Hawaii, the photographer was fascinated by this sunset and continued shooting until the sun disappeared into the sea (top). Although she wishes there had been a boat or a windsurfer to give the composition a boost, she knows that the clouds and color can stand on their own. She used an ISO 200 color-print film and handheld a dual-lens P&S camera. Courtesy of Karen Scott.

Most ISO 100 and faster color-print films are appropriate for shooting colorful subjects, such as this field of ripe strawberries being picked in California (bottom). The faster the film you use, the more depth of field your pictures will have. This is because the f-stops your P&S camera's auto-exposure system chooses become smaller as the film speed increases. Here, I focused a 38mm wide-angle lens on the pink crate, and the resulting image is sharp from foreground to background. In order to gain confidence and master using one or more color-print films, make some comparison tests; photograph the same or similar subjects, and decide which film gives you the color qualities you prefer.

exact, but you can alter or correct color to match the light by placing filters on the lens. What you shoot is what you get with color-slide films. To deal with the minimal latitude of these films, photographers *bracket* their exposures: they shoot one image at the recommended camera-meter setting, underexpose another image by a half-stop or a whole stop, and overexpose another image by a half-stop or a third-stop. While excellent prints from slightly overexposed color-negative film is routine, slight underexposure is preferable for pictures on color-transparency film; the color in the slides might be enhanced, showing more detail in the highlights. It is wise to test a type of color-slide film you haven't used before so that you can see if the recommended ISO speed suits your P&S camera. (You don't have to make comparable tests with color-print films.)

Most P&S cameras aren't designed to make manual exposure compensations for excessively light or dark subjects, which are necessary when you shoot slide films. Only a few P&S cameras enable you to manually adjust the exposure in order to accommodate the overall tonality of the scene. It is clear why most people prefer to shoot negative films: the limiting latitude of slide films can be a handicap.

Furthermore, although I don't want to recommend the following films for use in P&S cameras, I feel that Kodachrome 200, Ektachrome HC 100 and 200, and Fujichrome 100 and 400 are all good choices. Each has fine grain and provides pleasing colors. For dim-light shooting without flash, try Ektachrome P1600 and Fujichrome P1600. These professional films are aged to produce optimal color characteristics. Keep in mind that these high-speed films are grainy, cost more than amateur films, and must be stored in a refrigerator. There are a few professional color-print films, too, but I don't feel that they are worth the additional expense when the so-called amateur films are so good.

The color of light is measured in Kelvin degrees, and sunlight is about 5600K. The color of light in shade or on a cloudy day is cooler, leaning more toward blue, and is rated at 6000K and higher. All color-negative films are balanced for daylight, but they are much more flexible than slide films because they can be color-corrected during processing. For example, the orange tint you sometimes see in pictures shot under the light from ordinary room lamps can be corrected to a large extent when prints are made. *Fluorescent lighting* can pose even more of a problem with color-negative films because its light is greenish. This tint can be corrected somewhat during normal color printing, and corrected greatly with custom printing. A *color-correction filter*, such as a 30 magenta filter, is required for shooting color-slide film under fluorescent lighting.

When you shoot *daylight-balanced* slide film on a cloudy day or in shade, you must use a skylight filter to warm the light. The color temperature of indoor lighting is about 2900K, which means that it is much warmer than daylight. Several slide films are *color-balanced* for indoor light, especially for *tungsten light*; these include Kodachrome 40 and Ektachrome 160 and 320.

The process of matching black-and-white films to light sources is similar to that of matching color-negative films. Both types of film have extensive latitudes, so the exposure systems of P&S cameras adapt well to them. Some black-and-white films are slow and fine-grained; some, such as T-Max 3200, are very fast; and some are in between fast and slow. Despite the convenience and inherent flexibility of black-and-white films, few P&S camera users are fans of them. (For more information about exposing and processing black-and-white films, contact such film manufacturers as Kodak, Fuji, and Ilford, or read one of the many books on the subject.)

At dusk after a rainstorm in Seattle, part of the skyline glowed against a background of traffic and shorter buildings. Shooting at the infinity setting from my hotel window, I was experimenting with Ektachrome 100. The skylight filter I used warmed the scene, and the exposure was between 1 and 2 seconds.

FILM CHARACTERISTICS

Faster films are made so well today that they easily handle contrast between bright and dark areas and can be printed by the average processor without any problem. For this portrait of a woman, taken in Mexico, the photographer felt lucky that he had ISO 400 film in his camera. Although the light looks pretty bright in this picture, it actually wasn't, and an exposure made with slower film might have shown evidence of camera shake. He was also fortunate to find a dark background against which the woman seems to glow in reflected sunlight. Courtesy of Jim Jacobs.

In addition to their exposure latitude and color fidelity, modern films have other characteristics that help identify them and distinguish various films from each other. The more you learn about negative or positive films in similar film-speed groups, the better equipped you'll be to make choices about such characteristics as:

Grain and Sharpness. The grain seen in prints is a result of invisible bits of silver or dye in the film emulsion that convert light rays into images. The higher the film speed, the larger the grain; this makes the film more sensitive to light. You might see evidence of grain only in an enlarged color print from ISO 100 or 200 film with a magnifying glass. Both of these films have fine grain. Sometimes you can see grain texture in a print from ISO 400 film with your naked eye, and grain is usually more visible in prints from faster films. It is also important to keep in mind that films with fine grain have better inherent sharpness. Of course, image sharpness is also influenced by the quality of the camera lens, how steady you hold the camera, and whether or not the subject is moving. Slow- and medium-speed films give you sharper enlargements than faster films do.

Contrast. *Normal contrast* in a print or slide means that the image contains the tonal scale present in the original subject. This may be a full series of tones ranging from bright white to coal black, or a less extensive range. A *low-contrast image* might not have either bright highlights nor dark shadows, while a *high-contrast photograph* might have good whites and blacks but few intermediate color tones. In general, the faster the film, the lower its contrast. Prints made from ISO 100 or 200 films might have a better tonal scale and more vivid color than faster films; however, contrast and color provided by today's very fast films can be surprisingly good.

Speed. Film speed, or the ISO rating of your film, influences many pictorial conditions. The faster the film, the higher the shutter speed the camera might set in order to stop action, and the smaller the

lens opening it sets in order to achieve greater depth of field. You can choose among the following film speeds: ISO 25 and 50, which indicate slow films; 100, medium-slow; 200, medium; 400, fast; and 1000, 1600, or 3200, very fast.

Fine color results from ISO 25 and 50 films, but the risk of camera shake in dim light is high. If you want to shoot in bright sun, in dim light, or with flash, ISO 100 and 200 films are recommended because of their fine grain, versatility, and practicality. Although ISO 200 film costs a little more than ISO 100 film (and less than ISO 400 film), it is worth the difference. The film's added speed helps you overcome camera shake and subject motion. Furthermore, in shade, on a cloudy day, or after sunset, a P&S camera's exposure system sets a more practical shutter speed and a smaller aperture with ISO 200 film than with ISO 100 film. The increased depth of field that results is especially important with fixed-focus cameras.

In order to shoot anywhere the light is limited without having to use flash, choose an ISO 400 or faster film. In rather dim light, an $f/3.5$ lens opening isn't very large, so you must compensate by using a higher-speed film. One of my favorite high-speed, color-negative films is Kodak Ektar 1000. It is ideal in difficult lighting situations, and its grain is remarkably small. Other excellent color-print films, which are even faster, are Fuji 1600 and Konica 3200. All of these films are good choices for dusk and night photography, but you should avoid them in bright daylight because they have very large grain, their fast speed is necessary for special circumstances only, and they cost more.

The flash built into P&S cameras might seem bright, but the average *separate*, small flash unit for a 35mm SLR camera puts out five or six times as much light. When you have to photograph a distant subject or stand back from a large group of people, a very good way to enhance the power of a diminutive P&S flash unit is to use an ISO 400 or faster film. The faster the film, the farther the light carries (see chapter 6). Familiarize yourself with your camera's film-speed limits. Many single-lens P&S cameras work with an ISO range of only 100 to 400, while a few go as far as 1600 or 3200. Dual-lens and zoom-lens cameras have an average film-speed range of ISO 50 to 1600, although some go to 3200.

For a subject like this ivy-covered building, a slower, fine-grained film is a good choice. It helps you avoid grainy images and maintains sharpness when 8x10 or bigger enlargements are made. The ISO 100 film I used accurately captured the colors of this charming scene, which I discovered in Vence, France.

COLOR-FILM PALETTES

Periodically, *Petersen's Photographic* and *Popular Photography* magazines publish expansive color-film-test comparison pictures, showing how films from various manufacturers handle both bright and subtle colors. *Popular Photography* usually photographs a large assortment of fruit or a vase filled with flowers for one test and a pretty woman against a colorful background for another. The magazine also photographs a color chart of major hues as well as black and white, which is often the most significant test because it is easier to compare a flat color, however small it appears, than it is to compare a face or a flower. *Petersen's Photographic* tests a few films at a time by shooting an assortment of varicolored subjects in order to illustrate the film's palette.

Film-comparison pictures in magazines usually reveal slight differences in the way various films render color; of course, several films often might show almost identical results. Variations in magazine printing make it possible to draw only approximate conclusions from these tests, but the editors' verbal evaluations help as well. Magazine tests show that all popular films offer acceptable or excellent color rendition, with minor exceptions. However, you'll probably find Kodak and Fuji films for sale in more places. Fortunately, of course, this isn't a handicap.

Keep the following points in mind as you select films for specific shooting situations. Kodak Gold Plus 100, 200, and 400 are superb films in terms of their color rendition, as are equivalent Fuji Super HG films; Fuji 1600 in particular is terrific in low light. Kodak films might give you more natural flesh tones, while Fuji films' greens and blues might be a little more vivid. The color in Agfa films is slightly warmer, and I've also seen good results in film tests using Konica print films.

Experimenting with different color-print films is an enlightening way to make your own comparisons. See how the films reproduce colors in bright sun, how they work in dim light, and how they handle indoor and fluorescent lighting. Try several film speeds, and have 8 x 10 enlargements made in order to become familiar with grain and contrast properties. Decide on your own favorites because knowing how one medium-speed film, such as ISO 100 or 200 film, and one faster film, such as ISO 400, work will help you anticipate the pictures you'll get and will give you photographic confidence.

For this beautiful shot of a worker labeling barrels in a winery in California's Napa Valley, the photographer used available light to record the way the scene actually looked. After mounting his camera on a tripod, he chose ISO 400 color-print film because the scene was darker than it appears here. He locked focus, exposed for the man, held down the shutter-release button halfway, recomposed the picture, and shot a number of frames. Courtesy of Charles O'Rear.

The relationship between how you shoot color film and how it is processed is similar to how you buy good food and the way you prepare it. If a cook isn't skilled and conscientious, the best ingredients can be combined into drab-tasting, unappealing recipes. Similarly, if the lab that develops and prints your film isn't technically proficient and its operators are careless, distorted color and tonality might result from even the best negatives. If you aren't satisfied with them, complain and ask for reprints. The time may come when you decide to switch processing labs in order to get better prints.

Processing and printing color negatives is big business today. Large commercial labs across the country do contract work for chain drug and discount stores, often picking up and delivering prints seven days a week. The popular discount store near my home has changed labs twice in the last several years, perhaps for better service, perhaps for better prices. Each change improved the quality of prints I received, and the latest lab even provides overnight service. It also makes good-quality enlargements in about a week for reasonable prices. Such labs are fully automated to be competitive. Drug and discount stores must compete with one-hour labs, which are also widespread. However, if you're willing or able to wait another day or two for processed prints, the cost is about half of the one-day fee.

The one-hour labs I've used have all provided good-to-excellent prints, no better and no more consistent than other processing results I'm used to. Besides speed, the best aspect of a one-hour lab is being able to talk to the operators if you have a complaint. They must be more accountable than commercial contract labs, which you never visit. Furthermore, many one-hour labs will redo prints in less than an hour, unless they're rushed, at no additional charge. Some of these labs also do custom cropping at very fair prices and/or offer volume discounts for making multiple prints from the same negative.

Mail-order labs also develop and print color-negative film at competitive prices, so if there is no drugstore, discount store, or mini-lab convenient to you, try a mail-order

Both of these images of Goblin Valley, Utah, were made from one color negative. The lighter print is an enlargement made by a brand-name processing lab where the staff members ignored the properly printed 3½ x 5-inch shot the photographer sent along as a guide (top). When she complained and asked for a reprint, it wasn't much better. She then sent the sunset negative to a commercial lab used by a large national discount store, and the better resulting print illustrates the unpredictable way color negatives can be interpreted by various photo labs (bottom). Custom processing labs, used by professional photographers, are more likely to follow your directions, especially when you give them a guide print. But their services and expertise cost more. Courtesy of Kathy Jacobs.

outfit. The main drawback is the week or more it takes to get your prints back; reprints or corrections take additional time. Although slides, prints, and negatives can get lost in the mail, my experience over three decades suggests that this rarely happens. I've sent several thousand rolls of film to Kodak for processing, and only one roll is unaccounted for. The postal service might not be fast, but it is reliable. It is more important to be vigilant about quality even if you never have direct contact with anyone at the mail-order lab, and don't hesitate to switch labs if you aren't satisfied with the service you receive.

The October 1987 issue of *Consumer Reports* magazine evaluated processing services, including mail-order labs, and while the specific conclusions don't fully apply today, the article emphasized that "drawing conclusions about independent minilabs is akin to generalizing about delicatessens in different cities." The article also pointed out that because large contract processing companies work for so many different retailers, you might switch from one store to another, to another, trying to get better-quality prints and nevertheless

discover that your film is going to the same processing plant.

CUSTOM PRINTING

In most cities, primarily professional photographers use custom photo labs; custom labs usually don't have the necessary machines for making inexpensive 3½x5 or 4x6 prints. But the lab will follow your cropping instructions, and, by hand, will make bigger and perhaps even better prints than the ones usually available from drugstores and discount stores. The quality of custom color prints should be higher because the lab isn't involved with mass production. Keep in mind, however, that custom printing costs more. If you can't find a handy custom lab, call a professional photographer listed in the *Yellow Pages* for your area, and ask for a recommendation. You should be able to work satisfactorily by mail with a professional lab.

COLOR-SLIDE PROCESSING

If you decide to shoot color slides in your P&S camera, you should start with a test roll. Choose a Fuji or Kodak E-6 film that can be developed in many custom labs all

This picture of a Kirghiz patriarch was shot in the shade on a movie set. Attracted to the character's stern face, the photographer used a medium-speed slide film and printed this photograph in her own darkroom on Cibachrome paper. Courtesy of Lydia Clarke Heston.

over the United States. "E-6" refers to the chemistry that is used for processing all slide films except Kodachrome. E-6 processing is very standardized, and only rare carelessness can undermine the quality of slide processing.

Custom labs that develop and mount slides in a few hours are widely used by professional photographers. Kodak licenses Kodalux labs to process Kodachrome and all brands of E-6 slide films. You can often save money by buying prepaid Kodalux mailers for these films, which is a convenient way to have your Kodachrome or E-6 film developed if you don't have access to a custom lab, are traveling, or aren't in a hurry. Kodalux turnaround time for slide films ranges from 7 to 9 days, depending on the season and your location. All labs are busier after holidays. The closer you live to Kodalux labs, which are located in Findlay, Ohio; Fair Lawn, New Jersey; Chicago, Illinois; and Dallas, Texas, the faster your slides will be returned to you by first-class mail. Kodachrome is also processed by private labs in a few large cities, including New York, Los Angeles, Chicago, and Miami.

BLACK-AND-WHITE PROCESSING

If possible, do your own black-and-white processing. The equipment and chemicals required to develop black-and-white film and to make contact proofs of your pictures aren't expensive. An 8x10 contact-printing frame (or proofer) costs between $25 and $50. And while an enlarger with a good lens can be a major investment, it pays off in satisfaction—and fun. If you shoot three or four rolls of film a month, you'll amortize the cost of the developing equipment and the enlarger within a year or two. Alternatively, you can use a custom black-and-white lab; to find one, ask a friend or a professional photographer. Black-and-white processing and printing cost more than color work today because these services aren't automated. Once again, monitor the lab you choose, and train yourself to recognize an acceptable print. The keys to fine-quality black-and-white prints are a good black tone, good intermediate gray tones, and highlight tones with subtle details in them.

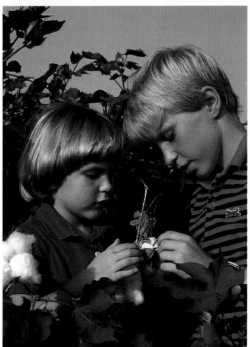

This gorgeous detail shot of fall colors won an award in an Eastman Kodak contest (above). The image was recorded on color-slide film, which isn't manipulated during processing; as such, exposure must be accurate. Courtesy of Dan Steinhardt.

Color-slide film was used for this shot of children in a cotton field to accommodate the farming-magazine editor's wishes (left). Most publications still prefer slides to prints even though today's color prints reproduce beautifully. Courtesy of Willma Gore.

PRIMARY PROCESSING PROBLEMS

Machines do most of the work in processing color film and making prints in a large regional plant or a one-hour lab. Developing is fully automatic, while printing is primarily automatic: operators make some decisions about color and tonality. Machines can malfunction and operators can make mistakes, but these are rare occurrences. Photographers are likely to have the following main complaints about color processing:

Scratches and Dust Spots. Since color-negative-film processing is automated, human hands aren't likely to scratch the film. If the equipment is cleaned carefully and regularly, the film shouldn't be scratched. Furthermore, there shouldn't be any tiny white spots on the prints, which indicate dust on negatives. These glitches are annoying and frustrating, and don't have to be tolerated. If two consecutive rolls of film are scratched or spotted, complain and be prepared to find another lab. Blow the dust from the inside of your camera regularly, however, because the scratches can originate there as well.

Incorrect Color Balance. During film processing, electronic sensors read negatives and determine the filters required to make prints that exhibit *color fidelity*, meaning realistic colors. If you've ever had a blue dress or sky appear greenish in a print, you know that control over automation isn't perfect. As *Consumer Reports* stated, "The negatives [from their tests] may have been identical, but the prints were not. In some sets of prints, the color of the sky ranged from pale, washed-out blue to lurid purple. In a shot of lavender crocuses, the flowers ranged from white to dark purple. Photos that don't contain fleshtones, sky or other objects whose colors can be guessed, are often hard for processors to print." However, the highest-quality prints in the *Consumer Reports* tests were judged to be "about as good as they could be."

To best evaluate your own prints, analyze them in daylight where color is seen most accurately. While you're getting the hang of this, keep some of your earlier good prints on hand for comparison. In most cases, the processor can easily remedy incorrect color fidelity, which is the most common color-printing problem. Reject pictures that seem too warm, or reddish, or too cool, or bluish, as well as those with specific colors that are wrong. Point out what you think is wrong with the shots when you ask for reprints.

The key to getting acceptable color prints is the way you judge them. If you recognize proper color and refuse prints with distorted hues, you'll get what you like. But if you act like so many people who don't bother to correct distorted color on their television sets and accept prints with offbeat hues, your photographic efforts won't be satisfactory. You must make side-by-side comparisons of prints of the same or similar scenes in order to detect subtle color or print-exposure defects. When in doubt, ask for reprints. Simply return the unaceptable prints with the order, along with such comments as "There is too much red in the carpet" or "The flowers are blue, not purple." The average lab will routinely try to please you.

Exposure. In 1987 tests, *Consumer Reports* found that about a quarter of the prints it had made were incorrectly exposed, and that most of those were underexposed, or printed too light; darker details were missing. Occasionally, a background was correctly exposed when a more important face in the foreground wasn't. Thanks to today's improved color-printing machines and operations, stiffer competition, and higher commercial standards, printing fidelity is more consistently satisfactory.

Prints that are too light or too dark are usually caused by the same type of scenes that mislead your P&S camera's metering system. For example, subjects very close to the camera are often overexposed when you use flash, while the rest of the image is fine. Machine-made prints usually retain a washed-out foreground and give you a normally exposed background. If you want faulty prints corrected, take them back to the processor and ask for better ones. Most processing services do this routinely at no extra charge. But before you complain, examine your negatives. If a negative is dense and opaque, it is overexposed. Still, unless it is extremely overexposed, it can be printed acceptably, although the grain will be more prominent. Negatives that are

almost transparent with little detail are underexposed, and there is a limit as to what the processor can do to improve the resulting dull, muddy colors. To prevent underexposure, try to avoid shooting without flash where there isn't enough light or where using flash is almost futile because the subject is too far away.

Exposure and color results produced by comparable labs aren't always the same. I recently had one of my wife's sunset negatives enlarged by a name-brand processing lab via a local drugstore chain, and I sent along a good 3½x5 print as a guide. The enlargement was too light, and the colors were faded. When I complained, the lab made a new print that was better; this took another week. Not yet satisfied, I had the same negative enlarged through a chain discount store; this store's lab followed the guide print and made a more brilliant enlargement for a lower cost. Obviously, paying more for color printing doesn't always guarantee that you'll get more acceptable results.

Framing and Trimming. Automatic printers do a remarkably good job making uniform borderless prints. Here, long rolls of printing paper are fed through a machine. Occasionally, however, negatives may slip and leave a thin black line or a strip of an adjacent photograph at the edge of a print. You can crop off the strip or ask for reprints.

More annoying is the way machines crop more along the edges than you prefer, eliminating parts of people's heads or half a person at the edge of prints. If this happens, check your negatives before you complain. When the cropped subject is right alongside the negative's edge, the loss of a thin strip is inevitable. When you compose, remember to include a little more of the subject around the edges to allow for normal printing practices. You can expect almost the whole negative to be printed only when you order custom-made prints.

Focus. My experience with years of commercially made color prints is that blurred or out-of-focus subjects are my fault. When I'm not sure, I look at the negatives with an 8X *loupe*, or magnifying glass. Loupes are available at camera shops or through the mail-order catalogs that are advertised in the back of various photography magazines. When I examine my negatives, I can usually identify blurry or soft-focus subjects reproduced in the prints.

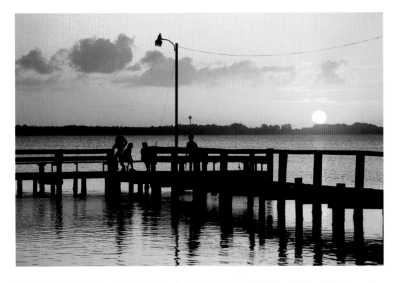

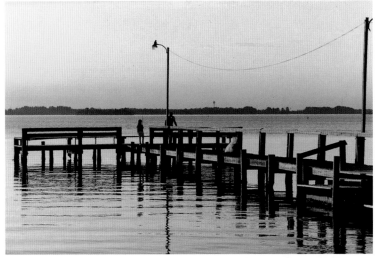

While I accept responsibility for these glitches, I might also blame lens and camera design, shooting conditions when I wasn't aware enough of depth of field, or a shutter speed that was too slow. But I must blame only myself when the focus spot in the viewfinder wasn't on the main subject.

Carefully evaluating prints made by processing labs is also an integral part of enjoying photography as a hobby. If you're still learning the basics, discuss print quality with someone who has more experience in order to help improve your awareness. If you have access to a darkroom, investigate the possibilities of making your own color enlargements after a lab has developed the film and made 3½x5 or 4x6 prints. Color printing at home is complex, tricky, and somewhat expensive at first, but it isn't difficult or mysterious. In addition, it enables you to be quite creative in ways you can't expect from a lab. The pictures you print will inspire you to more and better photography.

One evening, the photographer mounted her P&S camera on a tripod and took pictures during a Florida sunset (top). Months later, when the sun set farther north, the photographer shot the scene again, this time attracted by the orange tint on the dock (bottom). When she got her pictures back, she remembered the first picture and was amazed that she'd chosen almost exactly the same spot to shoot from each time. The photographer was also able to compare the prints and was pleased that the processing by a commercial lab had been consistently good. Courtesy of Kathleen Jaeger.

CHAPTER 6

LIGHT, FORM, AND COMPOSITION

This picture of a herd of elephants crossing a prairie with their young was made on a photographic safari in Kenya. Shooting from a distance of 50 to 75 feet, the photographer used her 35-105mm zoom lens and achieved extensive depth of field in bright sun using an ISO 200 film. Sidelighting provided even more visual impact by increasing the contrast between the elephants and the dry grass. Courtesy of Terri Wright.

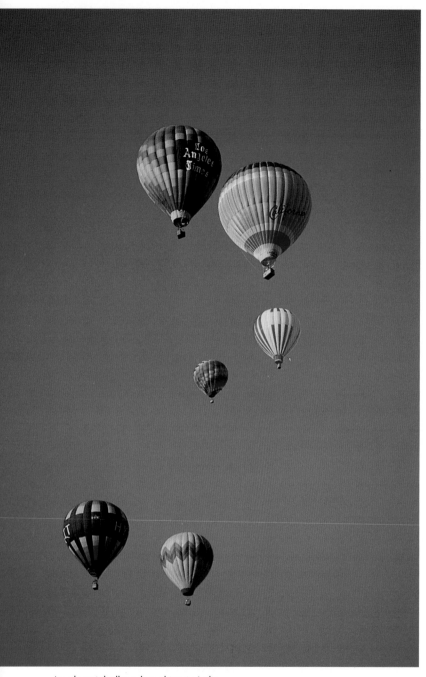

At a hot-air-balloon launching in Indio, California, I watched more than a dozen colorful giants drift skyward and be carried by a mild wind beyond the range of my zoom lens. About 4 P.M. on this beautiful autumn afternoon, the low sun sidelit the balloons against a deep blue desert sky. I waited patiently for a group of balloons to compose themselves harmoniously in the viewfinder and shot this arrangement with my zoom lens extended to 105mm.

Light from various angles and directions can make or break photographs. When you shoot outdoors, you can see the effects of sun, shade, or artificial light at night before you make exposures. And when you use flash with a point-and-shoot (P&S) camera, you know the light is directed from the front. The direction and quality of light help you anticipate a subject on film and influence whether or not you take pictures.

First, the direction of light enables you to decide whether to continue shooting from where you are or to move your viewpoint for a stronger effect. Perhaps the light shows the subject more clearly or dramatically from a new vantage point. How you respond to the possibilities depends on specific situations and on the subject you're photographing. The quality of the light creates contrast, which refers to the difference in the appearance of light and dark shadow areas. Cloudy illumination for a street scene might discourage you from shooting because the buildings appear to have too little contrast to be interesting. Overhead sun may be attractive on your son or daughter at play, even when the light is contrasty, because it is good light for capturing action and expressions. Soft, shadowless portrait lighting encourages you to take pictures of people looking relaxed. Late-afternoon sunlight is ideal for scenics because it can suggest a mood or a sense of mystery and show land forms beautifully, whether they are sharp mountains or rolling meadows. During the hour before sunset, warm, directional available light ordinarily enhances unusual and commonplace subjects. It can also inspire you to take pictures because the shapes and textures of a landscape, seascape, or cityscape are stronger and dramatically tinted.

EXAMINE THE LIGHT

Sometimes you come upon attractive light when shooting, but you have to ask yourself if the subject is interesting. A photographer I knew often shot light shining through the leaves of trees because he loved the effect. Sometimes he got an interesting pattern, but ordinarily he had only a *record shot*: the picture was pretty but otherwise kind of meaningless. Conversely,

with an *interpretation*, you do something with the subject and the way it is illuminated. For example, instead of just shooting a typical, sharp image of a lighthouse, find a dramatic camera angle, include people to show scale, frame the lighthouse under a tree, lie on the ground to accentuate height, or wait for better light. Do something that gives the picture a touch of your individual taste and talent and makes the result more compelling than an everyday snapshot.

As you examine the light wherever you are, shoot some pictures if you immediately feel that it enhances the subject. If the light and subject leave you feeling lukewarm, ask yourself some questions. Suppose, for example, that you're shooting a landscape with a meadow in the foreground, cattle in the middle distance, and a mountain in the background. The sky can either be clear and blue or somewhat cloudy. Here, you might consider the following elements:

■ Do the direction and character of the light help show the subject well? Almost all landscapes and buildings can be photographed more effectively in directional sunlight in the early morning and late afternoon. The best time of day depends on the season. During the summer, the light is angular early in the morning and in the late afternoon; during midwinter, the sun's rays slant all day. Directional light adds useful shadows to the mountains and cattle.

■ Do shadows enhance the subjects? Depending on the time of day, shadows may do a fine job of showing off a subject, but when the sun is high, the mountains may look boring because minimal shadows at noon do little to show form. The only exception is during the winter when the sunlight is always slanted. Even cattle in a meadow show up better when the sun is shining at an angle.

■ On overcast days, the landscape is softly and uniformly illuminated. As a result, unless there are wonderful color contrasts between the meadow, the mountains, and the sky and clouds, the whole picture might seem uninteresting. Landscape and cityscape pictures can be disappointingly flat without proper shadows from directional sunlight. If you can't return at some other time to shoot the scene, simply take a few record shots and try to find accents in color, contrasts, or camera angles.

The success of pictorial photographs often depends on the direction of the sun on the subject. Variations of 45-degree-angle sidelighting is usually strong and dramatizes form. In this shot of Buchart Gardens in Victoria, British Columbia, the sunlight came from both the side and back, creating shadows that make the larger plants stand out (top). Being able to shoot from atop a staircase enhanced this striking composition of a garden carefully laid out to please the eye. Here, I used the 35mm setting of my P&S camera's zoom lens and ISO 200 film.

The Grand Canal in Venice near midday in late summer is picturesque despite the high angle of the sun because the subject itself is colorful (bottom). I've seen this view from the Rialto bridge on gloomy, cloudy days when photography was futile. I've also photographed the opposite side of the canal at sunset when buildings glowed in warm light. Unlike a mountain landscape that may seem flat in midday sun, Venice has a character that the right light magnifies. I made this shot with ISO 200 film and a zoom lens set at about 38mm.

AN EXERCISE IN LIGHT AND FORM

For the directional-light exercise shown here, I decided to photograph an attractive couple at the edge of a golf course. As you can see, the light comes from one side, accenting the couple's profiles. I didn't use a reflector or add fill-flash because I like the effect of strong shadows; however, some illumination in the shadows could also have been pleasant.

To better understand how the direction of photographic light affects the people and other subjects you photograph, you should shoot a short series of pictures in an outdoor exercise. This will take about 20 to 30 minutes. Ask a person or a couple to model for you, or use a piece of sculpture or an interesting object you can move around to alter the lighting angle on it. You might also set up a simple still life on a sheet of illustration board that you can rotate on a table top. You'll learn more doing this exercise when the sun shines at about a 45-degree angle.

If you decide to shoot a still life, choose materials with both sharp and soft edges in order to produce a variety of forms and shadows. Use a sheet of illustration board

to create a uniform background. If you decide to photograph people for this exercise, pose them in front of a plain wall or some other simple background to eliminate distracting elements. Choose a location where the background will remain uncluttered when you ask the models to move in order to illuminate them from various directions. Head-and-shoulders views are fine.

For any of these subjects, mount your camera on a tripod if possible. If you can't, hold the camera the same way for each lighting situation. If you use a dual- or zoom-lens camera, choose a focal length between 50mm and 90mm. An ISO 100 or 200 film is ideal. Photograph the front of the model or still life for *each* lighting change. Rotate the subject so that the sun shines on the subject three different ways: from the front, for *frontlighting*; from one side, for *sidelighting*; and from behind, for *backlighting*. If possible, also pose the people as if the sun were coming from above them, for *toplighting*. If the shadows seem too dark in the side- and backlit photographs, shoot with and without fill-flash just to see the difference. Another option is to experiment with a reflector, such as a sheet of white posterboard; ask someone to hold it in place for you as you shoot. The effects of a reflector are more subtle and controllable than those of fill-flash (see chapter 7). If possible, you should shoot the same subject on an overcast day or in bright shade when the light is soft and shadows are minimal.

This exercise should help you make several important discoveries:

■ Changing the direction of the light changes how people and objects look. Light direction can considerably alter the mood of the picture. When you look at your prints or slides, consider which direction of light is most appealing, which is most intriguing, and which is most appropriate for the subject. You may like more than one lighting result.

■ Sidelighting often helps you to increase drama and show form in an image, and is often preferable to frontlighting.

■ Backlighting is almost always dramatic, and if the light is slightly off-center, the subject may be partly edgelit. For portraits

and still lifes, you'll find that backlighting can produce a glamorous effect.

■ Toplighting can be annoying. Faces photographed in high-noon sunlight are often rendered unappealing by shadows that hide facial features. Strong contrast from dark shadows isn't flattering.

■ Hazy sunshine filtering through clouds and light on overcast days or under trees can be wonderful for portraits. This holds true for bright shady places, especially where there is reflected light from an adjacent sunny surface. Keep in mind, however, that although soft illumination enhances facial features, it doesn't improve the appearance of angular forms.

Doing this exercise can help you become more sensitive to the various directions of available light and to recognize unwelcome shadows when you're taking pictures around home or on a trip.

Faces, places, and objects appear different as the light direction changes. This picture shows sun-from-the-front lighting, as you can tell from the shadow under the man's chin. I didn't need a reflector or fill-flash because the shadows in the image were minimal.

For this shot, I took the models to a shady spot where light reflected on one side of their faces. I think that sidelighting is ideal portrait lighting, although a lighter background might have improved the pictures. Soft, indirect light in which people don't have to squint is often more flattering than direct light. I prefer to shoot portraits under hazy sunlight and in places where light is reflected, for example, off a nearby bright wall.

COMPOSITIONAL GUIDELINES

While backpacking in California's Sierra National Forest, the photographer took advantage of early-morning light to make this lovely, subtle picture. He used ISO 400 film just after dawn and a 38-90mm zoom lens. He was pleased with the symmetrical nature of this evocative image and with the convenience of his compact P&S camera on this hike. Courtesy of Greg Lewis.

Composition involves the way you see and how you translate what you see through the viewfinder into prints and slides. Composition in photography or painting is the arrangement of subject matter, first in your mind as you design your pictures in your imagination, then with your camera as you look through the viewfinder and determine how the elements in the scene work best together, and finally on film and printing paper. Ansel Adams said that the essence of good seeing is *previsualization*. This is the ability to conceive in your mind's eye exactly how you want to photograph a subject, which requires some experience. As you take more pictures, you'll find that previsualization becomes easier in time and is a guide to creating stronger photographs.

Conventional composition is based on traditional principles used in painting and photography. Subject matter is arranged according to a specific type of balance, such as dividing a rectangle into an imaginary grid, or conforming to an academic order of design, such as including an "S" curve in a picture. These traditional approaches are popular with photographers who feel comfortable with the following visual principles: **Balance**. There are two types of balance: traditional balance and more contemporary, offbeat balance. A landscape with a horizon line above or below the center of the image is more conventional than one that is half sky and half land, or just a sliver of land and the rest sky. You're conditioned to feel that off-center, unequal proportions are more pleasing to the eye than symmetrical arrangements. A majority of photographers and artists feels that equal-sized areas, objects equally spaced in a row, or centered people are less interesting to look at. Such compositions can seem static because they lack variety in the way the subjects are spaced. So unless static serves a pictorial purpose, I think that you should avoid it; however, I don't think "rules" about symmetry should inhibit you from trying variations of balance. Some experiments might be eye-catching because they are offbeat, while others might be boring. Recognizing different effects will improve your photography.

The opposite of static is dynamic: compositions created by strong moving lines, which are often at angles to one another, or by impressive shapes, contrasts, or placements within the picture. Other dynamic images might contain curving or angular lines that run into or across each other; such images can also illustrate dramatic perspective with lines receding into the distance (see below), or shooting from unusual high or low camera angles rather than at eye level. Subjects in motion can also be dynamic as they run, emote, or are otherwise posed.

The Rule of Thirds. The grid system is called the *rule of thirds*, which advocates dividing the image into three equally spaced horizontal and vertical areas. The intersections of the lines between the resulting spaces are guides for the

placement of important picture elements. I think that a sense of conventional balance will lead you to locating interesting parts of a composition at the main intersections of the grid. As Stephen Schneiderman pointed out in the September 1992 issue of *Petersen's Photographic*, "There may be only one or two points of interest in your composition; if so, they should be placed on any one of these intersections. However, your photography will be more stimulating if you don't always play it safe."

The "S" Curve. Another traditional principle in painting and photography uses an "S" curve as the underlying basic design of a picture. Imagine, for example, a road that gently curves in an "S" shape from one corner of the image to the diagonally opposite corner. The eye moves willingly along an "S" curve. If you discover an "S" curve composition that works, make the most of it, but don't spend extra time trying to contrive pictures in this shape.

Content. While the way you see becomes the structure or design of your pictures, what you see becomes the content of your pictures. Content always influences composition through how you choose to arrange shapes, lines, contrasting tones, areas of color, directions of visual movement, patterns, and contrasting object sizes in your images. These are all elements of composition. Composition is based on what you do with what you see. Innovative photographers try to shoot ordinary subjects in somewhat unusual ways.

Dominant and Subordinate Forms. Most photographic designs contain a dominant form, such as one building, or related forms, such as a row of homes. Dominance is determined by a subject's size, shape, position, color, or storytelling importance. In order to quickly call attention to the main subject, place it prominently in the composition, position it at an angle in respect to the edges, or isolate it within an unobtrusive background. When looking at a portrait, you often first notice the eyes, which dominate the face. Sometimes dominance is gracefully divided. For example, a beautiful sunset sky might be prominent in a print, but interesting foreground activity seen clearly can be just as important.

Visually supporting the dominant subject in a photograph are subordinate shapes and lines; these elements are smaller, placed less strategically, or have less storytelling importance. In a beach scene, for example, crashing waves might be dominant while smaller-sized figures in the water or on the sand are important but visually subordinate. In another image, the whole side of a street might initially seem to dominate a composition, but on closer inspection one building stands out. It is helpful to be conscious of dominant and subordinate elements in your pictures.

Here, sunlight makes a sea of boats in a harbor in Catalina, California, stand out like elongated jewels. I photographed the attractive pattern both horizontally and vertically, but I find the horizontal version preferable because it separates the boats and water from the land in the background. With my 35-105mm lens zoomed to about 90mm, I shot this graphic scene using ISO 200 film.

ELEMENTS OF DESIGN

Design elements are the building blocks with which you structure a composition. A composition is, in fact, a design into which you place the subject matter you choose to photograph. People, landscapes, still lifes, and all the other subjects you capture on film can be perceived as shapes, lines, colors, textures, and various other aspects of design. You may be amused by or amazed at how everything you shoot is a kind of design element or a combination of design elements, including:

Shapes. Photographic designs or compositions contain elements with a seemingly endless variety of sizes and appearances. Shapes can be large, small, plain, textured, thin, or thick. How you relate important and lesser shapes in an image is one of the basics of design. A row of similar-size shapes that are spaced pretty evenly can be static or can suggest a strong pattern. To achieve visual variety and appealing compositions, you can include all sorts of shapes in your pictures; this will help make them outstanding.

Lines. These can move in all directions, twist and flow, and stand alone or connect. I call the way lines and shapes create a path for viewing a picture *eye flow*. As you look at a photograph, notice how your eyes start at one edge or at some point within the image; this starting point is influenced by both subject matter and composition. Your vision then flows along one or more paths and might switch direction until it reaches another edge. You don't consciously think of eye flow in the viewfinder, but it is involved in evaluating pictures once they're taken. If it seems difficult to decide how your eyes flow through a photograph, imagine looking along invisible lines that bring the composition together.

Color. Color is a very strong element of composition in, for example, shapes, lines, and textures. Warm colors, such as red and yellow, as well as combinations and pastel variations of them, seem to advance toward viewers and to dominate images because of their hue and intensity, as well as the way they contrast with adjacent colors. Cool

Walking along a Pacific Ocean beach at sunset, I met a young man pedaling his bicycle up a path and asked him to pose. This silhouette is a sophisticated, graphic snapshot in that it has visual impact and was planned. My P&S camera's autoexposure system worked perfectly with ISO 200 film.

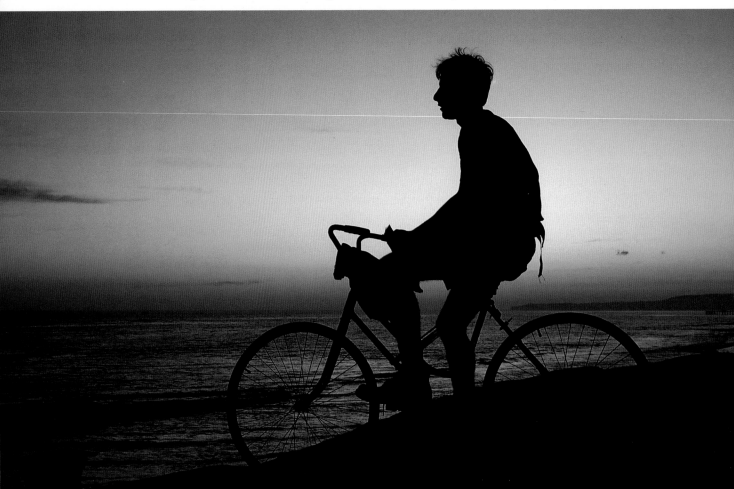

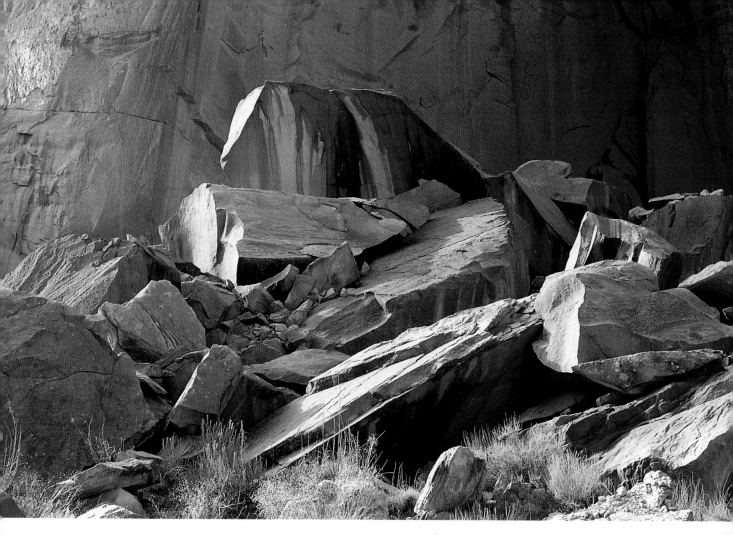

colors, such as blue, green, and mixtures of them, seem to retreat from viewers for the same reasons. Colors also often elicit unconscious emotional responses: think of sad or chilly blues; hot, exciting reds; and lonely, warm browns. When red and green are next to each other, they might appear to vibrate because of the way you perceive adjacent contrasting colors. You don't have to study color theory to understand the pull or attraction of colors, alone and together. You are susceptible to your favorite hues, and without even noticing, you might gravitate to them when you take pictures. Spots or areas of color that appear in the foreground of a picture and are repeated in the middle distance or background create a sense of space called *visual plasticity*. Look for plasticity in your own prints where colors in the foreground are repeated in the upper background. Keep in mind that your eyes unconsciously travel from front to back in such compositions, thereby creating a sense of space or distance.

Contrasts. In a composition, contrasts can take the form of brightly colored subjects that dominate because they attract viewers more quickly than pastel or grayed colors

grayed colors do. Grayed colors are subdued hues reduced in brightness by being mixed with their complementary colors of or with black. Contrasting black, white, and gray tones have similar prominence in black-and-white pictures. In addition to differences between colors and tones, pictorial contrasts exist between large and small, close and distant, active and passive, smooth and rough, and high and low subjects. Contrasts of all types influence composition because they draw the eye and help tell stories. Opposites attract to help make dynamic images.

Textures. Major parts of a composition may comprise large areas of texture, such as a picket fence, a pile of automobile tires, the spreading leaves of a tree, or the keys on a computer keyboard. From a distance, a group of colorful flowers first appeals to you as an area of texture. Texture is also a surface feature of all kinds of subjects, such as rocks, shag carpeting, feathers, wood grain, and corduroy. Texture also attracts the eye and can be the dominant element of a photograph, especially when you get close to a subject like the rough bark of a tree. Textured surfaces themselves and

Color is so easy to see and plays such a critical role in photography that it seems too obvious to discuss. But the great variety of natural and artificial colors and the myriad shapes in which color appears in pictures don't permit you to take color for granted. The colors in this shot of Utah's Capitol Reef National Monument are subtle, with contrasts of light and shadow in rocks of one hue. At first glance, the streaked rock seems to dominate the entire composition, but the other rocks are essential simply by virtue of the size of the area they cover. Sidelighting also plays an important part in the design, in which plasticity is created by colors that are repeated from foreground to background.

Although not every subject lends itself to both horizontal and vertical formats, many photographers are prone to horizontal framing; they forget to examine a subject with the camera in the vertical position. On an overcast day in Geneva, Switzerland, I was able to see an attractive arrangement of flowers, apartments, and trees in both directions; however, the horizontal format seemed better suited to the subject. Shooting with ISO 100 film and a 38-105mm zoom lens, I stood far away enough from the flowers so that depth of field extended well into the background.

large-scale textures can be effectively integrated into pictures without your being fully conscious of them.

Patterns. These popular subjects include shadows of fences, beach chairs, skyscraper windows, and bicycle wheels in bright sun. Patterns, which are related to textures, are often fascinating and worth considering for pictures, alone or as part of compositions. They are everywhere. So when you travel, you might find yourself photographing red tile roofs, people at a stadium, or the repetitive architecture of buildings. Pictures you take can not only tell a story, but can

also be entertaining to look at, too. Patterns may even be the main subject in an image. Consider undertaking a project in order to discover and shoot ordinary and unusual patterns, indoors or out, large or small, including textures. You'll both test your sense of design and enjoy feeling creative with your P&S camera.

Perspective. This involves how objects and lines in a composition recede from the foreground to the background, becoming smaller as they get farther away. Dramatic perspectives, such as those showing disappearing railroad tracks, buildings on a street, or haystacks in a rural landscape, can create strong compositions. You can also shoot pictures of cars from a bridge overlooking a traffic jam, or aim your camera up the face of a tall building in order to create a strong perspective. Try several focal lengths with a dual- or zoom-lens camera. Focusing fairly close to a subject with a wide-angle lens emphasizes perspective by making the foreground rather large in relation to objects in the distance. To shoot this type of image, simply set the focus slightly beyond the closest subject in order to increase depth of field. If you decide to use telephoto lenses, remember that they tend to compress perspective by making near and far subjects seem closer in size.

Horizontal versus Vertical Compositions. It is so natural to hold a P&S camera in the horizontal position that too often people forget to shoot vertical compositions as well. Looking at some student work recently, I noticed a number of horizontal shots that contained too much foreground and seemed to cut too much off the top. When I suggested to my students that some of their pictures would have been better as verticals, I discovered that they hadn't thought of turning the camera. Try shooting appropriate subjects in both formats. Some scenes are inherently vertical or horizontal, and others require exploration with your camera. At the Grand Canyon, for example, you'll find primarily horizontal views. But when you move close enough to the deep spaces between the plateaus, you'll notice that the vertical perspectives are more dramatic. As you shoot city streets, show the scenes horizontally, but be sure to shoot vertically, too, for another graphic approach to your images.

Although rules can be valuable, I feel that they tend to smother creativity and discourage experimentation. Become familiar with the rules of composition, but feel free to occasionally ignore them. If you think of them simply as guidelines, they can help you learn valuable ways to compose pictures without sacrificing creativity. The best teachers are your own successful images, but failed photographic attempts are also important because you try not to repeat them. Expect to eventually veer off in a personal direction, with pictorial views that evolve from breaking the rules. So after you discover—and practice—the fundamentals of composition, keep them elastic when you shoot to suit yourself and your photography.

Modern approaches to composition and picture content often aren't based on conventional ideas about composition or beauty. Strong news photographs may be off-balance to catch attention, and creative magazine photography may be emotionally moving but not necessarily beautiful. Pictures are modified by unconventional styles of seeing. In fact, some of today's most eccentric photographs hang in museums and commercial galleries. Such photographs can be surprising, pleasing, or downright irritating if they obviously distort image design or glorify the trivial in contrived ways. Work that seems to say, "Hey, look at this," I refer to as "leg-pull" art or "immaculate deception." Although I can't prove it, I'm thoroughly convinced that many photographers set out to make arty images in order to attract attention. However, nonconformists do help open other people's minds and encourage experimentation by making them view the world in different ways. Take a look at contemporary photography in books, museums, and galleries, not to copy these images or to be intimidated by them, but simply to become familiar with the ways principles of design are bent and twisted to individual tastes.

Uneven balance is more interesting to the eye than symmetrical balance, where lines or objects are closer to the center of the image and evenly spaced. For this portrait of a young woman in Ecuador, the photographer utilized the rule of thirds. The woman is off-center, and the background areas aren't the same size. I don't advocate strict adherence to composition formulas, but on occasion breaking the rules is quite acceptable. Courtesy of Austin MacRae.

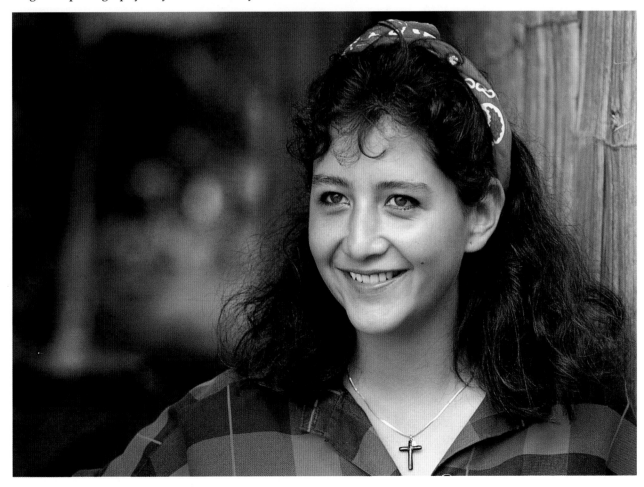

THE SNAPSHOT MODE

As you read this book, studying the pictures and captions, you may at some point wonder, "Do I always have to 'follow the rules' and take pictures carefully?" The answer to this question is a qualified "no." You must, of course, be conscious of technique and thoughtful about picture content, but when you see opportunities to make quick, casual photographs of people and places, follow your instincts, and don't be inhibited.

This spontaneous picture of a class of children on a tour at the National Gallery in Washington, DC, was made with a zoom lens set at about 90mm (above). The photographer was careful to keep her fingers away from the sensor windows in the front of the camera when she shot. Courtesy of Terri Wright.

For this charming candid, I asked the boy to pose with his fake snake, which he did willingly (right). Shooting in the late afternoon when the sun was low, I faced him almost directly into the light to get better detail. Shadows weren't a problem, and I didn't need fill-flash.

This isn't meant as a license to be careless. I want to encourage you to shoot how and where you wish, as well as to better enjoy the pleasures of informal photography. As I became more familiar with P&S photography, I gave in to the temptation to "wing it," to shoot without being concerned about whether or not I would get ideal pictures. I photograph many situations as carefully as possible, but I also make *grab shots*, which I take spontaneously in response to facial expressions and unexpected happenings. This is P&S photography for fun and by instinct, and I call it the *snapshot mode*. The photographic principles and experience you've absorbed and practiced are all involved in making good snapshots. You'll inevitably enjoy the snapshot mode when using a versatile, compact P&S camera. It is fun to impulsively look through your camera's viewfinder, get a quick impression of what you want on film, and be creative without thinking about theory. Snapshooting is a welcome relief, and it might even enable you to capture images that would otherwise be impossible.

SHOOTING SUCCESSFUL CANDIDS
When you are serious about using your P&S camera in the snapshot mode, a great deal of what you know about photography automatically comes through to your eyes and shutter-release finger. Experience gives you the ability to take pictures quickly in a lighthearted way. The pleasure comes from trusting your photographic instincts. This approach is also necessary when you photograph children and babies who are completely natural in front of the camera and pay little attention to your pleas and instructions. Grab shooting is candid photography, and with built-in discipline, you get pictures you like.

At one end of the P&S spectrum, the cameras are simple, with just one lens and flash. Dual-lens models have more complex options, and zoom-lens cameras offer the most photographic possibilities. Owners of single-lens P&S cameras may use the snapshot mode more often than owners of other types of P&S cameras. But whichever P&S you use, it is a pleasure to look through the viewfinder, decide quickly if

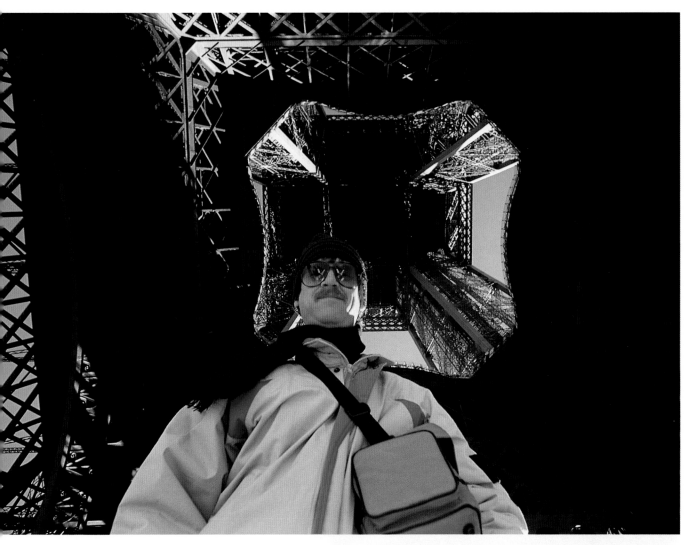

the subject looks all right, and snap some pictures. You might often find yourself doing this at family gatherings indoors and out. Experience helps you trust your own visual awareness. You gain pictorial understanding by making mistakes and correcting them at the next opportunity. While an uninformed amateur might take pictures like the way a beginner plays the piano—with one finger—your fast snapshots should be far better than those of a novice photographer.

Through these approaches, automated P&S photography frees you from technical concerns, so whatever aptitude you have with a camera is important. It is reasonable in a second or two to take spontaneous pictures, but they might not be elegantly composed. Casual snapshots often catch a moment in time that you, your friends, or your family enjoy reliving later.

Photographing in the snapshot mode also means not always waiting for the "right" light, an ideal camera angle, or an uncluttered background. You try for an effective viewpoint, pleasing light on people, or nonconfusing backgrounds, but when you shoot quickly and take chances, you can't predict what the result will be. You can, however, expect to get delightful or meaningful pictures without stress.

Educated, aware snapshooting is a valid approach to self-expression with a camera. It can be rewarding and appreciated, especially when you shoot plenty of film. If you find imperfections in prints or slides annoying, discard the worst and keep the images that please you. The goals are fresh pictures and shooting freedom that brings out the best in you. Give yourself the license to be casual and still remain visually responsible. In time, by refining your casual approach, you'll be both quick and more selective. You should be grateful that P&S automatic exposure, focus, and winding exist and are so compatible with snap-shooting. Practice grab shooting to catch the unexpected on film.

Here, the photographer made this unusual shot of her husband with the Eiffel Tower as a backdrop by lying on the grass. She used her P&S camera at the wide-angle setting of 28mm in order to get both her spouse and the structure in sharp focus. Courtesy of Kathleen Jaeger.

AN EXERCISE IN SEEING

This isn't your average photo opportunity, but it illustrates graphic toplighting. For this picture of a winemaker, the photographer felt lucky to find the high window beaming light into the wine cellar, which he otherwise blacked out. He shot a strong, atmospheric photograph using a 35mm lens setting and ISO 200 film. Courtesy of Chuck O'Rear.

For this exercise in improving your ability to see, take a walk near your home, go on a bicycle ride, or follow wherever your interests lead you. As you explore, choose subjects that appeal to you and consciously compose pictures with special care. If you have time, shoot several variations from different viewpoints, using several lens focal lengths and both horizontal and vertical formats when appropriate. Think about dominance, balance, contrasts, and other elements of composition and design. Even when you quickly photograph a subject in motion, try to be aware of how you arrange such elements as lines, shapes, and perspective. Look for subjects that have both interesting design and emotional appeal. If you're so inclined, use a tripod for some of the pictures because this encourages discipline when you compose.

As part of the exercise, you should also try to shoot some offbeat photographs of ordinary subjects. Suppose you're photographing children playing. Try lying on the ground in order to get a striking upward view of the children, which is an unusual perspective. Take some pictorial risks: do something "different." Shoot wide-angle views of people in Halloween costumes and telephoto views of buildings or other subjects standing in a row. Low and high camera angles and the imaginative use of wide-angle and telephoto lenses give viewers new perspectives and impressions of familiar people, places, and things. Look for guidance in magazines devoted to photography or art that contain a wide variety of images, or study a book of photographs you like. There is no need to copy what you see; just try to become stimulated and inspired. You have little to lose, and the film and time you invest might give you ideas about how to stretch the limits of your P&S photography.

This picture is part of an informal, ongoing project that I began as an exercise in visual awareness and is now a series of stock photographs. I've always found display windows interesting, and I search for decorative and unusual examples wherever I am. I discovered this store window filled with food and wine in Bergamo, Italy, on the shady side of a street. The theme you choose for yourself should offer a large variety of pictorial opportunities.

Not every photograph you shoot will be ideal. Murphy's Law often applies to photography. I try to compose pictures as closely as I can to the composition I want in the final image, especially because many shooting situations change rapidly. The light changes, your timing is off the first time, or the expression or action you hoped to capture has faded away. You can't go back, but you can often improve a composition by eliminating extraneous matter along the edges simply by cutting it off. The process is called *cropping*.

It is common practice for photographers to order 3½x5 or 4x6 prints when getting their color-negative film developed, and these can be cropped along any of four edges before you place them in an album, give them away, or have them enlarged. To do this more easily, make a pair of cropping Ls. These are two L-shaped pieces of thin, white cardboard an inch or so wide and long enough in both directions to cover the print sizes you work with. Place the Ls at the top and bottom of a print to form a window or frame, and mask off one or more edges of the picture to improve the composition. Cropping Ls make trying several variations easy to do. When you've decided on a suitable new composition, put a small dot in each corner of the new rectangle with a sharp pencil. Then cut the edges of the print using the dots as a guide.

When you want to indicate how a picture should be enlarged, crop a 3½x5 or 4x6 print in the same manner, but don't cut off the edges. Instead, use a ruler or triangle and draw lines between the dots with an erasable pencil that can be used on the glossy surface of a print. A custom lab can then follow your crop lines to enlarge the image. Some processing services keep prices down by printing only full 35mm negatives. If you're faced with this situation, have the shot blown up to a size that you can later crop to fit the desired frame or mat.

Improving the basic composition of a picture by cropping it along one or more edges is easy, and L-shaped pieces of white cardboard enable you to see the possibilities before you trim a print or place opaque tape at the edge of a slide image. To improve this wedding photograph, I decided that only minor cropping was necessary (left). By adjusting the cropping Ls, I eliminated small portions of three edges by placing small dots with a pencil in the Ls' corners as a guide to trimming the print with a paper cutter (below). You can, of course, crop prints without using cardboard Ls if you trust your visual judgment.

PHOTOGRAPHING PEOPLE

This photograph of a Kirghiz boy in Mongolian costume was taken on a movie set in Kirghizstan. Shooting while on vacation in Central Asia, the photographer composed the portrait so that some reflected light brightened the boy's face. Courtesy of Lydia Clarke Heston.

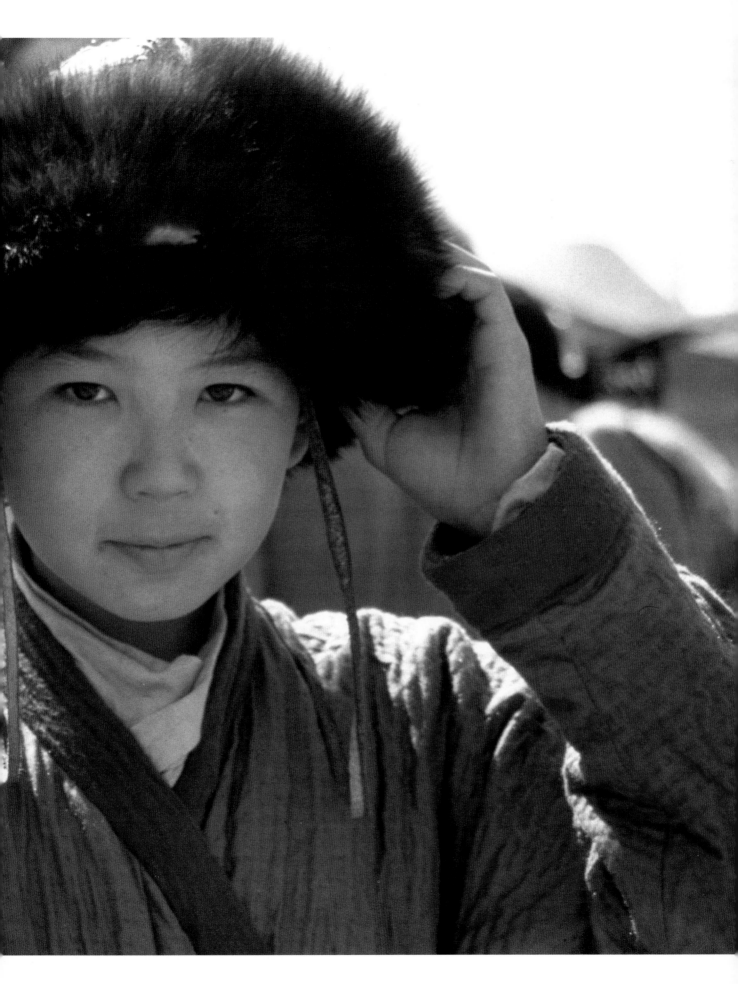

PORTRAIT OPTIONS

This young couple posed astride an ancient stone lion in St. Mark's Square in Venice for one of their friends (right). After he was finished shooting, I asked them to pose for me for a moment. Although the day was overcast, there isn't much color in the scene, and I would have preferred brighter light, I decided to shoot anyway. I'm pleased with the result.

Here, a grandmother carefully tucks a kimono corner for a child who will be presented during a ceremony at a temple in Japan (far right). The beautiful reflected light and simple background don't compete with the subjects. Courtesy of Alan Gore.

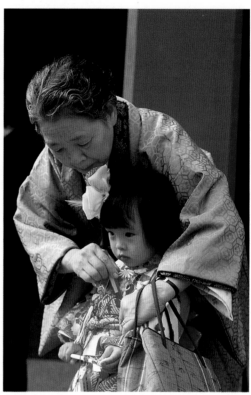

The most popular point-and-shoot (P&S) subjects are people and scenics, and these are probably photographed in equal numbers season after season. Pictures of people can be divided into various categories, such as posed and candid portraits, and action shots, many of which can be snapshot situations. Most portraits, whether they're taken on the front porch, on a vacation, or indoors, are suitable for a family album and are often suitable for framing. Some portraits are good enough for contests, but most portraits are shot quickly and casually when the photographer says, "Look over here." Their spontaneity makes them valuable.

Whenever and wherever you pose and photograph people, putting your camera on a tripod will lead to more successful portraits. Although a tripod isn't necessary when you photograph active adults or children outdoors, it can be useful. The tripod ensures sharp pictures, and it is helpful when you walk away from your camera to move a reflector, tilt someone's head, or answer the telephone. When you return to your shooting position, the camera will still be in the right place. Even when you shoot portraits with flash, a

tripod enables you to maintain a viewpoint you like. Flash illumination isn't as flattering as shady daylight or quartz lights that you can arrange, but sometimes it is the only light available.

When you're designing portraits, some of your choices include:

Formal versus Informal Portraits. What are the differences between casual and more serious people pictures? The answer depends on your approach, which is often influenced by the occasion and the amount of time you can devote to making portraits and classy snapshots. Posed portraits are, of course, more formal when you set up a background and handle the lighting carefully using daylight and reflectors or flash. Examples of formal pictures include shots of members of a wedding party, couples heading to a prom, or even youngsters posing quietly.

Informal pictures are more likely to be casual shots taken on the spur of the moment. At a wedding or some other large party, when you take candid shots of unaware subjects or ask people to momentarily look at the camera, you're shooting informal portraits. In some cases, when people are high-spirited and relate

well to each other, you can quickly pose a group or a few individuals for a wonderful series of informal, spontaneous images. Around home, a portrait session might take minutes when you make careful but casual snapshots with minimal preparation. To be successful, both formal and informal portraits require familiarity with your camera and sensitivity to subjects.

Indoor Portraits. You can shoot posed portraits in any interior location or in a homemade studio with artificial lighting (see below). P&S cameras adapt well to making casual or formal people pictures. The kind of lighting you use influences the types of portraits you shoot. In available light, people are usually more informal, while floodlights in an improvised studio might inhibit them at first. As such, I recommend using floodlights only as a last resort in terrible weather. For indoor shots with daylight coming through windows or doorways, use a posterboard reflector, artificial light, or fill-flash to brighten shadows. The resulting sidelighting can be moody and attractive.

Outdoor Portraits. The most available and predictably pleasant portrait lighting is daylight, indoors or out, for individuals and groups. Outside, the possibilities range from bright sun to bright shade and after dark, to flash. Try to avoid lighting that makes people squint and creates harsh shadows. Look for shade with sunlight reflected into it; this situation provides ideal portrait lighting. Reflected daylight is perfect for portraits because it is both soft and flattering.

When you shoot a portrait under a tree, avoid distracting spots of sunlight on people's faces or use fill-flash to even out the illumination. If you can't find a shady location, pose your subjects with their backs to the sun and use fill-flash. When you shoot on a hazy day, the sky softens the light for you. And remember, just before sunset the light is usually wonderful, soft, and warm, and right after sunset the whole sky can act as a warm reflector for portraits.

Be sure to select a setting where the background is as uncluttered as possible and where people can pose without distractions. Shoot in natural settings, such as on grass, in shaded gardens, in front of shrubbery, on a porch, or near a fountain. Simple backgrounds, which can be found around people's homes and in parks or playgrounds, are best. "The simpler, the better" is the best guideline to follow when choosing a background for a portrait.

Environmental Portraits. Photographing people in areas where they live or work can add an appealing visual touch to your images. This approach is called *environmental portraiture*. For example, a friend of mine once took portraits of a man and his son making wood kitchen and bathroom cabinets in their small factory.

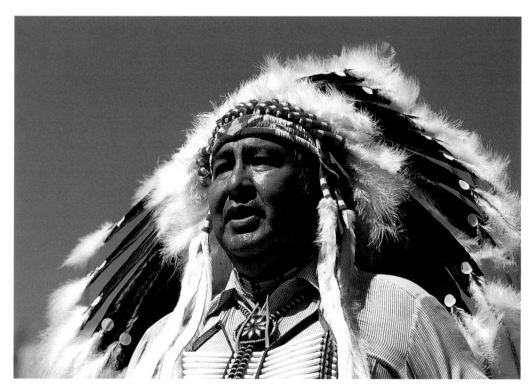

This compelling portrait of a Kiowa chief in full headdress was photographed in Albuquerque, New Mexico. The dramatic perspective is perfect for the subject, suggesting his power and strength. Courtesy of Austin MacRae.

CHOOSING THE BEST LENS

Some portraits are head shots, which are best taken with lens focal lengths of 80mm, 90mm, or 105mm. Other portraits include more of the subject, so various lens focal lengths are suitable. When I noticed this man on a pier near San Clemente, California, I asked if I could take his picture, and he agreed. The man's face was strong enough to look good in direct sunlight, and I set my zoom lens at 80mm to go in close for this head shot.

Upon discovering this curious young man peering out of his thatched home on the island of Irium Jaya, Indonesia, the photographer snapped an endearing impression with a zoom lens set at about 70mm. Courtesy of Chuck O'Rear.

P&S cameras with zoom or dual lenses are ideal for portraits. For head-and-shoulders pictures of people, a focal length of 70mm, 80mm, 90mm, or longer is appropriate. These enable you to stay back from your subjects in order to give them some space. Longer focal lengths are more flattering than shorter ones, and they don't distort the subjects' appearance, which wide-

angle-lens focal lengths do. Telephoto lenses also tend to throw backgrounds out of focus to minimize distraction behind a subject. P&S cameras with a single-focal-length lens in the 28-38mm range are likely to distort faces if you get too close, so stand about 4 or 5 feet from your subject and have the portrait enlarged later if you wish. While wide-angle lenses aren't suited to portraits, just for fun, you might try making a friend look like an ogre by photographing his or her face from a few feet away with a 28mm, 35mm, or 38mm lens.

For group pictures, either a wide-angle lens or a zoom lens set at 35-40mm is ideal because you can include a number of people and shoot close enough to use fill-flash to brighten shadows. Telephoto-lens settings are also appropriate for shooting candids of active subjects because you can shoot from some distance and still get a good-size image on film. Zooming allows you to concentrate on one or two subjects while staying out of their way.

PARALLAX CORRECTION

The average P&S-camera viewfinder doesn't see precisely what the lens sees when you are perhaps 4 feet away or closer to a subject, depending on the lens focal length and camera. To prevent parallax, which causes you to cut off parts of people's heads or to awkwardly cut into other subjects when you shoot closeups, use the parallax-correction lines or marks that are included in the viewfinder. Each P&S camera handles parallax in a slightly different way, depending on focusing distance, lens focal length, and camera design. In addition, it is important to be aware of how you sight through the viewfinder when you are close to the subject. Always try to keep your eye centered. A useful test is to put your camera on a tripod at a distance of 3 feet from your subject, shoot some comparison pictures using the full viewfinder, and then use the parallax-correction lines. You'll learn how accurate your P&S camera's viewfinder is, and you'll be able to frame closeup shots with confidence.

You can also shoot portraits by using photographic lights that are mounted on telescoping stands. For example, you might use 600-watt quartz lamps directed at the subject or reflected off white posterboard or a photo umbrella for softer effects. Keep in mind, however, that these lights can get pretty hot. Another light source is a reflector floodlamp; this is a bulb with a built-in reflector. Two lights on the subject and one on the background provide plenty of illumination. Using artificial light well takes practice, but you can learn. Set up the lights, move them to suit your own taste, try to avoid objectionable shadows, compose carefully, and shoot. Remember to switch off the camera's flash because it isn't needed with floodlights. The more you practice, the sooner you'll master this.

Artificial light is more warm-toned than daylight and may tint subjects, but this warmth can be reduced during color-print processing. Shoot your favorite print film using quartz lights or reflector floods. Then on the same roll, if you wish, try an 80A or 80B filter over the lens to correct the color of the light for daylight-balanced color-negative films (see chapter 12 for information about filters and filter holders). Using a color correction filter has one drawback: film speed is reduced, so an ISO 200 film responds like an ISO 50 film. The camera continues to compute exposure automatically, but at ISO 50 subject movement is more easily blurred and camera movement is magnified. Here, then, you need to switch to an ISO 400 film with artificial lights, or to use a tripod, or both. Available shade and hazy daylight are easier lighting conditions to shoot in, and they often produce more pleasant effects than artificial lights do. But quartz lights are convenient for shooting indoors on rainy days, and in time you might enjoy using them.

Shooting indoor portraits complete with floodlights or quartz lights is a more formal way to photograph people. Here, I hung a blue-sheet background behind the model as the background and used a reflector floodlight to brighten it. After placing a quartz light on the left, I held a posterboard reflector on the right to make this portrait.

This makeshift portrait studio is actually a living room. After arranging the camera and lights, I held the reflector and took this behind-the-scenes shot via my P&S camera's self-timer before shooting the formal portrait seen here.

POSING THE SUBJECT

Some knowledge of psychology can help you shoot successful portraits. Sometimes people are more comfortable if you discuss the setting and pay attention to their suggestions. Choose a location according to the quality of available light in the subject's home or on a patio or porch. Move pictures or furniture that appear to clutter the portrait setting. As you make preparations, explain what you're doing, and if you're using quartz lights, tell the subject why.

Professional portrait photographers know lighting and posing, but they also understand how to make people feel comfortable in front of a camera. Encourage subjects to talk about themselves while you shoot. Be sure to distract them if they are self-conscious. These techniques help make good people pictures.

Most people look better when they don't seem to be posing. Set your subject at ease immediately by telling them the light is flattering, and suggest new poses in order to take advantage of their features or the light. Friendly, lighthearted banter can elicit spontaneous expressions and smiles. Having your subject look right at the camera is often preferable, but you should shoot some three-quarter views and some pictures with the subject glancing to one

side or the other. Ask the subject to lean with one hand against a cheek as a change of pace, too. When you see an expression or pose you like, ask the subject to hold it if necessary, and snap several pictures. Regular pose changes make people less likely to be stiff. Even if you know your subjects well, showing interest in them minimizes self-consciousness.

VARY CAMERA ANGLES
Flattering camera angles often occur when the camera is at the subject's eye level. Shooting from above or below someone's face may create mild distortion that makes a jaw, nose, or forehead too prominent. Once you have enough eye-level shots, try for more dramatic images using telephoto focal lengths, such as 90mm and longer. Whether the portraits you shoot are for yourself or the subject, try to please the subject and be creative at the same time. When shooting unconventional poses, angles, or lighting, tell your subjects that you're experimenting. Then if the final images don't please them, they'll better understand why. Younger faces and figures adapt best to offbeat photography, but people of all ages enjoy seeing themselves in prints.

Here, the photographer deliberately composed this picture so that his wife's head was partly out of the frame. He wanted to compensate for parallax, which refers to the difference between what you see through the viewfinder and what the lens "sees" when you focus close. He achieved a portrait of a mother and son, which is exactly what the photographer wanted to show in the final image. Courtesy of Austin MacRae.

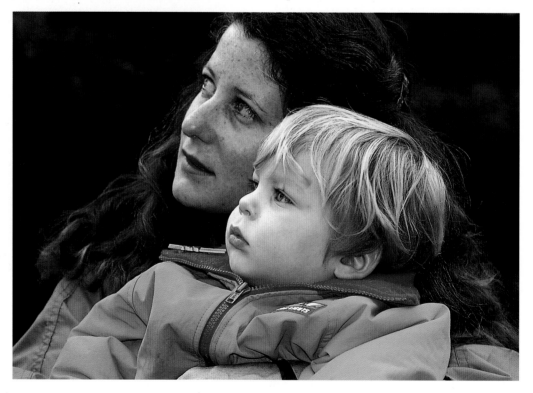

It is fun to photograph babies before they can walk. One way to keep an infant amused and capture its attention is to place it on the floor or on a blanket near a window, and use fill-flash if necessary. You can also lower one side of the crib, and put the baby in a sitting position if possible. Use your own resources when taking pictures of infants; you can usually outsmart them. Most people enjoy shooting baby pictures, which can be comic, delightful, or charming. A zoom lens set at 70mm or longer enables you to shoot closer portraits without making the child feel crowded. Of course, unobtrusive backgrounds are just as important for pictures of babies and children as they are for other portraits.

Children who walk and talk need to be cajoled and disarmed, so a good time to photograph them is while they're playing active or passive games. Other methods you can try while shooting include suggesting things for them to do, talking to keep their attention, promising them a treat when you have the pictures you want, and letting them know you appreciate their cooperation. To minimize sibling rivalry, photograph one child at a time, and then tell the children a story and group them for some final shots. Let them know you're pleased. You can occasionally say something like, "That was a terrific look," or "Please smile over your shoulder again. You looked so pretty." Children enjoy flattery as much as adults do, and they bask in special attention. Youngsters might relate better to you if you squat down or sit on the ground closer to their eye level rather than always shoot from a standing position. Photographing children with adults takes patience, too. If you are lucky, the grownups will help you distract the children and maintain order.

Since babies and older children move continually and quickly, it is a good idea to use an ISO 200 or faster film to be sure that the camera sets a fast shutter speed in relatively bright light. To shoot in shade, you'll find that an ISO 400 film can be helpful for the same reason. ISO 200 and 400 films also require smaller *f*-stops, which increase depth of field. In addition, if you can't focus accurately or you use a fixed-focus P&S camera, keep in mind that smaller apertures provide extensive depth of field.

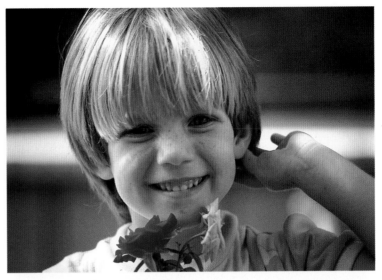

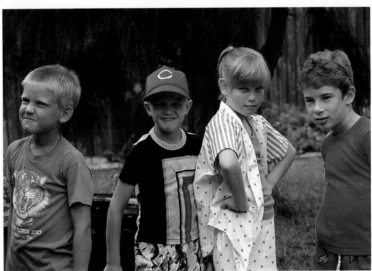

For this closeup, the photographer positioned the child so that the sunlight filtering through the tree branches produced highlights on her hair (top). Courtesy of Kathleen Jaeger.

This picture was shot in a backyard on a bright, hazy day with ISO 200 film and a 35mm wide-angle lens (bottom). The photographer kept the background simple and out of focus, and allowed the children to be themselves. Courtesy of Kathleen Jaeger.

PHOTOGRAPHING GROUPS

Once you choose a suitable setting, the next step is to make sure that everyone in the group is comfortable. For family portraits, let the members group themselves at first if they wish, and then rearrange them if necessary. Adults may be loosely lined up or staggered, give the older people chairs, pose younger family members on the grass or floor in the foreground, ask the taller ones to stand behind the others, and design an informal arrangement. As you compose, tell the group members how well they're shaping up. Relaxed people look more natural and will be more cooperative. Avoid gaps between individuals where annoying patches of background might show through. A large group, perhaps 12 or more individuals, will appreciate direction from you—which you can offer more easily when your camera is on a tripod.

When you use a wide-angle lens, the more people you photograph, the smaller those in the back of the group will appear in the final image. To make individuals more equal in size, use a 60-70mm lens if possible. Remember, too, that the farther away people are from the flash, the darker they'll be; to prevent this from happening, limit groups to two rows when feasible. Another way to solve this problem is to stand on a ladder or some other elevated platform and shoot down as the people look up. The distance between the flash and the front and the back rows will be closer, and the rows will be illuminated more evenly.

For the average group portrait, have everyone look at the camera. Of course, you'll want to shoot variations, too. If a child is near the center of the group, ask everyone to look in its direction. Similarly, have the outer people in a group of three look at person in the center. In shot of a foursome, the two people on the left side can look at the two people on the right side as a variation. You are the director, and you should tactfully design the picture and prompt pleasant expressions.

For informal, candid portraits of people posing or involved in various activities, settle for whatever they're wearing. If someone has on a garish shirt or blouse, simply find a camera angle to minimize the clothing. In general, pose people harmoniously in terms of their attire and be tolerant. If you can prepare for a shot ahead of time, explain that pastel and pleasant bright colors are preferable. Patterned fabrics are acceptable if they aren't too bold and distracting.

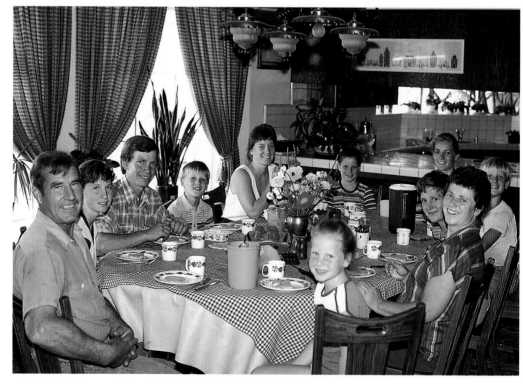

To show a large group of people having dessert, the photographer used the 38mm wide-angle lens setting on her P&S camera and ISO 200 film. Although the background is a little distracting, it is quite authentic, which is what she wanted for a magazine article. The autoflash feature on her P&S camera determined an exposure that shows the kitchen well and prevented her from having to manually compute the exposure herself, which can be a problem when you want a candid shot of a large group. Courtesy of Willma Gore.

Frequently, you want a picture of yourself alone or with a group at a particular place or moment in time. But either there is no one around to shoot it or you don't want to trust a passerby to take a suitable picture, so you decide to take it yourself. Shooting a self-portrait involves choosing an appropriate location, background, light source, and lens focal length, and using a tripod is almost a necessity. Before you get started, you should carefully read your camera instruction booklet to find out how to prefocus for self-portraits. Basically, first you mount your camera on a tripod, and then set the focus, preferably on someone you'll stand or sit beside. Set the flash or fill-flash if you need it, and put the camera in self-timer mode. Next, press the shutter-release button, and get into the image area within 10 seconds. If your camera has a remote-control feature, you might find it very convenient for self-portraits.

Compose self-portraits to suit the location by including more or less of your surroundings. My wife and I shoot self-timer pictures to help us remember where we picnicked or hiked, as well as to show friends or relatives the places we visited. When I don't have a tripod handy, I look for a level rock, a step, or some other flat surface that I can rest my camera on. Otherwise, I might place the camera on top of a shoulder bag on the ground or wherever I can raise the viewfinder just high enough in order to squint through it and compose a picture. A small clamp that enables you to attach your camera to, for example, a tree branch is sometimes a handy substitute for a tripod.

Anticipating poles or trees emerging from heads is important in self-portraits, too. For insurance, shoot from several viewpoints. If your camera is able to take two or more self-portraits with one setting, take advantage of this feature; if not, and your camera has a remote control, use it. You can also use the self-timer for pictures at slow shutter speeds in dim lighting when your camera is braced but isn't on a tripod; this prevents camera movement.

When my wife and I were on vacation in Alberta, Canada, we decided to take a shot of our rustic cabin to put in our photo album and to send to a few relatives. I mounted my P&S camera on a tripod and used the camera's 35mm wide-angle setting for this self-portrait. My tripod weighs less than 3 pounds and elevates the camera to my eye level. The day was overcast, but the ISO 200 film I'd chosen provided relatively bright colors.

PHOTOGRAPHING SPECIAL OCCASIONS

All photography enthusiasts, especially those skilled with a P&S camera, are asked to shoot special occasions at some point. Perhaps the most frequent request is for wedding pictures. If you find yourself in this position, you might want to take a tip from professional wedding photographers. They stick to a detailed list of picture situations, which includes the following highlights:

■ The bride getting dressed, surrounded by her attendants
■ The groom with his ushers
■ The parents of the happy couple
■ The bride coming down the aisle
■ The wedding ceremony
■ The reception line
■ The newly married couple dancing and cutting the wedding cake
■ The bride and groom's getaway.

In addition, the wedding party is often photographed in separate groups immediately after the ceremony. This is also when more formal pictures of the bride and groom are taken. Whether you shoot all these possibilities depends on why you're taking the pictures. If they are for yourself, photograph whatever appeals to you, put some in the family album, give some to the newlyweds and their parents if you wish, and enjoy the occasion as a pictorial challenge. Try to capture emotional moments, excited expressions, amusing activities, children's antics, and any situations that appeal to you. You are your own boss.

However, when you photograph a wedding for the bride, the groom, or their families, you might have to be more thorough. Although having to work when everyone else is just having fun can be annoying, you can have a good time shooting, too. Make a picture list before the wedding, and go over it with the bride, the groom, and/or their parents. Find out when you aren't supposed to shoot during the ceremony, and determine whether you can shoot without flash if you use a tripod. If the location of the ceremony precludes this, use an ISO 200 or faster film to make your small P&S flash more effective. As you shoot keep in mind that you have responsibilities even if you aren't being paid.

After the wedding, have 3½x5 or 4x6 prints made of each roll as proofs. Edit the pictures before you give them away or deliver them for whatever fee you've arranged. Removing the failures makes you and the remaining photographs look better. Number each roll of negatives, and give each print a roll and frame number (see page 140). The bride and groom can then easily order more prints or enlargements or have these made themselves if you lend or give them the negatives. Wedding photographs can be a unique, very much appreciated present for a couple.

If you're photographing a wedding that a professional photographer has been hired to shoot, be cooperative and stay out of the pro's way as much as you can, but don't be so accommodating that you miss pictures you want. Try not to be intimidated, but at the same time be considerate. Occasionally, you might alternate with the pro if you explain what you're doing. And as a family member or close friend, you might get pictures the hired photographer can't.

Besides weddings, life is often made more interesting by parties, birthdays, and other celebrations, all of which call for pictures. It can be fun to photograph friends and relatives at parties because you can catch them enjoying themselves. However, at many locations you can't control backgrounds, and sometimes the lighting is so dim that you can't see through the viewfinder very well, so you end up with unwelcome expressions and unphotogenic poses. A friend of mine asks her husband to aim a small flashlight on people in dark places so she can decide when to shoot. This also alerts people to pay attention to you; after all, they don't want you to take unflattering pictures of them either. Using a zoom-lens or dual-lens P&S camera for parties or weddings makes photography more efficient and rewarding.

Just how thoroughly you decide to photograph such special events depends on your own taste, what someone asks you to "be sure to get," or both. Typical party pictures include guests arriving, greeting each other, talking and otherwise enjoying themselves, the decorations, the host and hostess making a toast, people at a dinner table, blowing out candles on a cake,

opening presents, dancing, and playing games. Adult birthday parties are usually more sedate than children's, but not always. I remember shooting a party where the guests did some wild dancing, and when I showed them the pictures later, they didn't even recall the flash going off. Offguard photographs are rewarding, and a P&S camera is ideal for such celebrations. Watch what is happening and be quick enough to shoot it. Forget red-eye prevention here; it merely slows you down.

Children's birthday parties are quite colorful and amusing, even if they become somewhat disorderly. The children playing games, eating ice cream, and opening presents provide you with many opportunities to record wonderful facial expressions and activities. Your biggest challenges are timing when to shoot the best expressions and making compositions in which most of the children are at least recognizable. Pose them whenever you can because some of your candid pictures might not be flattering.

When you photograph people around a table at a special gathering, your main problem is finding a camera angle that prevents individuals from obscuring each other. Be prepared to rearrange your subjects so you can see everyone from the camera's viewpoint. If there are too many people to arrange easily, ask some to stand behind those who are seated. This will give you a clear view of everyone. When people around a table are illuminated evenly in daylight or good existing light, you can simply go ahead and shoot. However, when you shoot with flash, you face a problem: the people closest to the lens get more light than those farther away do. In this situation, it is best to reposition the people in order to illuminate them more evenly. Ask the people to move so that some are seated at the table and others are standing behind them.

Whenever you photograph a special occasion, be sure to take an extra camera battery with you since you'll undoubtedly be using flash when you shoot. If you are lucky, however, the party will be held outdoors and the available light will be pleasant. And, of course, be sure to bring enough film with you: running out is frustrating—and very embarrassing. On special occasions, your P&S photography skills will enable you to shoot excellent pictures that you, your friends, and your family will appreciate. All you need to do is understand your camera's features as well as its limitations, and to use your best photographic techniques.

I photographed this happy couple after the wedding ceremony with available light and ISO 200 color-print film, which adapts well to many lighting situations.

CHAPTER 8

SHOOTING SCENICS AND TRAVEL SUBJECTS

This photograph of the Golden Gate Bridge was shot with a P&S camera mounted on a tripod and Kodachrome 64 about half an hour before sunset. End-of-the-day light is warm, and here it enhanced the red bridge. When you want color to be particularly accurate, slide film is your best choice because the color isn't manipulated or interpreted during processing. Courtesy of Austin MacRae.

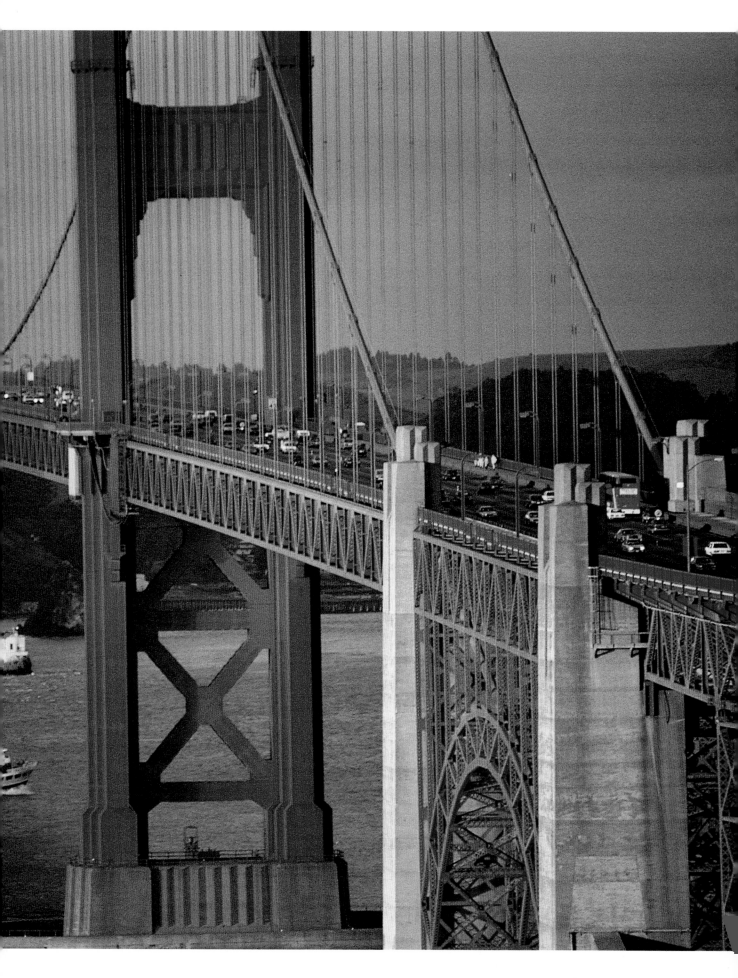

On both vacations and weekend trips, enthusiastic photographers find numerous opportunities to shoot visual memories of sights and people; they then keep these prints in albums or frame them. When you travel, you'll find that having a lightweight, easy-to-manage point-and-shoot (P&S) camera is very convenient. You can carry your camera and extra rolls of film in a small shoulder bag, along with your passport and some maps. In terms of versatility, zoom-lens and dual-lens P&S cameras are most useful for travel, although single-lens models are popular because they are so compact. But all P&S cameras offer automatic exposure and focusing (or fixed-focus) capabilities that free you to think about composition and timing. P&S cameras make technical decisions while their owners concentrate on what to shoot, from which angle, in which type of light, and with which focal length. If you have an older, less automated P&S camera and are planning a trip, you might want to consider getting a new dual-lens or zoom-lens camera to increase your shooting options.

Choosing subjects and shooting good pictures on the road can be a challenge. Thoughtful composition and careful timing are the keys to success. You must be aware of backgrounds and camera angles, as well as how subjects relate through lines, colors, and design. In addition, sometimes you'll want to include people in your pictures, while at other times you'll wait until they are out of your way. These decisions depend on both the shooting situation at hand and your personal approach to photographing places you visit.

MAKING TRAVEL PLANS

Before I go on a vacation, I gather newspaper clippings and printed material about places I expect to visit and hope to photograph. During the trip, I might come across only a few of the features that I've learned about; at least I know that these areas of interest exist, and I can make a detour to photogenic places if I have the time and pictorial inclination. Almost every state and many foreign countries have travel and tourist offices that offer maps and handsome illustrated booklets. To get started, look for advertisements and information about tourist offices to contact in the Sunday travel section of metropolitan newspapers during your preparation time.

There are two schools of thought about photographic traveling. One school advocates detailed, day-by-day planning in order to shoot specific sights and scenes discovered in printed materials, by friends, or during earlier visits. Perhaps the light was pretty dismal in parts of Yellowstone National Park the last time you were there, and you plan to return to places you know will provide you with great picture-taking possibilities. Photographers who believe in extensive preplanning usually regard their shooting list as an itinerary. They include subjects they want to cover, as well as the

I always look for unexpected scenic views when I travel, and though I planned to be in Utah's Arches National Park, I didn't know that I would be seeing an arch as vast as this one. To suggest its immensity, I included people in this shot for scale. Shooting with a 28mm lens and Kodachrome 64, I backed away as far as I could into a nearby rock formation to include the entire arch.

time of day when they expect to be in various spots. If such a plan isn't followed too rigidly, it is a worthwhile approach to travel photography.

The other school of thought takes a more casual approach to planning a trip. These photographers usually travel by car and single out places where they want to stay only a day or two in advance. They might do some exploring in the vicinity of towns and cities for a while, or they might move restlessly from one place to another, enjoying the serendipity of what they find to photograph. I've often traveled using this more casual system, which blends planning to see specific places with finding unexpected subjects. Not being too tightly tied to a schedule also permits you to change your itinerary according to the weather more easily.

WHAT EQUIPMENT TO BRING

It is helpful on a trip to carry your P&S camera in a shoulder bag to protect it from bumps. The size of the bag is up to you. I prefer one that holds one camera, film, a spare battery, and the camera instruction booklet. The instructions are handy when you forget how to use your camera's various modes and commands. If your camera case is fitted and holds only your camera, leave it at home when you go out shooting: you can't put anything else in it, and it will simply be in the way when you shoot. You can, of course, use the case at home to store your camera.

Also, whenever you go on a trip, and especially when you go by car, you should consider taking a tripod that weighs only a few pounds, folds to a compact size, and extends high enough so that the camera is at eye level. A tripod is a must for shooting pictures at night or in dim light, as well as for any situation when you want to compose precisely. If you aren't convinced, borrow a tripod from a friend, experiment, and see if there is a visible difference in your pictures.

If you expect to shoot closeups during your travels, you'll want to know that some camera manufacturers make telephoto lens attachments that can increase the lens' maximum focal length. You simply snap these into place, and an auxiliary view-finder is built into the converter to cover the camera viewfinder. A teleconverter usually operates only when the zoom lens is fully extended, so it might have limited

On safari in Kenya, East Africa, the photographer waited patiently for an animal to enter the foreground area of this scene as he watched the sun set. He was rewarded when an elephant passed by slowly, enabling him to make several shots with a zoom lens set at about 90mm. The photographer mounted his P&S camera on a tripod because the light level was actually lower than it seems, and he didn't want to risk any camera movement even though he was using ISO 200 film. Courtesy of Austin MacRae.

value for you. And a few companies make closeup attachment lenses that cover the camera lens and viewfinder and enable you to focus more closely than you can with the camera lens. Another advantage is that the autofocus setting adjusts immediately for the add-on lens.

In terms of filters, it is unlikely that photographers who use color-print films will need them to make skies bluer or to correct indoor lighting to match daylight-balanced films. Today's processing should handle all basic color corrections. However, if you want to reduce the warm tone of artificial lighting in prints, use an 80A or 80B filter. If you decide to shoot predom-inantly color-slide film, you'll probably want to invest in a skylight filter, a polarizing filter, and an 80A or 80B filter. And virtually all photographers are curious about special-effect filters, which can produce streaks, starbursts, and multiple-subject images.

Finally, be sure to bring enough film with you to cover most of your trip. You can, of course, buy additional film in many places, but running out of film might mean missed pictures. Furthermore, film purchased on location can be more expensive. You should carry an extra camera battery with you, too. You might also want to pack a tiny auxiliary flash unit in order to achieve more pleasant lighting of individuals or groups of people you visit.

This beautiful scenic was taken from a cruise ship off the Alaskan coast, with a zoom-lens P&S camera at its 90mm telephoto setting (top). Courtesy of Murray Olderman.

A 35mm wide-angle lens helped me get this entire view of France's Fontainebleau Castle into sharp focus on a day when the clouds were flirting with the sun, which ducked in and out in an irritating fashion (bottom). I included the border of flowers to act as a frame, and lines of color in the middle lead your eye toward the dominant subject. I locked focus just beyond the foreground flowers, and then tipped the camera up for the final composition.

Scenic pictures might include, for example, distant subjects, close details, and people involved in outdoor activities on a farm or at the beach. Scenics aren't always of nature: they can be shots of buildings, city streets, and/or skylines. The best scenics give you a sense of being there and are always taken in ideal lighting conditions. Unfortunately, you'll find that the light isn't ideal everywhere you go. Too often, you arrive at a scene when the light is flat and dull, is too harsh, is too high, or is coming from the wrong direction, so it won't produce good pictures.

IMPROVING YOUR SCENICS

Variations of attractive lighting are important in terms of the impact your scenic pictures have. You need to learn which times of the day and the year provide the most appealing illumination, as well as what to do when the light isn't ideal. For example, when the sun is high in the sky at midday, especially during the summer, mountains and other subjects may be almost shadowless. This is because the light is flat and uninspiring. Ideally, you should come back later that day or earlier the next day when the sun is lower and shadows show form more distinctly. If this is impossible, find a dramatic camera angle, include an interesting foreground, or do whatever you can to make the scene more interesting visually. Try not to be too timid, and take some risks. The price of a picture or two is a small gamble in adverse circumstances.

For photography, the best illumination comes from early-morning and late-afternoon light, when the sun is at an angle of less than 45 degrees. I've heard professional photographers say that they stop shooting landscapes, seascapes, and cityscapes before noon and take a long lunch break until the sun creates useful shadows again later in the day. The average amateur photographer can't usually afford such a long wait when traveling. So if you're faced with this problem, just do your best with what you see in any light if the subject is worth shooting. Sometimes at midday, landscapes and cityscapes look great because the light is actually low enough. For example, during the winter

months, take advantage of the day-long low angle of the sun for whatever you photograph. Snow scenes can be beautiful and varied—although you might need to wear waterproof boots in order to reach the best viewpoints.

No matter what the season, on an overcast day, shadows are soft and a scenic subject can look boring, especially when you want sharp edges of mountains or buildings. Of course, the sun might come out if you wait, but you might have to come back. If you can't return some other day, take some pictures anyway. Maybe what you shoot will come out looking pastel and beautiful. On a day of gentle rain, the light is usually dismal. But if you can't come back when the sun is out, try to shoot moody pictures; you might also want to include reflections or wet subjects, which can add interest to some scenes.

Clouds, on the other hand, are often wonderful elements in scenic pictures. Wait for them to move into the scene, or if they shade the sun or cast unwanted shadows on your subjects, be patient as the clouds pass. Large, dramatic clouds are welcome additions when they hover over nature's wonders, such as fields of wheat and seascapes. While you wait for clouds to move, look for a better viewpoint. You'll find that the difference between a shot of a scene in bright sun and a shot of it shaded by clouds is worth the extra time it takes.

FINDING SCENIC VIEWPOINTS

Because there are so many scenic variations of land, sea, and city, you should try to keep in mind the following suggestions, which fit changing situations, when you shoot. First, the foreground is always important even when the dominant subjects are in the distance. Look for rocks, a bend in a stream, flowers, ruins, people involved in an activity, or anything that produces added pictorial interest or color in a scenic foreground. Such subjects add depth to your pictures as well as make them more interesting.

Frame the main subject by shooting through or under foreground objects at the top, bottom, or edges of the picture. For example, if you shoot across a rock

formation in order to include a beautiful scene in the background, the foreground acts as a partial frame, particularly when the rocks are in shadow. If you compose from under an overhang that frames the top of your picture or through either an arch or doorway that frames the whole background, you can make the graphic quality of your images more dramatic. Notice how creative framing devices effectively enhance pictures in magazines or scenes in movies or television shows.

You might decide to shoot an imperfect scene anyway, knowing that you can

strengthen it later by cropping the print. Many photographs can be improved via slight cropping; however, if you notice that your photographs habitually contain extraneous elements, try to move closer to your subjects so that only the important parts of a scene fill the viewfinder. If you can't get close in a particular shooting situation, you might be able to extend a zoom lens in order to make a larger image. When you've moved and zoomed as close as possible and you are still too far away for your subject to completely fill the frame, arrange to have just the important area of the negative enlarged. Think of cropping as a picture-saver, not as a panacea.

A wide-angle lens setting can dramatize subjects that are reasonably close. For example, to include people in the foreground as well as a stream in the background, stand a few feet away from

Much has been said about the value of using a tripod, and many nature shots benefit when you can shift the camera slightly or change the focal length of the zoom lens to improve what you see in the viewfinder. I photographed this somewhat abstract pattern of rocks in Lone Pine, California, late one morning in early spring when the sun was fairly low. I saw quite a few lizards on the rocks, but they skittered off before I could get close enough, even with the lens on my P&S camera zoomed all the way to 105mm.

While searching for Roman ruins in France, I wandered to the edge of a cliff and discovered St. Romain (top). I waited for clouds to clear and then took a number of pictures with my zoom lens at various settings between 38mm and 105mm on ISO 200 film. The high elevation proved to be a stroke of luck, and I shot extensively from different viewpoints, trying not to be too quickly satisfied with the images.

During a trip to Kenya, East Africa, the photographer came upon two cheetahs guarding against predators in their territory (bottom). Although these animals are fairly used to people and vehicles, the photographer drove up slowly and shot from the van because he finds that some elevation is always helpful in a flat location. He used a bridge camera with its 35-135mm lens at the longest telephoto setting. The sun was high and to the left and the scene was monochromatic, but he knew that the different textures and the animals' stance would make this picture appealing. Courtesy of Austin MacRae.

the closest subject and shoot the scene with a 35mm or 38mm wide-angle lens or a wide-angle zoom setting. Lock focus on the closest person or object for one picture, and then on the next closest for another. Remember where you focused in case you're faced with a similar situation in the future. In bright light, the depth of field offered by a wide-angle lens usually gives you sharp pictures from foreground to the background. Once you are aware of the overall sharp focus a wide-angle lens offers, you'll take advantage of it in many other shooting situations.

Photographers have a tendency, which I share, to shoot a spectacular scene quickly, and then to slow down and consider its other possibilities. Walk around to survey the subject from several viewpoints. You might find other strong camera angles that offer good perspective and enhance the way subjects in the foreground and background relate. When shot with a wide-angle lens, foreground subjects seem larger. When you step back and use a telephoto-lens setting, foreground and background subjects appear more equal in size. As the spirit moves you, shoot from several appealing viewpoints and select the best when you get the prints or slides back.

People tend to stand and shoot pictures from eye level, which is often suitable, but occasionally a higher or lower camera angle improves a scene. Try squatting or moving down a slope. You might also want to try placing your camera just close enough to the ground so that you can still see through the viewfinder. Note how this view adds a kind of exaggerated drama to some scenes. Another option is to climb to a higher place. Depending on the subject, shooting from unconventional spots helps produce better, more appealing pictures.

Although some photographers like to shoot passing scenes from a train or bus window, don't expect too much. Try to avoid reflections by placing the camera close to the glass or open the window. Be prepared for camera shake because you can't anticipate when the vehicle will hit a rough spot. If you are skilled at making instant decisions as you swiftly pass good picture possibilities, you might get some attractive shots—as well as many that are disappointing. If the subject is worth shooting and you don't expect to return to the spot, shoot some film and have faith.

You can include people in scenic shots one of two main ways. First, photograph those who are naturally in the scene to get an authentic look, outdoors or indoors. I like this journalistic approach because it adds to the visual interest of most scenics. Of course, the people should fit smoothly into the composition. The other way to include people in a scenic is to pose friends or family in the foreground and focus on them. If you can't avoid a background full of strangers, squat down to shoot so that your friends and family hide unwanted background subjects. To eliminate this problem, you might also try shooting from a greater distance with a telephoto lens in order to diminish depth of field. The middle distance may then go out of focus. To photograph friends and family and the scene behind them all in sharp focus without strangers at the edges or in the background, be patient and wait for others to shift or to walk out of the scene.

Other good reasons for including people in scenics exist. Without human interest, some scenic pictures seem empty. When a picture includes a person walking on a country road or climbing a rock in the middle distance, the photograph of the place can be more appealing. People also help to establish scale in photographs. A small figure at the top or bottom of a waterfall, for example, adds to the immensity of nature and to the graphic impact of your images.

When no one is around to add a human touch to a landscape and provide scale, place the camera on a tripod, a rock, or some other secure position; set the self-timer; and walk into the scene, either facing the camera or with your back to it. You can move 20 or 25 feet away in 10 seconds with a little effort. Count the average self-timer's 10-second delay in your mind to anticipate when the picture will be snapped.

For this shot of a Quechua Indian boy fishing in the Rio Napo of Ecuador's Amazon Basin, the photographer aimed his camera across the water with a 35-135mm lens set at about 90mm (top). Shooting in bright shade, he used an ISO 200 color-slide film and a skylight filter to prevent a bluish tint. Courtesy of Austin MacRae.

A 28mm or 35mm wide-angle lens in bright sun is capable of providing extensive depth of field, which means that everything from the foreground to the background is in sharp focus (bottom). This photograph of Venice, Italy, is both a scenic and a pattern picture, the kind of shot that traveling photographers enjoy finding.

SHOOTING CITYSCAPES

The pictures you shoot of cities are personal impressions and souvenirs. You can, of course, buy idealized postcard views, but these aren't the same as photographs made with your own eyes and camera. Wherever you go, whether familiar or remote, give your photographic memories an individual touch. And remember, cityscapes look more appealing during the early morning and late afternoon when the sun enhances color and shadow direction.

When you shoot down a street or head-on toward a row of homes or historic buildings, look for distinctive camera angles. If none are available, be satisfied with a viewpoint that is pictorial and interesting. Many parts of a city can dominate photographs, from fountains and mall activities to great cathedrals, main streets, office buildings, and public parks. Explore cities by walking and observing what you want to shoot. Change lens focal lengths if possible in order to include more or less of a subject. A wide-angle view can emphasize the foreground, whereas a telephoto lens can compress perspective in a graphic way. Be sure to shoot verticals as well as horizontals.

You can record memorable views and details, such as store windows or people on park benches, from numerous spots. Look for symbols and activities that help describe a place; these include traffic or signs on well-known streets, and people rushing by in clusters, paying no attention to you. And remember, you can get closer to subjects with telephoto focal lengths without getting in anyone's way. For example, a scene with an ice-cream vendor who is visible from the waist up might show a great deal of the neighborhood in the background, which you don't want to include. As you shoot, try to visualize what you want to see in prints, and when you have time, shoot several views in different directions if the subject warrants this type of treatment.

The edges of buildings tend to converge skyward as you get closer to them, especially with a wide-angle-lens setting. You might like this dramatic effect: it can make an ordinary subject look as if it towers over other parts of the scene. When you photograph a cathedral or a building with irregular sides, feel free to enhance the effect via your choice of camera lens and viewpoint. However, when you prefer having the edges of buildings parallel to the edges of the viewfinder, move back as far as possible and use your longest telephoto setting to minimize converging lines at the picture's edges. Ideally, you should shoot from an adjacent window in a convenient building at a level about halfway between the ground and the top of your subject. This may result in edge lines that are straight, like those you see in professional architectural photographs.

When faced with shooting from within a crowd that you can't see over, such as at the side of a parade, hold your camera above your head and aim it as accurately as possible at the subject. In situations like this, a wide-angle-lens setting is preferred. Include some of the foreground crowd to help frame the parade or whatever your specific subject is. When you lift your camera over your head to shoot, you risk getting tilted or poorly composed pictures. But you can crop these later, and they are better than none at all. Take several shots when possible, and hope the law of averages is in your favor.

While shooting in city streets, at an amusement park, or wherever there are crowds of people, try to be selective. This isn't always easy when the scene keeps changing. Wait for subjects to reach good positions. If this doesn't work, move to other spots for more orderly compositions. Zoom or change the lens to increase the possibilities. Photographs are more lively with people in city streets, in the main plaza of a town, in front of a church, or wherever a human figure can increase the appeal of a scene. Patiently look through the viewfinder, watch for fortuitous arrangements, and follow your instincts when you shoot. Quite often professional photographers capture exciting images this way.

SHOOTING INTERIORS

Taking pictures inside many cathedrals, churches, and historic buildings can be difficult. Either you aren't allowed to use flash or the interiors are so huge that flash from a P&S camera would be almost

The closer you are to a building when you shoot, the more its sides tilt inward on both edges of your photograph. You can correct this perspective distortion somewhat by shooting from a higher perspective opposite the midpoint of the structure. In other words, you must be in a building across the street when you shoot. Another way to minimize perspective tilt is to stand back and use the longest focal-length setting on your P&S camera. Here, I set the lens at 105mm and although the edges of the famous Santa Barbara, California, Mission tilt a little, the building looks relatively normal.

useless. The light level in most of these places is usually low, but with luck there will be windows along one or more walls to help illuminate the interior. In most cases, you must use a fast film, such as ISO 400, 1000, or 1600, if you hope to get any successful interior images of dark and cavernous places. Even with fast films, the camera chooses a slow shutter speed so you have to brace your camera against a wall or pillar to prevent camera shake. Use a tripod when possible for interior shots; the resulting images will be sharp and often beautiful. Keep in mind that even with a fast film, the average $f/3.5$ lens setting together with a shutter speed of 1/2 sec.

might not be able to produce enough exposure for useful pictures of relatively dark interiors. Unless the camera signals underexposure, shoot the scene and get ready for surprises.

If you have two P&S cameras, load one with very fast film when you anticipate photographing places with large, dark interiors. If you have only one P&S camera, load it with ISO 400, 1000, or 1600 film to shoot inside a cathedral, and if necessary, finish the roll shooting outside locations. Pictures made with faster films are often noticeably grainy, but the color is usually good outdoors. Carry a few rolls of fast film on a trip, and be prepared.

CAPTURING SCENIC DETAILS

Detail shots of scenic places you visit can be as small as a display of military miniatures and as big as two graceful gondolas parked in a canal in Venice, Italy. Details of a larger scene add variety to your image collection and may be beautiful and unusual enough to frame and hang.

You can find scenic details everywhere. They are pictorial sections of a larger scene, such as patterns of tile, thatched roofs, local people relaxing at a sidewalk cafe, reflections in a pond, a sculpture outside a museum, and signs. You might decide later to enlarge and frame these detail shots. Some other people might photograph a fabric display on a foreign street and move on, while you might stay to shoot details of the fabrics' colors and designs. Try to shoot

from different positions with more than one lens focal length in order to take advantage of some subjects.

Abstract designs are details that you can photograph as a personal project. For example, I've been shooting rock details and arrangements at many locations throughout the western United States for many years. I see the rocks as nature's sculptures, and they are a challenge in visual geometry for me. It is stimulating to find designs in nature or in man-made materials. Furthermore, detail shots are a nice change of pace from the more typical travel scenics.

The next time you are on a trip, develop a detail series of your own. Choose details that are large enough for you to shoot closeups of comfortably with your camera (see chapter 10). If you're driving through rural areas, parts of colorful or ancient barns might seem like an interesting project. Isolating all or part of a barn and concentrating on its color and textures is a way to photograph larger details. And these subjects don't require closeup capability. Keep in mind that for many detail pictures, you can compose more precisely on a tripod, and your pictures are apt to be sharper. When you enlarge a 35mm negative to make an 8x10 print, you'll appreciate the image's extra clarity and sharpness.

When you're traveling and shooting, you'll need a great deal of both physical energy and perseverance. But you'll undoubtedly feel satisfied as you concentrate on finding good pictures that other people overlook. After you aim your P&S camera at your subject, select a lens focal length, lock focus, and shoot, your visual senses will be focused, too. You'll get an emotional charge from taking pictures. Rewarding images are the result of being alert, and having a project adds to your photographic pleasure.

KEEPING RECORDS OF YOUR TRAVELS

If you've ever traveled through half a dozen states or several foreign countries during one vacation, you understand the value of keeping notes about what you photographed. A small bridge over one

river with a barge going under it can look very similar to a bridge over another river with two rowboats going by. Too many times, I've come back from vacation with plenty of pictures to edit but been unable to identify some of the places I shot. There are two ways to avoid this frustration. Both involve numbering your film rolls, starting with "#1." Then either make detailed notes in a pocket-size notebook about subjects you photograph at locations that might be difficult to recall, or record notes using a miniature tape recorder.

Each system refers to roll numbers you can mark on pieces of tape attached to film canisters earlier. In your notes, you can also use frame numbers to be more specific, such as "roll #1, frames 7-11 on the Salmon River, Idaho." Write or say as little as necessary to help with captions or to identify prints or slides. These notes will prevent you from spending a lot of time trying to guess which town is which.

I found a rich display of old license plates and signs at an art fair where rusting materials are part of the aesthetic scene. I composed vertically first, but cutting a little off the top and bottom created a horizontal image that I liked better. Shooting about 5 feet from the subject, I used the 38mm setting on my zoom lens and made a slight correction for parallax, just in case.

Stained-glass windows are often pictorial details worth shooting, but they can be difficult for the average P&S camera to expose properly. Despite this potential problem, you should shoot stained-glass windows that you like because your camera's autoexposure system is versatile. Furthermore, overexposure can be corrected easily when prints are made.

CHAPTER 9
SHOOTING ACTION

I set my P&S camera's 35-105mm at its telephoto setting in order to reach out to the go-cart drivers, which were quite a distance from my shooting position. For this picture, I used ISO 200 film and shot between 18 and 20 exposures to ensure that I recorded a good image of a situation I wasn't able to control. This often happens with action photography.

WHAT DIFFERENT SHUTTER SPEEDS DELIVER

It is breathtaking to watch the surf breaking on rocks, and it is very satisfying to capture the action on film. Breaking waves can be tricky to photograph, however, because you have to shoot perhaps half a second before the water will look most exciting. I made this picture with a fast shutter speed of 1/500 sec., which is available on many P&S cameras. While a shutter speed of 1/400 sec. would have done just as well, a slower shutter speed, such as 1/150 sec., would have produced a less sharp splash.

The following factors determine whether you can get sharp action pictures with your point-and-shoot (P&S) camera: the highest shutter speed of the camera, the direction and speed of the subject, the brightness of the light, your timimg, and your ability to anticipate *peak action*. Not all action subjects move at the same speed, and many that move slowly don't call for high shutter speeds. Fast action does require using faster shutter speeds, but one camera's "fast" speed may be another camera's "medium-fast" speed. If you aren't certain of the top speed of your P&S camera, you should look it up in the instruction booklet. When you get to know your camera, you'll be prepared to do your best when photographing either a child having lunch or a football game. Here is what you can expect from typical shutter speeds:

1/100 and 1/125 sec. These are the lowest maximum shutter speeds found on P&S cameras. They aren't adequate for such fast action as tennis or touch football, but they are suitable for the moderate motion of people walking and talking. Unless you expect to shoot such subjects as sports and pets with flash, which does stop action, I suggest that you look for a camera with maximum shutter speeds in the next range; you are likely to be disappointed by too many blurred pictures using a P&S with top speeds of 1/100 or 1/125 sec. A top speed of 1/170 or 1/180 sec. is only slightly better for action. Some inexpensive cameras, particularly those with fixed-focus systems, are limited to one shutter speed, such as 1/100 sec., and one lens opening.

1/250 and 1/300 sec. These fast speeds are adequate for such moving subjects as children playing but not running very fast past the camera, musicians playing, slow auto traffic, swimming, and some sports. Using ISO 200 film on a bright overcast day, I photographed a tennis game with a P&S camera set at 1/250 sec., and the players were mostly blurred. I assume the camera set its fastest shutter speed, but I can't be sure. I was also disappointed trying to photograph monkeys fairly fast at play at

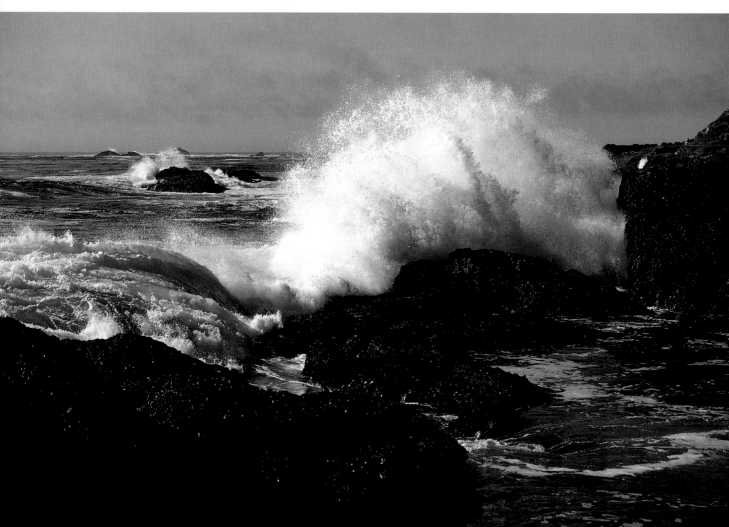

the zoo. They weren't sharp enough for satisfactory prints. Using a camera with its fastest speed in this range prevents some successful action photography, but for general usage, a shutter speed of 1/250 sec. can be adequate.

1/400 and 1/500 sec. If you expect to shoot football, tennis, baseball, and other sporting events, you need a P&S camera in this shutter-speed range (or in the next one). Shutter speeds of 1/400 and 1/500 sec. are more practical, and if I'd photographed that tennis game at 1/500 sec., I probably would have been pleased with many of the action shots. The direction of movement influences sharpness at this or any speed (see below), but 1/500 sec. is fast enough for many sports activities. You'll discover more about this through experimentation.

1/600, 1/730, and 1/1000 sec. The first two fractions of a second sound a bit odd, but they were taken from a comprehensive chart of P&S camera specifications published in the May 1993 issue of *Popular Photography*. These three speeds are adequate for shots of people diving into a pool, touch football and other sports, and scampering pets and children. Higher shutter speeds are necessary to ensure sharpness when action is fairly fast. These speeds are found in P&S cameras that range in price from about $200 to more than $300, although cost and maximum shutter speed don't always correspond. Ask for shutter-speed data, and make comparisons while shopping for your new P&S camera.

Keep in mind that the choice of P&S cameras remains wide. I can't anticipate what shutter speeds future P&S cameras have in store for you or how much they'll cost. I urge you, however, to choose a camera with a maximum speed that matches the kind of action you want to shoot (see chapter 13).

Depending on the type of action involved, most sports are shot at shutter speeds of 1/500 and 1/1000 sec. If the game is played inside, you might want to use ISO 400 film in order to make even faster shutter speeds possible. In order to capture this peak action at a football game, the photographer positioned his camera fairly low and fully extended his zoom lens to get as large an image as possible from his viewpoint. The crowd seen in the background is out of focus, so the football action is more prominent. Courtesy of Lewis Portnoy.

THE ANGLE OF ACTION

I made this photograph of a young woman in St. Mark's Plaza in Venice, Italy, where thousands of pigeons entertain the tourists. The birds fly fast and veer off in different directions, so I was lucky to catch one in midair. To capture this peak moment in the plaza, I stood directly in front of the subject and used ISO 100 film in a P&S camera with a top shutter speed of 1/250 sec.

In addition to the shutter speed, the direction a subject is moving in influences whether or not you'll be able to get sharp pictures of it. Action passing horizontally in front of you, such as a car or a cyclist, crosses a frame of film more quickly than an object or person moving at an angle toward you or away from you. Moving subjects coming directly at you or moving directly away from you change position least on film during an exposure that lasts a fraction of a second and make it easier for you to stop or freeze their action sharply.

The following observations apply to pictures taken in sunlight, at a distance of 10 feet or more. The brighter the light, the more likely it is that your P&S camera will be set at its fastest shutter speed. Most action moving across the scene you photograph will be sharp only with a shutter speed of 1/500 sec. or higher. Since the camera doesn't indicate what speed it chooses, one way to be certain it sets its fastest speed is to use a fast film, such as ISO 400. Higher film speeds force the exposure system to choose faster shutter speeds and small lens openings. Not only are moving subjects more likely to be sharp, but such small f-stops as f/16 provide some insurance if you fail to set focus exactly. This is because smaller apertures produce greater depth of field to compensate for some focusing errors.

Average-speed subjects, such as a child riding a bicycle, moving diagonally toward or away from you, should be sharp when the camera uses shutter speeds between 1/250 and 1/500 sec. Subjects moving directly toward or away from you should be sharp at a shutter speed of, for example, 1/250 sec. The closer the action, the greater the span it covers on film in a fraction of a second, and the faster the shutter speed must be for sharp pictures.

There is another technique for capturing action: *panning* the camera in sync with the action. Here, you pivot yourself and the camera at the same speed as the passing subject, which is roughly centered in the viewfinder. In this way, you keep pace with the movement. It is possible to keep the main subject sharp even at 1/125 sec., although the background will be somewhat blurred. Start your panning motion a second or two before the subject arrives at the spot where you plan to make the exposure. The camera should automatically focus on the centered subject. Snap the picture when the subject is approximately opposite you. After shooting, follow through, or maintain the rotation, for smoother movement. If you play golf or tennis, you know the value of following through on a drive or serve. The same principle applies to panning with your P&S camera.

Be sure to shoot some action-stopping tests on a bright day with a film of your choice. Photograph someone running or biking, and ask your model to run or ride across the scene, diagonally through it, and directly toward you at least twice. Your timing may be better in one picture than another. Hold the camera steady for each directional movement. As part of the test, practice panning pictures with the subject crossing perpendicular to the camera. Foliage provides an appealing background for these shots because it blurs decoratively. Another way to photograph action is with slow shutter speeds to create intentional blur (see chapter 12).

Remember: many cameras permit you to set the focus for a picture by depressing the shutter-release button halfway and holding it there while you recompose the image. It is important when following a moving subject not to press the shutter-release button too soon as you track the action. Rely on your P&S camera's autofocus system to sharply focus, set exposure, and shoot instantaneously when you snap the picture. If you sense a delay of a fraction of a second during these operations before the shutter snaps, try to anticipate the action the next time and expose a fraction of a second sooner to compensate.

CATCHING PEAK ACTION

Experience teaches you how to predict the moment of peak action and exactly when to press the shutter-release button. Some P&S cameras hesitate a fraction of a second when focusing in dark locations before taking the picture. Experiment to see if your camera does this, so you can anticipate peak action a moment sooner and compensate. A Fuji company photographer made this nighttime shot of a horse race with Fuji 1600 print film and flash at precisely the right moment. A very fast film gives your P&S camera's flash a longer range, thereby making pictures like this one possible.

During sporting events, action reaches a peak at the split second a particular motion is at its apex; then an opposite motion begins. For example, when someone leaps into the air, the action peaks when the person is at the top of the leap. When you successfully shoot peak action, you capture a decisive moment and you're assured of a reasonably sharp image. Using a shutter speed of 1/250 sec. or faster, you can expect to freeze the moment when the ball leaves the pitcher's hand or when a child briefly stops running, turns, and starts off in the other direction.

Eventually, your P&S photographic experience will train you to anticipate peak moments for the most effective exposures. Many P&S cameras are capable of taking one picture after another less than a second apart. If your camera has this capacity, you should learn to begin shooting a short series of images a moment before the action peaks in order to ensure getting at least one

good storytelling picture, and perhaps even recording a sequence of strong shots.

Skilled anticipation enables you to shoot peak action with relatively slow shutter speeds, such as 1/60 sec., and get sharp prints if your timing is well refined. For example, I've mounted my P&S camera on a tripod in order to make portraits of people talking in a room that was rather dimly illuminated. I didn't want to interrupt the flow of conversation with flash, so I hoped the camera would choose a shutter speed of at least 1/125 sec. By waiting for facial expressions that naturally occur at momentary pauses between sentences, I was able to shoot some acceptably sharp pictures, though numerous prints were blurred. If you try this, be sure to shoot plenty of film for two reasons. First, subjects won't be sharp when your timing is off, and compelling action scenes appear unexpectedly. You may follow a game or activity and shoot more

film if you miss something, but it is important to stay alert in order to capture action when it happens. Remember to change your camera viewpoint as often as necessary to follow the flow. In action photography, you can expect to miss some pictures in order to get a few successful shots.

Another kind of peak action occurs the instant when something meaningful happens to tell a story explicitly. Examples of this type of peak action take place the moment when someone opens a present and looks genuinely surprised, and when someone glances at a loved one adoringly. Being ready to capture a storytelling moment is even more challenging than shooting peak action during a sports event because you can't always anticipate when it will happen. Narrative action can be photographed at 1/125 sec. or faster. Your sense of timing is absolutely critical in these shooting situations.

SHOOTING ACTION SEQUENCES

Sequential pictures taken a few seconds apart can tell a story with a special kind of impact. Since many P&S cameras include motorized film wind to do this, it is possible to shoot a series of pictures, perhaps only a second or so apart, in a kind of cinematic way. For example, suppose you're photographing a child's birthday party in a well-lighted area. Obviously, you don't need flash, which slows down the sequence process. As the birthday boy opens a present, photograph him tearing the wrapping, opening the box, and taking out the gift. This sequence might take only 10 seconds. Additional shots might show the child putting on sunglasses or a cap, or running a toy across a table or floor. Later on, grouping these pictures in an album or slide show can make them more gratifying than a single strong shot of the occasion.

USING FLASH

Flash itself freezes action in dark settings when the subject is close enough without regard to shutter speed. As a result, it is feasible to use flash for many pictures of moving people and other subjects, even if the maximum shutter speed of a camera is relatively low. You might get faint double images when you use fill-flash to brighten a subject in daylight, but this isn't usually annoying and can even be interesting.

Here, the photographer was able to shoot this car coming toward him using ISO 100 film and a shutter speed of 1/500 sec. He zoomed his lens to about 50mm and set the camera for continuous mode, which enables you to make sequential pictures at one-second intervals. Courtesy of Jim Carr.

CLOSEUP PHOTOGRAPHY

At the Mirage Hotel in Las Vegas, you can watch Atlantic bottlenose dolphins swim in huge tanks. I used ISO 200 film, which enabled my P&S camera to set a fast enough shutter speed for the underwater sunlight. I held my camera flush against the large viewing window and was grateful that the camera focused automatically and accurately.

CLOSEUP MODES

The photographer came upon this marine iguana perched on lava rocks in the Galapagos Islands during a trip to Ecuador. Slowly, he moved in close, hoping not to scare the creature away, and stopped at a distance of about 3 feet; he used the 105mm setting on his zoom lens to get this closeup. Luckily, the sound of the film being wound in the camera was drowned out by the sound of the sea behind the iguana, so he was able to shoot three good frames before it disappeared among the rocks. Courtesy of Austin MacRae.

Many point-and-shoot (P&S) cameras make it possible for you to shoot fairly close to subjects, and some include what is known as a *closeup*, or *macro*, *mode*. In photographic terms, this means focusing the lens close enough to a subject to feature only part of it, as well as to show it in a larger-than-usual image. Typical subjects for closeups are clusters of flowers and small sculptures. You should become familiar with the *close-focusing limit* of your camera by reading the instruction booklet; this number is an important reference.

Close-focusing distances for P&S cameras vary considerably. As shown on *Popular Photography* magazine's 1993 chart listing 58 P&S camera models, these distances range from 13 to 39 inches, with an average minimum distance of about 26 inches. With a simple fixed-focus P&S model, your limit is usually 4 feet from a subject, although a few single-lens cameras focus as close as 13 inches. Close-focusing for dual-lens models averages 28 inches. Focusing limits for zoom-lens cameras in the macro mode (and super-macro mode—see page 115) vary. For example, two expensive zoom models focus to 30 inches; another, to 24 inches; and still another comparably priced model, to 18 inches. These distances are relative because a 90mm lens positioned 30 inches from a subject enlarges a subject much more than a 35mm lens at the same distance does.

Closeup or macro autofocus capability permits you to shoot details of such subjects as paintings, rocks, and faces. Close-focusing can be tricky. Some cameras have an LED adjacent to the viewfinder that indicates the lens is sharply focused on whatever the autofocus mark covers. Other cameras use a blinking light to indicate that you are too close to a subject, and in a few models the shutter-release button locks and won't let you shoot until you back away slightly. Being aware of the indicators on your camera helps ensure getting sharp closeup pictures. I neglected to notice a green LED blinking on my P&S camera, and my first closeup pictures were sadly out of focus. Practice focusing carefully so you can do it automatically with ease.

Some sophisticated cameras offer a specific close-focus setting called a *super-macro mode*. Usually, a button or switch activates this mode, which in some P&S cameras deactivates the autofocus system. This means you must measure the precise focusing distance when you shoot or risk out-of-focus pictures. Cameras with a super-macro mode have a measuring device built into the camera strap to adjust the proper lens-to-subject distance. In the super-macro mode, the flash may fire for each picture, whether you want it or not. This is the camera's way of guaranteeing sharp pictures in case the existing light isn't suitable. Check the instruction booklet to find out if your camera has an autoflash feature for shooting extreme closeups. In most models, the closest flash distance is usually the same as the closest focusing distance; the exceptions are super-macro focusing distances.

Depth of field may only be a few inches when you are very close to something. To help you shoot successfully, position the focus mark in the viewfinder on the center area of the subject. If, for example, you're shooting flowers, that spot and petals farther away will be sharp, while petals closer to the camera might be out of focus. This is because sharp focus behind the point of focus is greater that in front of it. The following suggestions can help you take better closeup pictures.

Shoot in sunlight or bright shade, and use an ISO 200 or 400 film. The brighter the light and the faster the film, the smaller the *f*-stop the camera exposure system sets. A small *f*-stop, such as *f*/22, produces greater depth of field, which is an advantage in closeup pictures. If you back away slightly from the subject to increase depth of field, you can plan to enlarge only a portion of the negative.

ACHIEVING SHARPNESS

It is possible to shoot good closeups with a handheld P&S camera in bright light because a P&S camera's exposure system sets a fairly fast shutter speed. This, in turn, helps prevent camera shake. Remember that blur due to camera movement or soft

focus is magnified in closeups along with the subject. Faster films, such as ISO 200, 400, and 1000, require the camera to set faster shutter speeds, as well as smaller apertures, both of which make depth of field more extensive. Practice holding your camera steady as you photograph flowers or whatever small objects appeal to you. You'll undoubtedly be pleased with the final results.

However, if you plan to shoot closeups often enough, you should invest in a lightweight tripod. Discount stores often sell well-made models that can be greatly improved with the addition of a ball head, which enables you to quickly position your camera horizontally or vertically, and anywhere in between. The camera is mounted on the head, which pivots on the ball in the socket. You secure the ball in the position you've chosen via a locking knob. You can adjust a ball head more easily than you can a regular tripod head, and you don't have to level the legs in order to compose precisely. (Ball heads are available at camera stores and through photography-equipment catalogs.) Keep in mind, too, that the closer you focus to a subject, the steadier your camera support must be in order for you to achieve precise composition and sharpness.

It is hard to resist a colorful display at an outdoor fruit-and-vegetable stand. To shoot this closeup of bright yellow peppers sparkling in the sun, I zoomed the lens slightly for several different views to be sure that the final image would show the exact composition I wanted.

USING LIGHT TO YOUR ADVANTAGE

The light was bright enough behind this remarkable peacock display to add luminescence to its colorful feathers. As this image shows, backlighting is often dramatic. Courtesy of Kristal Kimp.

Other aids to producing good closeup pictures are sidelighting and a combination of side- and backlighting. Fairly low sidelighting brings out texture and form very effectively, and although you might not be trying to record the finely textured surface of a slice of bread, the enlarged textures of many natural and man-made subjects create worthwhile decorative closeup patterns in your images. If the light is soft, such as on a bright cloudy day, you'll need to focus carefully, try to get some tonal contrast in the picture, and choose a subject with a texture that is large enough to show up in a print.

For better lighting, move the closeup subject itself or move the camera around the subject to photograph it in the most advantageous light. Side- and backlighting help create shadow areas that are usually necessary for contrast. Try to shoot light-colored subjects against a dark-toned background and vice versa to increase visual interest. When you set up a still life for your own satisfaction, a light-against-dark scheme results in pleasing contrast and stronger pictures. If the background is distracting, you can minimize it by focusing near the front of the subject; this will throw the background out of focus.

Parallax correction is the trickiest aspect of P&S closeup photography. The problem is that what you see in the viewfinder isn't exactly what the lens sees. The short distance between the lens and the viewfinder causes these parallax difficulties. So when you're photographing people from a close distance, such as 2 to 4 feet, and don't attempt to correct parallax, you might crop the top or side of someone's head, depending on the camera and the lens' focal length. Use the parallax-correction lines in the viewfinder to form an alternate set of frame guides for closeup work and compensate for the fact that the viewfinder can't precisely duplicate the view of close images as the lens sees them.

Proper use of parallax-correction lines requires both patience and practice. Here are some helpful guidelines to deal with parallax. Try to consistently center your eye in the viewfinder for more accurate pictures at any time, and especially for closeup pictures. Centering your eye enables you to position the viewfinder and its parallax-correction marks more accurately. As a result, you'll get fewer cropped heads in your images.

Practice using the parallax-correction marks while shooting a subject that is a few feet away by repositioning the camera or zoom lens several times. Use a tripod if possible. As you focus closer, make a sketch to show where you placed the parallax-correction lines in relation to the subject for future reference. Measure the distance from the front of your lens to the middle of the subject, and jot that down, too. By keeping data from your notes on the backs of prints, you'll soon have a record of valuable experimentation. When you don't frame the subject precisely, whether you're shooting in the horizontal or vertical format, your notes will help you make more accurate adjustments the next time you shoot. Careful closeup tests are necessary to help you observe and remember the relationship of what you see in the viewfinder to the final image.

CLOSEUP FOCUSING

After you shift the viewfinder to use the parallax-correction lines, the autofocus mark might not cover the part of the subject you want in sharp focus. To correct this, set the focus mark where you want it using the full viewfinder. Lock focus by holding down the shutter-release button halfway, and adjust the composition within the parallax-correction lines. Throughout this process, maintain pressure on the shutter-release button. The viewfinder is now tipped and the autofocus mark is off-center, but the focus remains in the area where you set it for the shot. Although this procedure can be a bit of a nuisance, the pictures this technique enables you to take can be worth the patience and effort.

Don't be put off by the parallax ogre. Closeup capability is built into your P&S camera. Furthermore, you can learn to use it well and eventually become comfortable with the process.

How much parallax correction is necessary depends on the focal length of the lens in use, the camera-to-subject distance, and the camera design. Some cameras handle parallax better than others, so you must experiment to discover how well your camera does. For this handheld shot taken about 3 feet from the water lilies, I observed the parallax lines in the viewfinder and left enough room around the edges of the flowers so that I could crop the print if necessary.

NIGHT PHOTOGRAPHY AND LONG EXPOSURES

I made this shot of the moon, which hadn't set yet, before sunrise in Palm Springs, California. With my P&S camera mounted on a tripod and my zoom lens set at 105mm, I exposed ISO 200 film at the slowest shutter speeds the camera offers, 1 second and 2 seconds. Although I shot several variations that included more or less of the tree, I prefer this particular composition.

SHOOTING AT NIGHT

You may remember how impressed you were with the results when you first took pictures after dark without flash. I made my first night shots, which were of a snowy street, with a 1950s vintage camera on a borrowed tripod. A couple of friends volunteered to be chilled while standing under a street light and casting shadows in the snow. I made a series of different exposures because my handheld exposure meter wasn't very accurate, and there were

City lights at night usually make beautiful impressions on film, which is a good reason to buy a P&S camera with shutter speeds as slow as 1 or 2 seconds For this shot of cars in Reno, Nevada, that were either parked or stuck in traffic, I mounted my camera on a tripod and used the 35mm wide-angle setting on my zoom lens. Shooting ISO 400 film, I exposed for about 1/2 sec.

no built-in camera meters in those days. Later, I was amazed to see more detail in my black-and-white prints than was apparent at the scene. The reason is that while our eyes have a sensitivity limit, film collects light during even a few seconds of exposure. Longer time exposures amplify shadow detail, although highlights might be overexposed and the tones somewhat corrected when color prints are made.

CREATIVE EFFECTS

Technically speaking, night photography begins at dusk and continues until just before dawn. Time exposures, which are 1 second or longer, can produce exciting effects after dark or in deep twilight when shadows are somewhat brighter.

Serendipity adds to your photographic success because you can't be sure of how a night scene will register on film. This is especially true when you photograph dimly illuminated areas; people, who show up as blurs; and headlights and taillights on a moving vehicle, which produce decorative streaks in images.

Perhaps you are familiar with a famous photograph of Pablo Picasso "painting" a pattern in the air with a lighted wand, which was shot in the dark. At the end of his motions, a flash showed the artist behind the lines of light he created. If your camera has a "B," or bulb, mode, you can try to produce the same effect in a dark location with the help of a friend holding a small flashlight. Even when the camera's flash pops first to illuminate the "painter," the lines of light will still appear against a darkened background after an exposure of a few seconds duration.

Not all P&S cameras are designed to make time or bulb exposures, but those that are have slow shutter speeds of 1 or 2 seconds or longer. Several more complex models offer exposures up to 6 seconds for one model and 60 seconds for another. However, you have to either guess the exposure time needed for the scene or use a handheld meter, which is tricky because you don't know the f-stop in use.

SHOOTING COLORED LIGHTS

Photographing colored lights at night or in dark areas can produce special pictorial effects worth exploring. If you aren't sure whether your P&S camera can make such pictures successfully, do some testing. First, find scenes, displays, or fountains that are brightly illuminated. Then using a fast film, such as ISO 400, 1000, or 1600, shoot handheld as well as with your camera on a tripod to guarantee sharpness. As you look for subjects, keep in mind that city lights reflected in wet streets after a rain can result in very effective images. Choose a location you can reach easily, and plan to shoot colored lights just after the next rainstorm ends. You might also try shooting colored lights at such places as Epcot Center in Orlando, Florida, or inside the tunnel between the United Airlines terminals at O'Hare Airport in Chicago.

You might get pleasing pictures with a fast film, even if your camera's slowest shutter speed is only 1/2 sec.

You need exposures of only 1 or 2 seconds to shoot brightly illuminated city streets at night when you use fast films, which have film-speed ratings of 400, 1000, 1600, or 3200. The reason is simple. For example, in such places as Times Square in New York City and downtown Las Vegas, bright lights are concentrated in groups, and even 1/2 sec. exposures might work. Outdoor cafes, statues, Christmas displays, and illuminated buildings are often bright enough for you to shoot pictures without flash. If your camera's slowest shutter speed is less than 1 second, try making some after-dark exposures using an ISO 1000, 1600, or 3200 film.

With one of these fast color-negative films and a slow shutter speed, you should get appealing night pictures. If, however, your prints turn out grayish or muddy, the film was underexposed. What you need to do at this point is to shoot the same or similar scenes again, using an even faster film. Whatever your camera's slowest shutter speed, you won't know exactly how to handle night shots until you try. For all dusk and night shooting, you must use a tripod in order to get excellent and surprising images when shutter speeds of 1/2 sec. or slower are required. Experiment to find out what you and your camera can accomplish off after sundown.

In addition to street lights, colorful neon signs, and brightly illuminated office buildings, the amusement section of a county fair or carnival offers a rainbow of slow-exposure picture opportunities at night. Think of the colorful lights of the ferris wheel and the other even more dizzying rides. Select a fast film, set up your camera and tripod, compose the image, and let the camera determine the exposure. You have to imagine how banks of moving lights will make patterns during 1 or 2 second exposures, so compose your pictures accordingly. This becomes easier as you practice and gain experience. Remember to turn off the automatic-flash feature unless you want to include people in the foreground. Of course, you might want to try shooting the scene both with and without flash because a dark foreground can be dramatic.

Fireworks can also look exciting and beautiful in 1 second or longer exposures.

A tripod is essential for these night shots, too. Aim the camera where you expect the next explosion to appear in the sky, and press the shutter-release button the moment it happens. The sparks of light that arc and fall while the shutter is open become curved patterns in your pictures. The exposure system usually chooses the widest lens opening for night shots, but no P&S instruction book I've ever seen mentions this. If your camera enables you to take multiple exposures, shoot two fireworks patterns on one frame of film for added visual interest. Try to limit the overlap of the brightest areas to avoid patterns that blend confusingly.

To ensure that your camera will expose colored lights at night, choose a relatively fast film; it makes the slower shutter speeds of your camera more effective. For this shot of colored fountains, I handheld my camera steadily at a shutter speed of about 1/30 sec. on ISO 200 film.

BULB EXPOSURES

Because film collects light, you might see more detail in pictures made with the camera shutter remaining open for a few seconds than you can see with your naked eye. Bright white overexposures in this county-fair scene occur in places where too much light collected; the camera exposed for the darker subjects. You can't fully predict what time exposures at night will look like, but the surprises are worth any failures that result.

Some P&S cameras enable you to make exposures of 2 seconds or longer, which are automatically timed by the camera system. Some cameras also include a bulb setting that permits time exposures of 60 seconds or longer. Here, the shutter stays open as long as the shutter-release button is depressed, up to the camera's limit. Subjects that readily lend themselves to time and bulb exposures include auto traffic; city skylines; street scenes; interiors of buildings, such as museums and cathedrals, all in very dim light. If you photograph a waterfall or moving stream in dim light for a second or longer, the water looks like strands of fine hair blended together. While effectively blurred moving water may seem simple enough to record on film, you need

exposure should be, you might benefit from using an exposure calculator. This lists many shooting situations, such as sunsets, city streets, city skylines, and moonlit landscapes, and recommends exposures for different films. If you don't use this type of calculator, practice and experience can teach you how to estimate exposure intervals. Be sure to keep notes about test exposure times, and jot them down on the backs of your prints for future reference. Fortunately, color-print films adapt well to exposure aberrations.

CONTROLLING DEPTH OF FIELD

Your camera instruction booklet might not make it clear that during bulb exposures, the lens is set to its widest aperture. So you have to vary the lens' focal length in order to control the aperture. The longer the lens' focal length (and the closer it gets to its maximum telephoto setting), the smaller the lens' maximum f-stop. At a wide-angle setting, the largest lens opening may be $f/3.5$ or $f/4$. At the longest telephoto setting, the maximum f-stop is reduced to $f/6.3$, $f/9$, or $f/10$, depending on the lens and camera brand. Whether you're guessing the proper exposure or using an exposure calculator or a separate exposure meter, you must estimate f-stops set by the lens from its wide-angle to telephoto settings. For example, you have a 38-90mm lens that you know is $f/3.5$ at 38mm and $f/6.7$ at

to shoot in a low light level, use a very slow film, and set a zoom lens at its longest focal length and maximum f-stop. To ensure success, you should vary the exposure times and focal lengths.

With a P&S camera, you have to guess how long to set the bulb interval because this isn't automatic. Time the exposure using a watch or by counting seconds. When you have enough experience and have a sense of what a proper bulb

90mm. At a focal length of 60mm, the maximum aperture would be about $f/5$. If focal lengths aren't marked on your lens, you'll have to guess them as well. Clearly, satisfactory bulb exposures come about via trial and error and the flexibility of color-negative prints and films.

BULB-SYNC MODE

Here, flash is added to the bulb mode. In these exposures, the main subject in the

foreground is illuminated by flash and the background is exposed by available light. To use the *bulb-sync mode*, mount your camera on a tripod and focus, for example, on a person standing on a street at night where there are lights in the background. Ask the person to stand fairly still in order to avoid blurred ghost images that show subject movement. When you press the shutter-release button, the flash illuminates the person who is, perhaps, 10 feet away, and the shutter stays open for a timed exposure, such as 1 second, depending on your P&S camera. This is a creative and efficient way to shoot people pictures using a combination of flash and time exposures. For bulb-sync pictures when a subject is within 6 or 8 feet of the lens, you'll find that an ISO 100 or 200 film is preferable to an ISO 400 or 1000 film; slower films prevent flash overexposure.

INTENTIONAL BLUR

At night or at dusk, moving people and objects that are illuminated well enough will blur pleasantly at slow shutter speeds, such as 1 second In most such situations, sharp lights and stationary subjects contrast nicely with blurred moving subjects. Find a good vantage point in, perhaps, an indoor mall, mount your camera on a tripod, and shoot a series of pictures without flash. To be sure the camera sets a slow shutter speed, use a slow-speed print film, such as ISO 100 film. Use the bulb mode if your camera has one, and hold the shutter-release button down for several seconds. Experiment with different exposure times, and keep some notes for future reference. The longer the exposure, the more blurred the images will be. Keep in mind, though, that when excessively blurred, some subjects become unrecognizable.

This chart offers approximate exposure times for various subjects, some of which may be possible to shoot with your P&S camera. The *f*-stops shown here are for *f*/3.5 and *f*/5.6 lens openings. For an *f*/4 lens opening, simply use the *f*/3.5 recommendation and make several exposures to ensure one that is correct. For a zoom lens, which might have a maximum lens opening of *f*/8, double the time shown for *f*/5.6. For example, if the *f*/5.6 time shown is 2 seconds, shoot at 4 seconds. If your camera has limited slow shutter speeds, compensate by using a versatile

EXPOSURE TIMES		
SUBJECT	FILM SPEED	
	ISO 100	ISO 200
Distant cityscapes	8 seconds, *f*/3.5	4 seconds, *f*/3.5
	20 seconds, *f*/5.6	10 seconds, *f*/5.6
Skyline at dusk	6 seconds, *f*/3.5	3 seconds, *f*/3.5
	15 seconds, *f*/5.6	8 seconds, *f*/5.6
Amusement-park rides	1/2 sec., *f*/3.5	1/4 sec., *f*/3.5
Fireworks	2 seconds, *f*/5.6	1 second, *f*/5.6
	2 seconds, *f*/3.5	1 second, *f*/3.5
	4 seconds, *f*/5.6	2 seconds, *f*/5.6

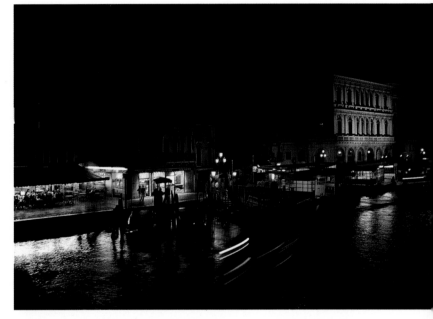

fast film, such as Ektar 1000. Then divide the exposure time for an ISO 100 film by 3.5. Thus, 8 seconds becomes about 2 seconds, and 15 seconds becomes 4 seconds. Automatic or manually timed exposures made in dim light or at night with a versatile P&S camera can be beautiful when you use medium-speed films. But fast films offer you more opportunities. For example, Kodak Ektar 1000 and Fuji Super HG 1600 have good color and image quality despite their slightly more noticeable grain. Fast films can give your P&S camera the capability for night photography. But no matter what kind of P&S camera you use, you should check its slow shutter speeds, as well as what else its instruction booklet tells you about which options you can enjoy after dusk and at night.

Venice seems mysterious at night when you can't tell where the sidewalk ends and the canal begins. For this shot, made with a P&S camera from a nearby bridge, I held the shutter open on bulb for what I estimated was 1/2 sec., 1 second, and about 2 seconds. Because the camera didn't make automatic time exposures, I had to use the bulb setting with the lens wide open to ensure a variety of exposures.

CHAPTER 12

SPECIAL TECHNIQUES AND CAMERA FUNCTIONS

This colorful picture of arched interior lights was shot from a moving cart during an amusement ride at Florida's Epcot Center. The photographer was surprised, but pleased, that the picture wasn't blurred. The ISO 400 film she used helped to produce a sharp image. Courtesy of Kathleen Jaeger.

ZOOMING DURING EXPOSURE

This sophisticated feature is a favorite of mine, but it is tricky. Like other special-effects camera functions, it challenges your creativity; however, it also adds to your point-and-shoot (P&S) opportunities. If your P&S camera has a zoom lens and a shutter speed of 1 or 2 seconds or longer, you can zoom the lens during the exposure. Shoot at night because bright lights are the best subjects: they blur beautifully against a dark or black background. Depending on subject brightness, the camera's autoexposure system is more likely to set the shutter at 1 or 2 seconds with an ISO 50 or 100 film. Nevertheless, you need to experiment because you can't be sure. Faster films might not require the camera to use a slow shutter speed, which is best for zoom-blur effects.

If your zoom-during-exposure shots aren't successful because the shutter speed that the camera set was too fast—or before taking that chance—try the following technique. Before shooting, aim the camera at a nearby dark area, hold down the shutter-release button halfway, and then turn and shoot the lights you want while zooming. The specifications listed in your camera's instruction booklet should show its shutter-speed range. If the slowest speed isn't 1 second or longer, zooming during exposure might not work; still, see if you can create any sort of decorative patterns on film. Here are some zooming tips:

Time Exposures. Several sophisticated P&S cameras on the market permit exposures from 15 to 60 seconds long, but with at least two of them, exposures longer than 1/4 sec. aren't automatically timed by the camera. With these bulb exposures, you have to guess what the proper exposure should be. If your camera has a bulb (or night) mode, read the corresponding instructions carefully in order to determine which exposures are set automatically and which are set manually.

To shoot time exposures with a zoom lens or intentionally blurred exposures (see below), set a shutter-open bulb exposure for 2 seconds or longer, and experiment. Keep in mind that in the bulb or night mode, the lens is always wide open, and the camera's autoexposure system doesn't set the aperture. In order to stop down the lens and prevent overexposure, zoom the lens toward its maximum focal length where the maximum f-stop is smaller than it is at the wide-angle setting. Start at 2 seconds with ISO 100 film, and begin zooming the lens at the telephoto setting where the f-stop is smallest. Follow this by 2 or 3 second exposures at longer focal lengths, in small increments. If you keep notes of the zoom settings, you'll be able to duplicate your best results. If you use ISO 200 film, try these experiments because color-print film has a very wide latitude.

Select an appropriate subject, such as a bright movie-theater marquee, and begin zooming the lens slowly just before you depress the shutter-release button. Try to limit the zooming speed to last only as long as the shutter speed you or the camera sets.

Practice zooming for the full time for best results. Whether you zoom the lens from close to far or vice versa doesn't matter to the design of the image, but it can influence exposure. When you photograph lights in either zoom direction, you'll get a series of sharp, blended, and overlapping lines or mysterious blurs that can be quite fascinating. Wiggling the camera slightly adds to the effect. If you get consistent ovexposure, begin zooming with the telephoto-lens setting.

Keep in mind that there is no way to accurately anticipate how your pictures will look when you zoom during exposure. Experience offers an approximate idea of what to expect, but the design and shape of the subject matter, the shutter speed, the speed and direction of the zoom, the amount of intentional camera movement you add, and serendipity all work together for successful images. Endless abstract designs are possible.

If your camera's slowest speed is 1/2 or even 1/3 sec., try zooming quickly during the exposure. Begin to zoom slowly before pressing the shutter-release button, then continue the zoom to its end because you can't be certain exactly when the shutter opens and closes. However, the effects you get might not be worthwhile because the shutter isn't open long enough. As a substitute, try moving the camera as you shoot (see page 130).

Automatic Portrait-Zoom Mode. Some P&S cameras offer an *automatic portrait-zoom mode*, which maintains a constant size of the subject within the frame even though the distance from the camera to the subject may vary. In this mode, when you choose a head-and-shoulders view of someone with the zoom lens set at, for example, 50mm and then move closer or farther away, the zoom automatically retains the same size image of the subject. You may also change the composition by manually zooming the lens while in this mode. I prefer to do my own compositions with a zoom lens, and I've only experimented with this mode in order to see how it works. However, some photographers may find automatic portrait zooming to be a welcome aid for shooting people pictures.

Zooming a lens during exposure is a visual adventure worth trying if your camera has slow shutter speeds, such as 1 or 2 seconds, or a bulb exposure mode. Use a slow film with an ISO speed rating of 25, so the camera's autoexposure system doesn't complete the exposure before you complete the zoom motion. If you use a faster film, turn off the flash, aim the camera at a dark area, hold down the shutter-release button halfway, and then aim at your subject. At the moment you shoot, begin zooming the lens and try to complete the motion from the shortest to the longest focal length, or vice versa, within a second or two. This is the strategy I used to shoot this movie-theater marquee (opposite page). As I zoomed the lens, I also moved the camera in order to create squiggly lines in the final image.

When I came across a museum art exhibit that featured an assembly of television monitors showing a fanciful tape in sequential style, I thought that it would make a fascinating target for a zoom-during-exposure image (above). I had no idea what the final picture might look like, so I zoomed both slowly and quickly, near to far and vice versa, in 1 or 2 seconds. In this variation, the four television screens seem to blur separately; in other shots, the images blended together. You can use this special technique more effectively after you've done it a few times and studied the results.

SPECIAL MODES

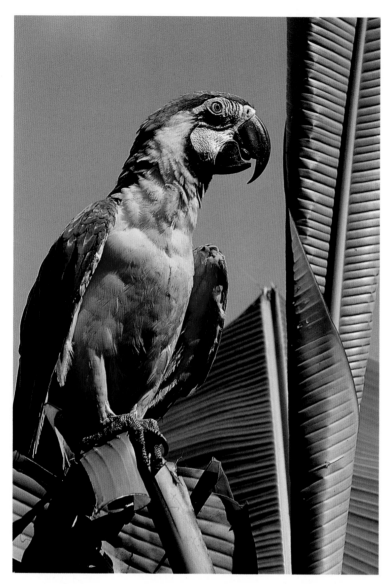

For this shot of a blue macaw parrot, the photographer experimented with the remote control on his P&S camera, which he'd mounted on a tripod. In a concealed area, he waited for a bird to perch in the right spot. Shooting with a telephoto zoom lens, he made several well-composed exposures, and some in which the parrot was half out of the frame. Remember, remote control can be unpredictable. Courtesy of Austin MacRae.

P&S cameras are designed to prevent accidental double exposures. With more complex models, the film is advanced automatically after each exposure. With simpler cameras, the shutter will operate for the next shot after the film is advanced manually. However, some P&S cameras include various special modes for creative purposes. These can make your P&S photography a more exciting experience: **Multiple-Exposure Mode**. Creativity and serendipity are combined when you intentionally shoot more than one picture on the same frame of film to overlap images for an often striking effect. In the *multiple-exposure mode*, the camera takes two or more pictures on one negative without advancing the film. A symbol for multiple exposures will show or blink in the camera's information display. A favorite subject for multiple exposures is flowers. When you make the first exposure, try to compose so that it includes some dark or empty areas where bright flowers from a second exposure will show through. Remember the pattern of the first shot in order to fit the pattern in the second one into it harmoniously. When you make intentional double exposures of flowers or other subjects, try several patterns to increase your chances for success.

Be prepared for disappointments, too. Recently, I superimposed two planes taking off from an airport a few minutes apart. It was a sunny day, but the sky was full of fluffy clouds that obscured the second plane in the print. The plane that did show was passing in front of a dark blue patch of sky. The lesson: Shoot several multiple-exposure combinations, and try for light-against-dark contrasts.

Photographing people at night with flash against a black background is another multiple-exposure technique. Choose a location where objects in the background are too far away to be illuminated by the flash. If background subjects show, their image will partly bleed through your models. For an amusing combination, with your camera mounted on a tripod, pose someone at the left of the picture facing inward for one shot and at the opposite side for the second shot. In the print, your model will seem to be talking to himself or herself. If your camera can make a third multiple exposure, photograph another person, or the same one, in the unoccupied center of the picture. The final result will look as though twins are harrassing the person in the middle, or perhaps you used triplets as models.

The instructions for one P&S camera I owned recommended doing only two overlapping images on one frame of film to avoid too much overexposure. The camera reset the shutter between exposures without winding the film, but it didn't compensate for a double exposure by cutting each exposure time in half. You must do this manually if the camera offers exposure compensation. If not, the latitude of color-print film can handle a double

exposure neatly, and your final prints should be fine. When you photograph someone three or more times in front of a black background and the figures overlap only slightly, the multiple-exposure image will be exposed correctly without halving the exposure. Slide films are more sensitive to overexposure and require exposure compensation for multiple exposures.

Landscape or Infinity Mode. The auto-focus system of many P&S cameras won't focus easily, if at all, when you shoot through a window or when you aim the camera at distant mountains and there are lots of bright clouds in the scene. Window glass blocks the infrared focusing beam, and subjects at infinity are too far for the beam to reach if there is no closer fore-ground subject. Some cameras include an infinity or landscape mode in the form of a button you press to shoot through a window or at infinity. While you keep the button depressed as you shoot, the LED light for proper focus and the flash are disengaged. Since the flash would be useless at the infinity setting or would reflect in the window, it is logical for it to be off. If your camera doesn't provide an infinity or landscape mode, check the instruction booklet for any special tech-nique required to shoot through windows or at infinity. (Cameras with fixed focus don't have an infinity problem.)

TV Mode. A few P&S cameras include a *TV mode* that sets the shutter speed at about 1/30 sec., thereby enabling you to photograph images on a television screen. A faster shutter speed, which the camera might set in such a situation, would produce a picture with a black line or bar across it because the shutter and the television's scanning speed didn't match.

Remote-Control Mode. Photographers often shoot self-portraits with this mode instead of the delayed-action self-portrait setting. When your camera is set for remote shooting, you can take a picture of yourself or others at will with a small remote control, rather than depend on a 10-second-delay self-timer. The average remote control operates 10 to 16 feet from the camera, depending on the angle at which it is aimed. Some remote systems operate instantaneously, and some make the exposure within 2 or 3 seconds.

The remote mode is also useful for taking pictures without being very obvious about it. At a child's birthday party, for example, mount your camera on a tripod at a good spot opposite the children, and position yourself out of the picture at the edge of the scene. When you aren't behind the camera, subjects tend to be more relaxed and less self-conscious. Unfortunately, you can't operate P&S remote controls from behind the camera, but you could place the camera securely in a tree and photograph birds from a spot in front of it on the ground.

Intentional multiple exposures, in which two images are shot on one negative frame or slide, can lead to creative pictures. Keep in mind, though, that the final results can also be unpredictable. Here, the photographer carefully planned to blend red flowers above white and yellow ones in a double-exposure composition that is more interesting than either picture would have been by itself. Flowers are good subjects for multiple exposures because they blend so harmoniously. Courtesy of Kathy Jacobs.

INTENTIONAL CAMERA MOVEMENT

With or without a zoom lens, you can shoot decorative patterns of lights at night using the camera's slowest shutter speeds, preferably 1/2 sec. or longer. The slower the speed of the film you're shooting, the longer the shutter tends to stay open during the exposure. I've shot my favorite pictures using this technique through the window of a moving car or airliner. Aim the camera at passing lights, and then simply jiggle it a little or a lot in order to achieve irregular light tracks on the film.

The longer the exposure and the more you move the camera while you shoot—within reason, of course—the better the pattern of light lines will be in the final image. While the shutter is open and the camera is moving, lights register as colored lines. By zigzagging the camera, you make random designs on film. However, unless the camera's slowest speed is 1/2 sec. or slower, shots of passing lights made by intentionally moving the camera during the exposure may be disappointing.

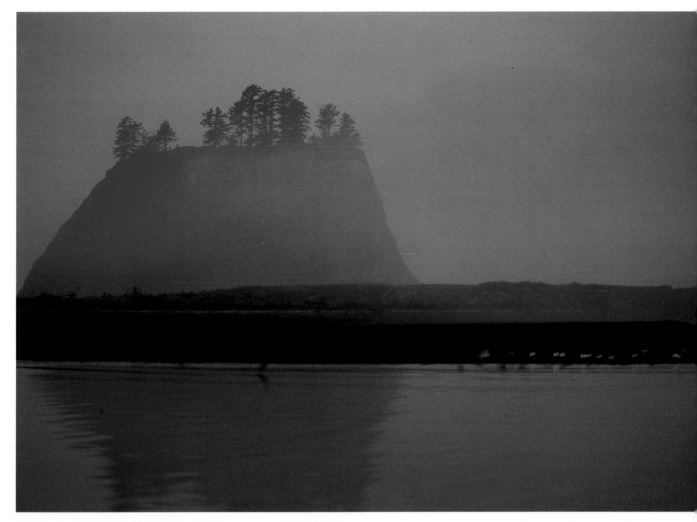

Filters are rarely needed when you shoot color-negative film because color corrections are made during processing. If, however, you want to use a colored filter to tint a scene or a *neutral density (ND) filter* in order to cut the speed of your film in half (perhaps to shoot patterns of lights at night at a slower shutter speed), you might want to consider the Cokin Creative Filter System. It includes filters and a filter holder for P&S cameras. The system is convenient and simple to use. The holder attaches to the front of a camera, and the various filters slide into it easily.

Another special effect that requires a shutter speed of 1 or 2 seconds involves moving the camera during the exposure while pointing the lens at passing lights. You can even do this through the window of an airplane that is landing or taking off or from a moving car. Use a slow film so that the shutter will stay open longer.

For this shot, I jiggled my P&S camera a bit, although some of the zigzag lines are the result of the motion of the plane landing at Los Angeles International Airport (opposite page). When you see the abstract-design pictures you get, you probably won't remember exactly what the subject looked like or how you manipulated the camera. Nevertheless, you'll probably like the results.

To enhance the atmosphere of a chilly morning in the Pacific Northwest, the photographer used a blue filter over her camera lens (above). She mounted her P&S camera on a tripod because she knew that the filter's density would increase the exposure time; even with ISO 200 film, she wasn't sure that she would get a sharp picture if she handheld the camera. Courtesy of Kristal Kimp.

BUYING AND CARING FOR A POINT-AND-SHOOT CAMERA

Photo opportunities have to be enjoyed between rainstorms, which plagued me while I was visiting Vienne, France. I made this picture while shooting at 9 A.M. one October day as the sun shone through dark clouds to produce great reflections in the Rhine River. I used a zoom lens set at about 90mm to show St. Maurice Cathedral dominating the skyline.

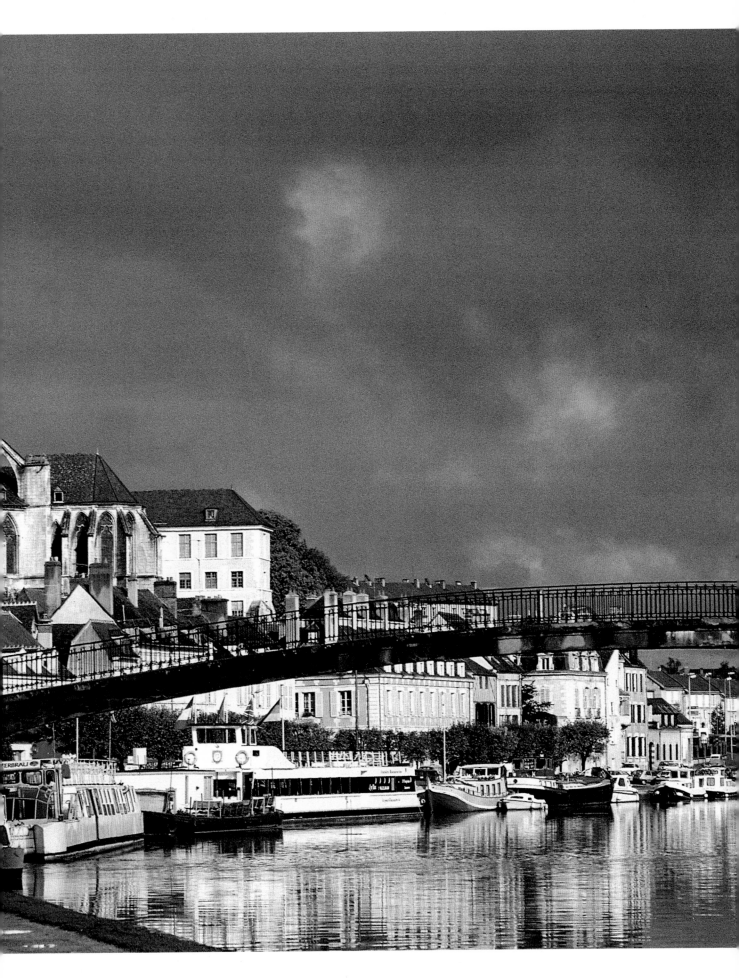

CHOOSING THE RIGHT CAMERA

Perhaps you already own a point-and-shoot (P&S) camera and want another one with more features, or you are about to buy your first P&S camera, or you want to give one as a gift. In any case, you face a mind-boggling selection of brands and models that can make choosing the right one for you quite difficult. Millions of P&S cameras are sold every year, and photographic-supply and discount stores advertise sales regularly, so you can compare prices and features by watching the advertisements. However, to make an informed decision about what type to buy, you first have to

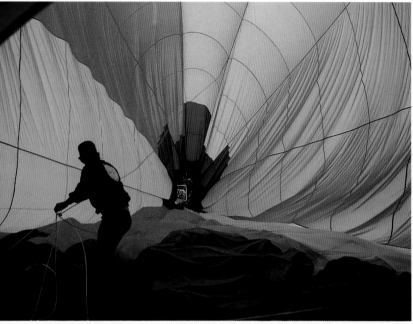

For this behind-the-scenes shot of a hot-air-balloon festival in Albuquerque, New Mexico, during the fall, the photographer shot through the flap at the top of this balloon to show a crew member at work. He handheld his dual-lens camera and used the 28mm lens setting and ISO 200 film. Courtesy of Austin MacRae.

decide who the camera is for and how it will be used.

For preteenagers, check out an inexpensive, fixed-focus model with manual winding or a simple autofocus camera with autowind. For older teenagers or anyone with only a casual interest in photography, a basic, less expensive, one-lens or dual-lens P&S camera is an appropriate choice. For both more serious photographers, younger or older, and for people who need more flexibility when taking family snapshots at home or on vacations, choose a dual-lens or mid-range zoom-lens (such as 38-70mm) model. For anyone who travels occasionally and wants a compact P&S camera that is easy to pack and carry, a more expensive, more precise single-lens model or a compact mid-range

zoom-lens camera is a good choice. And for all serious photographic enthusiasts who will read the instruction booklet, appreciate sophisticated features, and shoot with care, a wide-range, zoom-lens (38-90mm or 35-105mm) model is appropriate. A zoom-lens model might also suit someone who owns an SLR camera with several lenses but wants a versatile camera that can be transported more easily. The five types of P&S cameras have a wide range of prices that overlap considerably. The following short summaries of each group should help you decide which camera best fits your needs or those of family and friends:

Single-Lens Models. These are the simplest and often the least expensive P&S cameras. This type of camera has a single-focal-length lens, usually a 35mm lens, which is fine for shooting scenics and groups of people, but doesn't adapt well to head shots; these portraits might be distorted when you shoot so close to your subject. Basic inexpensive models usually take only ISO 100 to 400 print films and can have a fixed-focus lens, which isn't as useful as a lens that adjusts focus automatically. One-lens cameras do include built-in flash, but most don't have slow shutter speeds for shooting night and low-light pictures without flash. However, a few expensive single-lens models have an $f/2.8$ lens or a 24mm ultrawide-angle lens, as well as shutter speeds as slow as 1 or 2 seconds. Single-lens P&S cameras range from beginner models that cost about $30 to complex models that sell for $200 to $1000.

Dual-Lens Models. These cameras have two lenses, such as a 35mm wide-angle lens and a 60mm or 80mm telephoto lens. The longer focal length enables you to shoot larger images of distant subjects and is more suitable for portraits. Dual-lens cameras usually have a stronger flash than single-lens models do, to ensure proper lighting with the lens' longer focal length. To change focal lengths, all you have to do is push a button or a switch; this very convenient feature can lead to better photography. Prices for dual-lens P&S cameras overlap prices for some zoom-lens models, so you can consider a zoom-lens camera as well if you plan to spend $150 to $200.

Zoom-Lens Models. These P&S cameras offer the greatest versatility: you can shoot at an extensive range of focal lengths from wide-angle to telephoto. Longer zoom-lens focal lengths, such as 90mm and 105mm, make better scenics possible when you can't or don't choose to move closer to the subject, as well as undistorted portraits. By pressing buttons or sliding a lever, you zoom the lens to a composition selected in the viewfinder. More advanced features, such as macro focusing, multiple exposures, exposure compensation, infinity mode, and automatic zoom, are often included in zoom-lens cameras. The higher number of lens focal lengths and other photographic options might justify the correspondingly higher cost of a zoom-lens camera. These prices range anywhere from $150 to $400.

Bridge Models. These sophisticated, noninterchangeable-lens cameras "bridge" the gap between zoom-lens P&S models and 35mm SLR cameras. Like SLR cameras, most bridge cameras offer TTL viewing, which is very valuable, as well as a 35-105mm zoom lens and excellent focusing and exposure systems. But bridge cameras are heavier and are the most expensive P&S cameras. A better choice might be a comparably priced autofocus SLR camera. Its interchangeable lenses and more conventional configuration can tip the scales in its favor. Compare the bridge models you like with similarly priced SLR cameras while you're shopping.

Disposable Cameras. These inexpensive "throwaway" or cardboard cameras are popular with people who forget their own camera or don't own cameras. They're made by Eastman Kodak, Fuji Photo Film Company, and Konica. A disposable is sold with a 12- or 24-exposure roll of film in it, the speed of which varies according to camera type. Some models include a tiny electronic flash, one type has a telephoto lens, one type can be used underwater to a depth of 10 feet, and several take panoramic pictures. When the roll is completed, you turn the whole camera in to the photofinisher. The film is removed and processed, and the camera is returned to its manufacturer for recycling. A one-time-use camera might be an ideal first camera for young photography enthusiasts. If youngsters use the proper care and show promise, they can graduate to better P&S cameras.

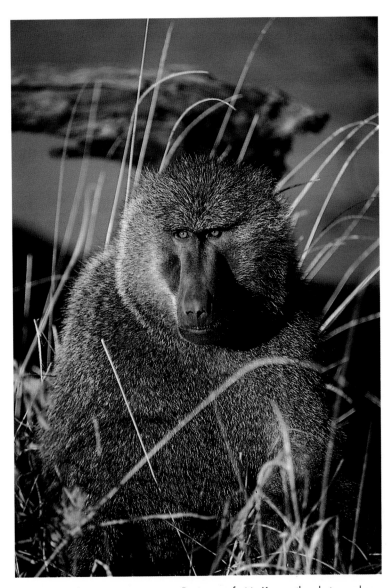

During a safari in Kenya, the photographer discovered this placid-looking baboon. He mounted his bridge camera on a tripod, set the zoom lens to 135mm, and made this shot. Seconds later, the photographer was startled when the baboon let out a scream, and he shot another picture as a reflex action. Courtesy of Austin MacRae.

CAMERA FEATURES

Here is a list of important camera features to help you choose a satisfactory model in whichever group you prefer:

Camera Size. Most P&S cameras are lightweight and compact. If you prefer the smallest models, keep in mind that they usually have a single-focal-length lens; only a few offer zoom lenses. The smallest P&S models fit into a pocket or purse with ease, which might be an advantage. Such a camera might not be full-featured, but you'll carry it more often. Full-range zoom-lens models tend to be somewhat bulky compared to compact minis, but they aren't uncomfortably heavy.

Lens Focal Length. The longer the focal length of a zoom lens, the more convenience it offers in terms of shooting scenics, sports, portraits, and casual pictures. If you find a P&S camera with a 38-105mm lens that costs $20 or $30 more than one with a 38-90mm lens, the longer zoom range is often worth the money. Cameras with longer zooms may also have other features, such as a more extensive shutter-speed range, that increase their value. This comparison applies to buying a dual-lens model, too; a 38-80mm range is preferable to a 35-50mm or 35-70mm range. Since you'll use a P&S camera for a number of years, during which time you become more expert at picture-taking, you should choose a lens combination that offers the most pictorial possibilities.

Lens Aperture. Most P&S camera lenses have a maximum aperture of $f/3.5$ or $f/4$. Zoom lenses have a graduated scale of maximum apertures that become smaller as their focal length increases. An aperture of $f/3.5$ or $f/4.5$ lens is suitable for most pictures in good light, even on cloudy days with an ISO 100 or 200 film. In dim light, most P&S cameras automatically shift to flash before the maximum aperture is required in order to avoid slow shutter speeds that can cause camera shake. In lower light levels when a zoom lens is extended, the maximum aperture becomes $f/5.6$, $f/8$, or smaller, and flash is necessary sooner. Extended zoom and shutter-speed ranges are more important than slightly greater maximum apertures.

Shutter-Speed Range. Slow speeds of 1/2 sec. to 2 seconds and a fast speed of 1/400 or 1/500 sec. offer you more shooting options. Shutter speeds of 2 seconds, 1 second, and 1/2 sec. are valuable because they allow you to capture the moodiness and reality of available light by using a tripod or bracing the camera. Many picture situations look more appealing and closer to real life when shot in existing light than they do when photographed with flash.

Even more important are fast shutter speeds to ensure sharper action pictures for such subjects as tennis, football, and children running. Speeds of, for example, 1/100 sec. and 1/125 sec. are too slow for getting sharp images of these moving subjects, though you can sometimes catch peak action or achieve creative blurs. Speeds of 1/250 sec. and 1/400 sec. are preferable here, although 1/250 sec. still isn't fast enough to render some action sharp. Shutter speeds from 1/500 sec. to 1/1000 sec. are usually required for sharp action shots.

Note that some expensive P&S cameras with good dual- or zoom-lens ranges have maximum shutter speeds of only 1/250 sec., which is a handicap when subjects are moving swiftly. Ask about shutter-speed ranges when shopping for cameras if you plan to take sports and other action-oriented pictures.

ISO Range. The latest P&S camera models include a film-speed range of at least ISO 100 to 400, which is adequate for most photographers. If you intend to use ISO 50, 1000, 1600, or 3200 films, you should select a camera accordingly.

Autofocus Zones. The least expensive P&S cameras may include three autofocus zones, such as 5, 10, and 20 feet. The lens sets the focus at whichever distance the subject is closest to. This isn't as precise a system as multi-zone lenses found in more expensive cameras; these offer from 16 to more than 100 zones. However, when you shoot in daylight, after dawn, or before dusk with an ISO 200 film, and use recommended techniques, any autofocus camera should produce sharp pictures.

Flash Range. P&S cameras offer various flash ranges at ISO 100, such as 3 to 16 feet, 4 to 12 feet, 3 to 13 feet, and 2.6 to 10 feet. The lower number usually indicates the maximum closeup setting of the lens.

A greater maximum distance is particularly helpful when you stand back to include more of a subject at night or in poor light. The flash range for one typical P&S camera is 2 to 14 feet for ISO 100 film at 38mm, and 2 to 8.9 feet for this film at 90mm. With ISO 400 film at 38mm, the range extends to 28 feet, and at 90mm, to 17.7 feet.

Flash Modes. Many P&S cameras automatically turn on the flash when the light level decreases and permit you to turn it off for available-light photography. Fill-flash that you can set manually in order to accommodate backlighting, bright sun, and shade is also very handy. Modern P&S cameras do an excellent job of seamlessly blending flash with available light to improve and brighten pictures.

Red-Eye Reduction. Some cameras flash a tiny light a moment before the camera's flash pops. This causes the pupils of a subject's eyes to close down and reduces the chance of people having red eyes in your prints or slides. Many cameras enable you to turn on the red-eye reduction feature whenever you want it. However, I rarely use red-eye reduction because in that one-second interval, the subject's expression may change from what I originally wanted to record and what I capture on film isn't as appealing.

Date-Print Option. A number of P&S cameras offer an auto-date or date-imprinting model with a clock and calendar built into the camera back. The display is easy to program, and you can turn dating on and off at will. Decide if small numbers in a right corner of prints will be helpful or annoying. For those readers who don't routinely put dates on the back of prints and who end up wondering when they took many of their shots, the cost of the date-print option might actually be a bargain.

This appealing photograph of Bonaguil Castle near Fugel, France, was made with a P&S camera with a 35-105mm zoom lens in atmospheric light. Clearly, the photographer is very familiar with how his camera operates. Before you buy a P&S camera, you should be more concerned with how comfortable you feel with it than with how many autofocus zones or shutter speeds it has. Courtesy of Jim Hopp.

A 1993 chart of P&S cameras lists 16 brands. Not every company makes all four P&S types, and the highest number of brand names appears in the zoom-lens category. If you read discount-store flyers or advertisements in newspapers and photography magazines, you learn to compare prices and models. Some cameras are sold as part of a kit, some include a carrying case, and some come with a roll of film. I've seen sale advertisements for cameras that cost $25, $50, $70, $100, $150, $200, $250, and even more. Close examination may show that one or two cameras in each price group offer more than the others, all of which are brand names. But price isn't the only factor. How comfortable a camera feels to you and how

Before you buy a P&S camera, you need to think about who will use it and what kind of subjects that individual likes to shoot. This picture of California's Kings Creek Falls could have been made using any P&S camera with a lens with an 80mm or longer focal length.

well your eye seems to adapt to the viewfinder are also very important. Here are more pointers to help you make choices.

Cameras sold in kits may include equipment you don't want or need, and some more expensive models may include features you feel you'll never use. Ask for brochures about cameras and models you like best; if the store doesn't have any, write or call the manufacturer to request literature. (You can find addresses in various photography magazines.) Read the camera descriptions and the list of technical specifications. If you don't have the time or patience to read the brochures, ask the salesperson about details that interest you. If the person isn't informed, ask to look at the cameras' instruction manuals. At the back of most manuals, you'll find a chart listing lens apertures, shutter speeds, and other important data.

Try to determine if a camera you like will be easy enough for you to use. More sophisticated models operate via a series of computer-like commands, some of which work together. These are easy to learn but hard to remember if you don't use them often. To avoid complex features, buy a less expensive single-lens or dual-lens model.

COMPARING BRANDS

Is one P&S camera brand better than another? All are competent, all come with a one- or two-year guarantee, all have suitably sharp lenses, and all are likely to take good pictures. However, some very similar brand-name cameras cost more than others do. Higher-priced models might be more dependable, but this isn't always the case. It is better to spend less if you get what you want than to spend more for what may be a status brand name. Check the differences in features built into seemingly comparable P&S models. You may find a greater zoom range, a higher shutter speed, a larger maximum aperture, or an automated feature on cameras that cost less. You should also talk to friends who have P&S cameras and find out what they like best and least about their equipment. Finally, you might want to read the December 1992 issue of *Consumer Reports*, which evaluated and compared P&S cameras in an eight-page article.

P&S cameras are easy to care for. Almost every model includes a lens cover that opens manually or when you turn the camera on. The lens is protected, although getting dust and finger marks on it is possible. Buy a small, soft lens brush to remove dust particles on the front and back of the lens. Dust can distort picture sharpness, as can fingerprints. Fortunately, both can be removed via the delicate use of lens-cleaning tissue. Each time you change film rolls, gently blow the dust out of the camera interior, and never leave the camera back open unnecessarily.

Make it a point to close the lens cover of your P&S when you aren't shooting, to save both the battery and the lens, and store the camera in a small shoulder bag out of harm's way when you are on a trip or at home. (Remove the batteries if you don't expect to use the camera for about a month.) If you prefer to leave the shoulder bag behind, you can put an extra roll of film in your pocket and pull the camera strap over your head and across your chest. Your handy P&S camera won't swing freely and get damaged, or slip off your shoulder.

You should also protect your P&S camera from unfavorable weather conditions. To shoot outside in the rain, put your camera in a plastic bag and make a hole for the lens. You can look through the viewfinder through the open end of the bag. The average P&S camera should operate normally in cold weather, but if you know in advance that you might be shooting in extremely frigid temperatures, between 0°F and 32°F, ask the manufacturer or a camera repairperson about protective measures. If possible, don't keep your camera completely covered in a warm place because when you shoot, moisture may condense on the lens and viewfinder. After you return indoors with a cold camera, place it on a table or someplace where moisture will evaporate. You may wipe the lens, viewfinder, and flash with a soft tissue or cloth to accelerate this process, but use a lens-cleaning tissue to finish the job.

Above all, try not to drop the camera; this can damage the circuitry inside. P&S cameras are solidly made, but optically and electronically, they require—and deserve—protection.

Shooting this neon-light work of art, which I found in a museum, required a P&S camera with a slow shutter speed of 1/2 sec. (top). I also needed a wide-angle-lens aperture of f/3.5 or f/4 and a way to turn off the flash.

To shoot this field of sunflowers in France, the photographer used the 28mm wide-angle setting on a P&S camera (bottom). He focused on the slope from a distance of about 8 feet, locked focus, and shot several pictures in order to ensure overall sharpness. Courtesy of Jim Hopp.

AFTER YOU SHOOT

STORING YOUR PHOTOGRAPHS

According to comic tradition, the way to store photographs is in a shoebox, a drawer, or an old trunk. As the years pass, prints and slides from childhood through college graduation and beyond get mixed together. As you sift through family albums and slide boxes, you notice that the images are disorganized, friends and relatives become anonymous, and dates are confused or forgotten. These are strangely casual methods of preserving images that you try to shoot with care and precision. The following well-tested suggestions will enable you to avoid archival chaos.

LABELING AND FILING
YOUR IMAGES

It is easier to caption pictures when your photo album contains a cardboard page you can write on, although you can write captions on blank paper labels as well. Include simple identifications adjacent to prints that need them, labeling only one in a related series. Use a permanent marker with an extra-fine point that writes on all surfaces. Arranging pictures on album pages is a worthy challenge, and your reward will be compliments from people who enjoy looking at well-planned and interesting layouts.

For years, I've systematically filed negatives, slides, and prints taken for magazine jobs or for my books, and these methods work effectively for personal pictures, too. I give each roll of color or black-and-white film its own number, and each print or slide its own file number. Many times, this system has enabled me to find a picture taken years earlier, such as a black-and-white negative to be reprinted or a slide among the many I have stored in notebooks. Numbering is the first key to easy photograph retrieval. The other is keeping a simple index of film-roll numbers and subjects.

When I began shooting color-negative film with my earliest point-and-shoot (P&S) camera, I started a separate filing system for negatives and extra prints stored in marked boxes. I record each roll number in a 4x6-inch spiral-bound notebook that will last about a decade for the average P&S enthusiast. I date the top of each index page, which helps me find pictures when I'm not sure when I took them. For example, an aunt asks for a specific family print because she sent the one I gave her to a sister in Australia and, of course, she didn't write down the file number. Once she and I agree the picture was taken in August two years ago, I look to see if it is in my own family album before I check my dated index pages to find the negative number. If there are two or three look-alike negatives and I'm not sure which one I used for the print I gave to my aunt, I have them all printed and let her decide. Finding the right negatives is a cinch with a simple filing system.

Because prints are almost always returned by the processor in the order in which they were taken, they have a built-in organizational scheme. To be sure, check the first prints with negatives 1 and 2. If you look through a batch of new prints before you number them, keep them in order. As soon as possible, give the roll a number and put that same number on each print along with the negative frame number. Throw away unsatisfactory pictures at this point. Record each roll with its own number in your index notebook. An entry might look like this: 144-Picnic at South Park, Aunt Alice's family/Visit to Mom's/Start of Laura & Matt's party.

After numbering your prints, you can shuffle them or mix them with pictures from other rolls and you'll always be able to find the right negatives quickly for reprints or enlargements. For example, if you give a print of Laura and Matt to Laura, and a month later she wants an 8x10 enlargement for her mother, your professional numbering system makes retrieval painless. Occasionally, I see a good enlargement on someone's living-room wall, and I suggest a trade for one of mine.

I regret when the person says, "I'd really have a hard time finding that negative. I shot it three years ago." Clearly, this photographer has no numbering-and-filing system. If that same person sent an outstanding picture to a contest, he or she might not be able to identify or find its negative to claim first prize! Maybe this will encourage you to file pictures carefully if you haven't done so before.

EDITING PHOTOGRAPHS

You probably have a friend, as I do, who hardly ever discards a print and shows you every picture from every roll. The person I have in mind has an excellent camera, but on a scale of 1 to 10, I would rate his photography at 3. His outstanding pictures are few, while his ordinary pictures, poorly composed or inane, are many. I know because I have to look at every shot that he should have rejected. He stores his prints in envelopes and has yet to start a photo album. If he did, perhaps he would be sensitive enough to realize that duplicate pictures, especially mediocre photographs, bore people.

So ruthlessly edit your pictures, and show only the best or near-best to win friends and influence viewers. When it comes to scenics and other shots made on vacation trips, put the near-misses and look-alikes in your file, not in your album. Don't allow your personal interest in them to have an emotional pull. For example, if you have five pictures of the Capitol in Washington, DC, to choose from, only two views may be really satisfying; file the other near duplicates. Pictures of friends and relatives may be harder to edit because some people have the urge to show multiple photographs of their children, parents, siblings, or closest friends. Ignoring your mistakes and being unable—or unwilling—to discriminate aren't photographically wise.

Toss out weak or offending prints; this will enhance the value of those you do show. Here is a short list of visual flaws that detract from your images:
■ No center of interest or conflicting, uninteresting centers of interest; empty scenes with tilted horizons; clumsy camera angles; important subjects out of focus.
■ Main subject too small to be seen well, too many shadows to see the subject clearly, confusing or cluttered background, unfortunate timing of action subjects.

■ Foolish facial expressions, awkward posing, blurred action that spoils image, entire pictures blurred by camera movement.
■ Dark or muddy prints made without flash in poor light, dark flash pictures taken too far from subject, prints with washed-out foreground because flash was too close.
■ Overlapped pictures caused by film advance not working properly (have camera checked).
■ Poor color quality caused by printing errors (return to processor for reprints); poor color because film may have been left in camera for 12 months in heat and humidity.

Edit your photographs, and show only those you don't have to apologize for. A well-designed family album with carefully edited pictures can add to the joy of photographing people and places with your P&S camera by providing you, your family, and your friends with pleasant memories.

CROPPING PRINTS

While I like the ease of slipping prints back-to-back into custom-sized plastic pockets, pages with lift-up plastic sheets offer more layout flexibility in an album for color prints that need to be cropped. P&S camera viewfinders aren't always as precise as you might like, and you aren't always able to compose pictures carefully. So, trimming prints to eliminate unwanted elements is sometimes necessary to make your pictures more appealing.

Using a pair of scissors for cropping is possible, but it is hard to cut a neat, straight line. If you regularly crop prints for your albums, invest in a small paper trimmer (available at photographic-supply stores and catalogs). Squarely trimmed prints make your album pages more presentable. Using lift-up plastic pages, you can design your own layouts with pictures of various sizes. Cropped and uncropped prints back-to-back in plastic pockets don't appear as neat. Perhaps you could put blank-paper spacers, which are found in photo albums, between back-to-back prints for a more uniform layout.

PUTTING TOGETHER A PHOTO ALBUM

I know an otherwise intelligent couple who actually keep their family pictures in shoeboxes, piling new prints on top of old ones. These people sift through the

collection, showing pictures to friends or relatives almost at random. Ideally, photography enthusiasts have the urge to edit their prints and display the best ones in different albums. One album may contain family pictures, informal portraits, and shots of parties and holiday celebrations, while another album may be used for pictures taken on vacations and other trips. In this way, you can show your everyday collection or vacation images to different audiences.

It is easy to start and maintain a photo album. There are two basic methods, each using a three-ring binder available at discount stores. Binders filled with pages on both sides that have lift-up plastic sheets are the more popular choice. Test the lifting and sticking quality of a few pages before you buy the album to be sure it is suitable. I have a number of these albums made by various manufacturers, and most of the plastic pages adhere well. It is likely that some types of lift-up plastic storage sheets will in time accelerate the fading of color prints because of the plastic's chemical composition. Color prints usually fade in 10 to 20 years, depending on how they're preserved. You might, however, want to get albums with archival-quality, lift-up plastic pages with pockets; this plastic won't affect color prints. (These are available at photographic-supply stores.)

MAKING A PHOTO MONTAGE
Another way to display color prints is to assemble them into an informal montage. Since so many film processors offer double prints inexpensively or at no additional charge, some of the same prints used in albums are left over and can be used for montages. Here are the simple directions for making a montage. First, think of a theme to give the montage coherence, such as a summer vacation, a trip to Disneyland, a visit to close relatives, or any subject for which you have enough pictures to work with. Then choose a background of heavy white or colored paper that isn't so bright that it is distracting. The background serves as a border and is visible between prints that don't fully overlap. Heavy paper stays flat more readily when you glue pictures to it. The size of your montage should be comfortable for you to work with. Popular size frames are 11x14, 14x18, and 16x20.

Try to find a location where half-finished montages won't be disturbed when you leave them for several days. Then gather all the appropriate prints on a work surface large enough for you to spread them out, and choose the images you want to include. You probably won't use all of them, but you can't be sure beforehand which will work best in a design. With a pair of scissors, cut around the edges of people, places, or other subjects in your prints, leaving any background you want, and begin to compose on the mount board. You can start in the center, in a corner, or at any spot that appeals to you. Overlap prints that seem related in some places, and put pictures of contrasting subjects in other places. Try for harmonious arrangements and contrasts as well. Visual surprises help make an attractive montage.

Fit and revise, study the result, and revise again. It helps to start a montage, work an hour or so, and leave it for a while. When you return, you'll have a fresh vision about making changes and adding new pictures. You might decide to further trim prints to fit a particular space. It is your montage, so feel free to assemble it to your own taste.

Try to achieve a kind of visual flow within the montage, from one picture to another, but don't be concerned about placing unrelated pictures next to each other. As you mix images and revise, you'll create a design that pleases you. If in doubt, ask someone whose judgment you trust to critique your work. A worthy critic will make constructive suggestions. When you feel the montage arrangement you've made is relatively final, photograph it with your P&S camera if possible; if not, use a Polaroid camera to make an instant print. You'll need a record of the montage composition for reference because prints within it get pushed out of position as you mount them one by one.

You have to choose an adhesive carefully. Rubber cement will eventually cause chemical damage to prints, as will household cements. I suggest using Scotch's Photo Mount Spray Adhesive, which is available in art-supply stores. It is relatively expensive, but it lasts, and used according to directions, it is a clean way to work and mount montage prints efficiently. Finally, frame your montage for display and expect to receive many compliments on the original way you've used your P&S people pictures, or whatever subjects you choose to assemble.